HISTORIC PHOTOS OF
ST. PAUL

TEXT AND CAPTIONS BY STEVE TRIMBLE

TURNER
PUBLISHING COMPANY

There were several "railroad suburbs" in St. Paul in the 1880s. Highwood was built in the far southern part of the city and was promoted as an area of exclusive homes built into tree-filled hills. In 1887, trains ran to this depot six times a day going to and from downtown, but the project collapsed during the 1893 depression.

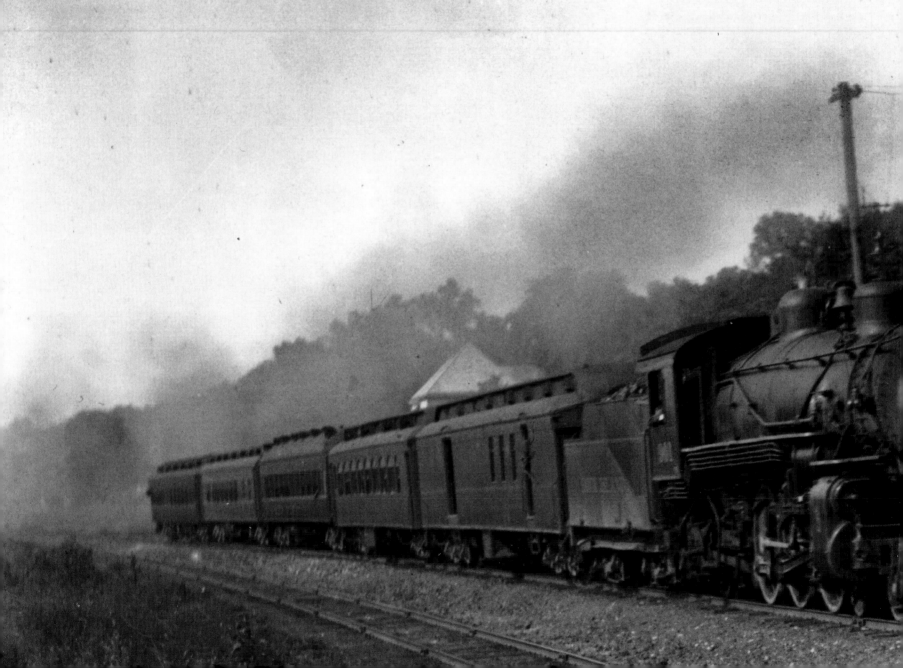

HISTORIC PHOTOS OF
ST. PAUL

HIGHWOOD

Turner Publishing Company
200 4th Avenue North • Suite 950
Nashville, Tennessee 37219
(615) 255-2665

www.turnerpublishing.com

Historic Photos of St. Paul

Copyright © 2008 Turner Publishing Company

Library of Congress Control Number: 2007929567

ISBN-13: 978-1-59652-395-1

Printed in the United States of America

08 09 10 11 12 13 14 15—0 9 8 7 6 5 4 3 2 1

CONTENTS

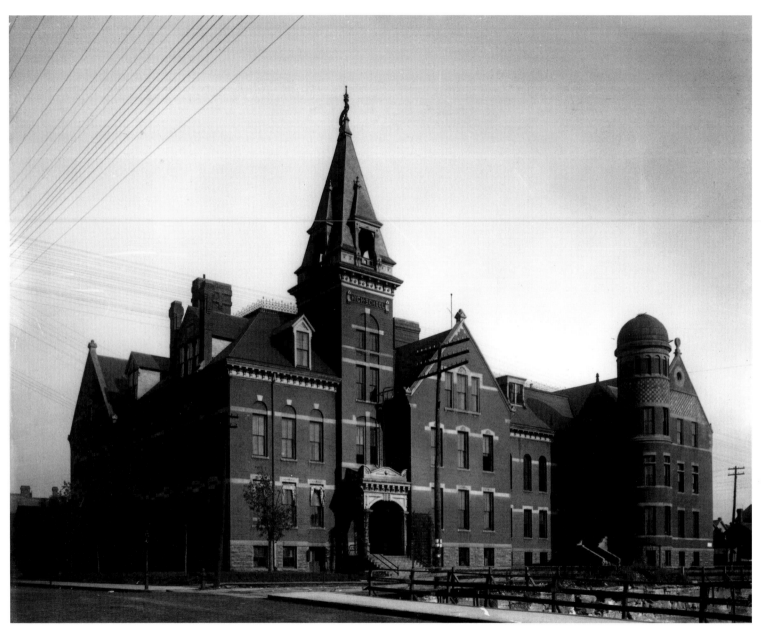

When it started in the 1860s, it was called St. Paul High School. As the population grew and other institutions were added, it became Central High School, because of its downtown location. This Tenth and Minnesota image was taken in 1892. Central is now housed in a different building at the corner of Lexington and Marshall.

ACKNOWLEDGMENTS

This volume, *Historic Photos of St. Paul,* is the result of the cooperation and efforts of many individuals and organizations. It is with great thanks that we acknowledge the valuable contribution of the following for their generous support:

Minnesota State Historical Society
Ramsey County Historical Society

Thanks in particular to Maureen McGinn of the Ramsey County Historical Society and Debbie Miller and Tracey Baker of the Minnesota Historical Society.

———————

For Richard C. Wade

who helped so many of us
to understand the importance
of urban history.

PREFACE

With Minnesota celebrating its sesquicentennial, 2008 seems an appropriate time to reflect on St. Paul's past. But what is the best way to tell its story? The city has constantly changed, has grown, moves outward, is home to a shifting population. New institutions take the place of old. Using mostly photographs to tell the story of St. Paul could seem a little problematic. After all, historians write at length about the past while photographers capture only moments, frozen in a snapshot.

People often say the camera doesn't lie, but a bias often hides in images just as it hides in words. Photographers choose what images to produce. The people, events, and city scenes are filtered through their subjective values—what to shoot, how to frame it, when to take it, and, perhaps just as important, what to leave unrecorded. Photos of accomplishments are far more common than those of failures.

It is also said that a picture is worth a thousand words, but again this is only partly true. Even wonderful images can be more helpful in understanding the past when a narrative is added. There is always a story that accompanies a photograph. The two boys shown boxing in this book, it turns out, were going to be part of an open house for Christ Child Center.

Without visual images, however, it would ultimately be far more difficult to understand the history of St. Paul. Letters and diaries may mention houses, the river landing, or crowded streets and neighborhoods, but images give an important sense of how the city looked and was once arranged.

The selections in this book may show some sort of bias. Telling the city's story with two hundred photos is difficult, so choices had to be made. Historical societies mostly preserve photographs that have been donated haphazardly, so sometimes it is impossible to find images to illustrate particular aspects of urban life. With the addition of introductions and captions, however, the effort has been made to present a balanced perspective on one of the nation's great cities.

This volume has been divided into four sections. Its first, "The River City," starts in the 1840s when St. Paul was a

frontier outpost and continues through 1869, when it had established itself as an important Midwest commercial center. The city relied heavily on the river trade and when the Mississippi was frozen, St. Paul was a very isolated place to be.

"The City on Rails," the second section, stretches from 1870 to 1918 and looks at an era generally characterized by a booming economy. It was a time when new forms of transportation were the key factor in determining the shape and direction of the city and its people. The railroad was a large employer that linked St. Paul with the rest of the nation. Streetcars aided the city's outward spread, helping create ethnically and economically diverse neighborhoods. The city expanded and needed new infrastructure, investing in roads, sidewalks, sewers, streetlights, and a grand park system.

The period from 1919 to 1945, called "The City in Transition," highlights events from the beginning of one world war to the end of another. The economy boomed and busted and boomed again, causing cultural shifts. The automobile, movies, and radio had a strong impact on St. Paul. Autos allowed people to live in areas not served by streetcars, so housing and new neighborhoods developed. But during the Great Depression of the 1930s almost all construction came to a halt that lasted through World War II.

"The Modern Metropolis" is the last era. Starting in 1946, it takes St. Paul through to the turbulent 1960s and 1970s. Cars had an increasing impact and the city was linked nationally by truck and air transportation. The freeways cut into communities and, in the case of the Rondo neighborhood, destroyed one. There were "urban renewal" projects, old buildings came down, and public housing went up. Starting in the 1970s, new immigrant groups seeking a better life came to St. Paul from Central America, Asia, Africa, and elsewhere. People from rural areas in the Midwest migrated to the city, along with large numbers of African Americans from various parts of the nation.

Although no single volume can tell the complete story of St. Paul, it is hoped that these photographs and accompanying narratives provide a good glimpse of its people and the city's growth over the last century and a half.

—Steve Trimble

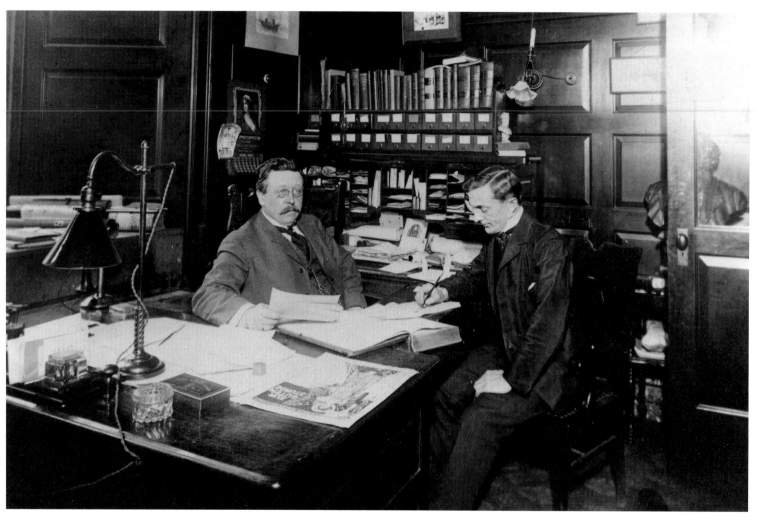

Engebreth H. Hobe in his 315 Jackson Street office around 1904. Hobe settled in St. Paul in 1883 and successfully engaged in the real estate business in the city and other states, as well as Norway. He served as Norwegian consul in St. Paul from 1893 to 1940 and had connections with the Norwegian America Steamship Line.

THE RIVER CITY

(1840–1869)

St. Paul was part of an urban frontier and was an important economic and cultural force even before Minnesota became a state. Its settlement began in the late 1830s, when squatters were driven away from Fort Snelling and went east to a place then known as Pig's Eye. Because a waterfall a few miles upriver made further travel on the Mississippi nearly impossible, St. Paul, as it was later named, was bound to thrive because it had the nearest landing for steamboats.

When Minnesota became a Territory in 1849, St. Paul was its capital, and there was a rush of settlers to the area. The population swelled from a handful to nearly a thousand and it was a sizable town even before many farmers were claiming land in the area.

St. Paul was isolated when the river froze, but people pulled together and thrived. Ponds were drained, hills graded away, and streets laid out. The city established basic services including water and gas. The Wabasha Bridge, built in 1858, helped the city expand across the Mississippi.

The city was new, but boasted amenities. Most residents had lived in urban areas and knew what a city should be like. Those from New England and the Midwest wanted to plant a Yankee culture and quickly passed laws for civic betterment and social control. Along with the native-born, German, Irish, French Canadian, and other immigrants built churches and music halls, and started fraternal groups and clubs. Visitors were astounded by St. Paul's rapid growth and often remarked on the number of languages heard on the sidewalks.

The fur trade, lumbering, and agriculture were the mainstays of the early economy. Most people worked in small shops, and farmers brought produce into the city market or hawked on the streets. In the winter, people relied on what they had preserved, or purchased staples from small stores.

The aspirations and concerns of the early urban dwellers were similar to those expressed today. They worried about crime, public health, the education of children, the need for housing, the quality of city services, and what to do with the poor. They took pride in the progress of their new metropolis on the Mississippi.

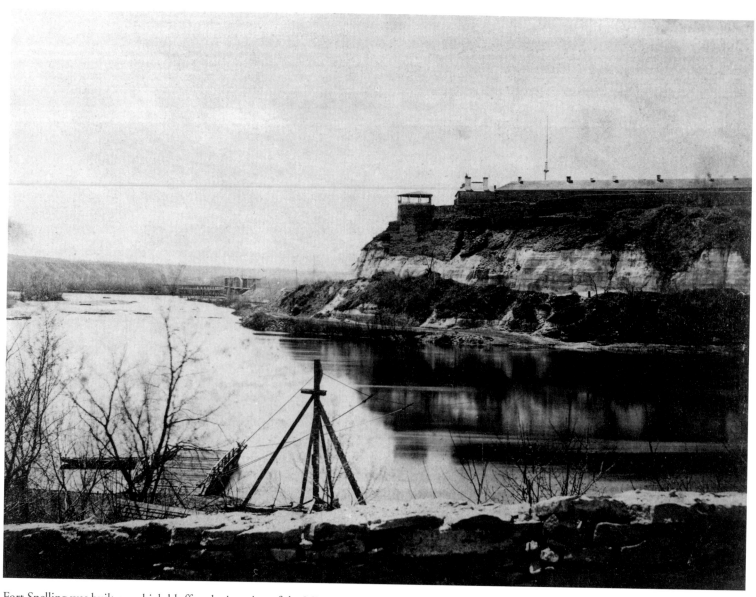

Fort Snelling was built on a high bluff at the junction of the Mississippi and Minnesota rivers in the 1820s. This military outpost would have a close connection with St. Paul. Former soldiers, squatters, and traders ended up moving eastward to the new settlement of Pig's Eye, as the city was originally known. This view is from the ferry landing on the east side of the river.

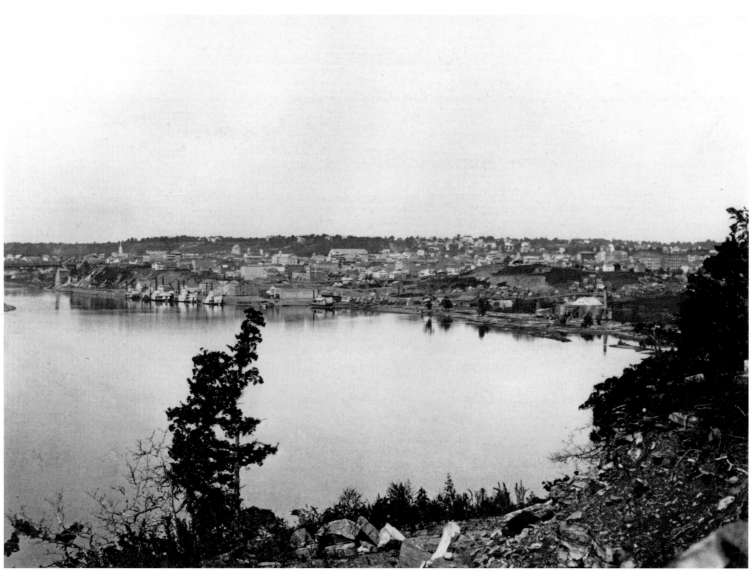

Geography determined St. Paul's location. Steamboats could not go beyond St. Anthony Falls a few miles upriver. This early photograph illustrates the break in the high bluffs along the Mississippi and its gradual slope, which was ideal for loading and unloading people and merchandise. The site was well suited for the founding of an important commercial city.

Frontier St. Paul was full of small frame houses, piles of wood for heating, and at least one tree in 1851. This image shows the First Baptist Church on a high spot known as "Baptist Hill." In the early days, artillery took advantage of this natural elevation, discharging a round to announce the arrival of the first steamboat of the spring.

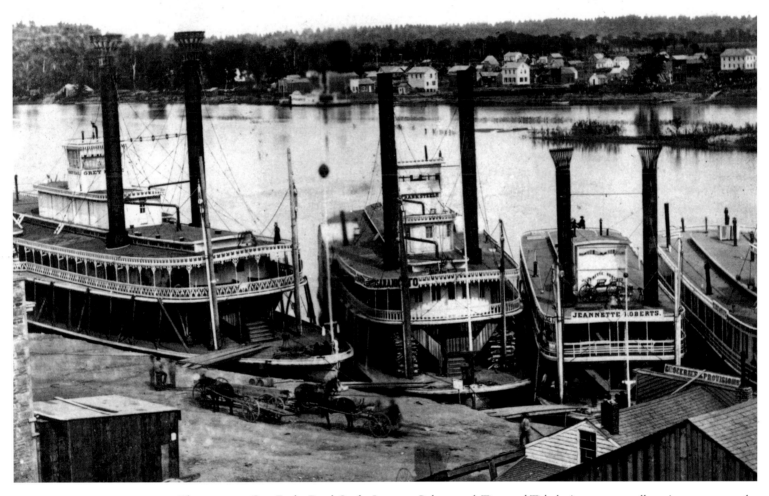

The steamers *Grey Eagle, Frank Steele, Jeannette Roberts,* and *Time and Tide* during an unusually quiet moment at the Lower Levee in 1859. Across the river are the beginnings of St. Paul's West Side. It would start booming later in the year when the Wabasha Bridge replaced the older ferry.

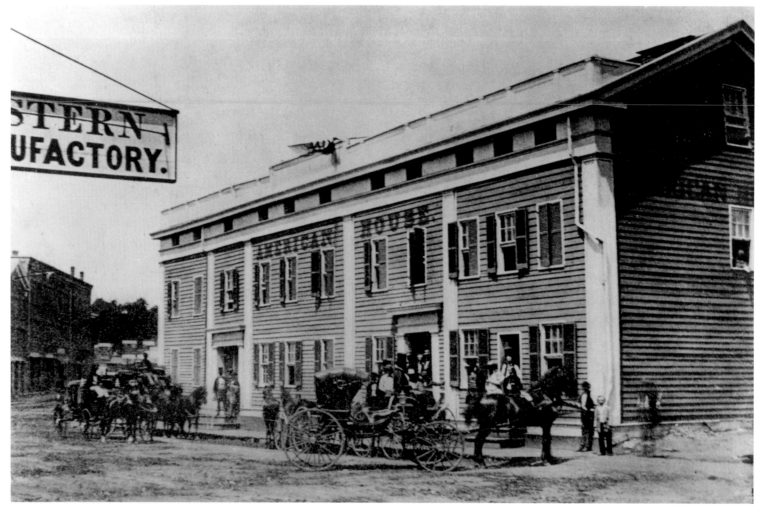

The American House was built at Third and Exchange near the Upper Landing in 1849, and looked like this a decade later. It was considered a quality hotel and was one of the largest north of St. Louis. The wood frame structure was built in only ten days, an example of the rapid construction techniques of the period. It burned down on December 20, 1863.

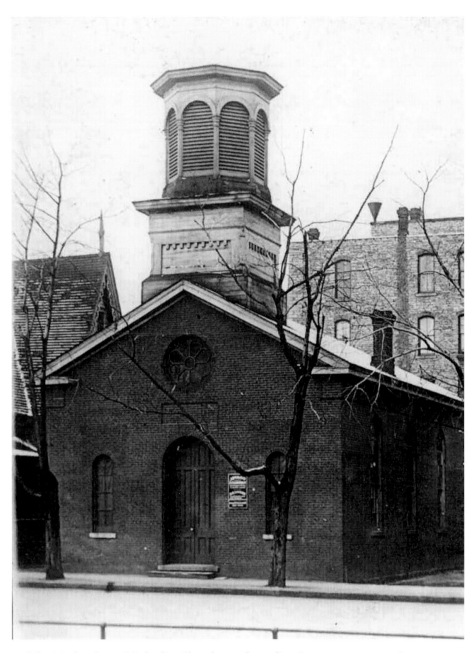

The Market Street Methodist Church was the earliest Protestant congregation to erect a building in the city. It went up in 1849 on the site of today's St. Paul Hotel. Much of the carpentry work was done by freed slave James Thompson. He was a charter member and also contributed lumber, shingles, and a tidy sum of money for the construction.

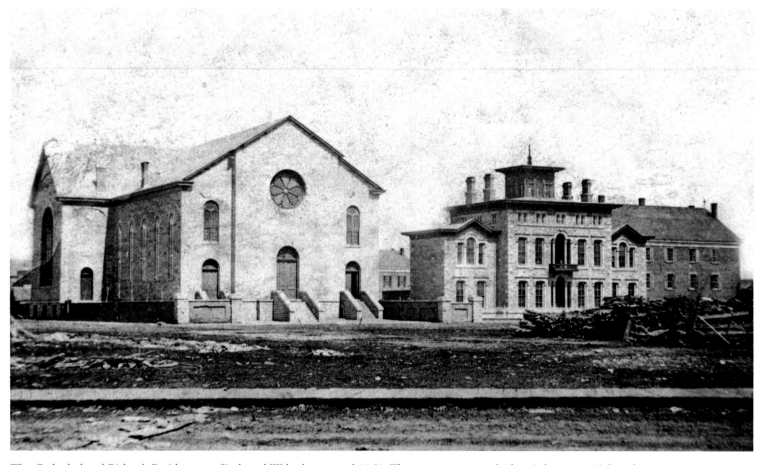

The Cathedral and Bishop's Residence, at Sixth and Wabasha, around 1860. The cornerstone was laid on July 27, 1856, but the financial panic of 1857 caused a work stoppage. The first mass was celebrated on June 13, 1858. Bishop Cretin of St. Paul was overjoyed with the progress of his parish, but died less than a year later.

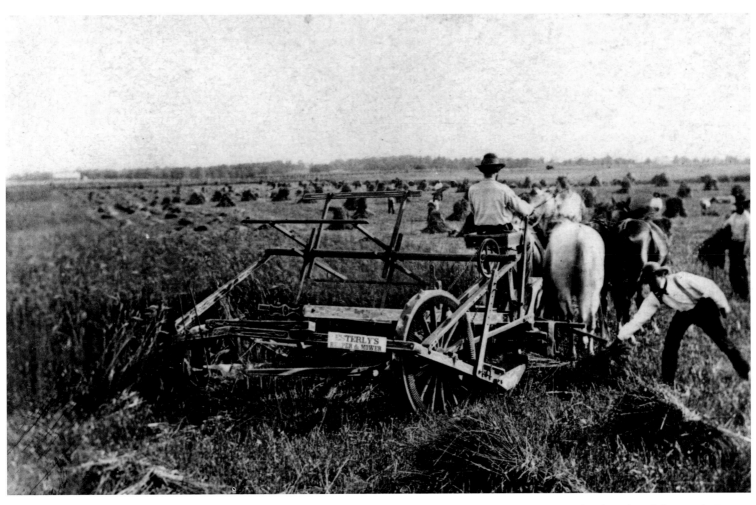

Following the wheat frontier, George Esterly set up shop in St. Paul in the 1850s. He patented and marketed the Esterly Reaper, which could handle two acres an hour. By cutting and raking the stalks at the same time, it saved farmers many hours of work. The reaper is being demonstrated in a local field in 1860.

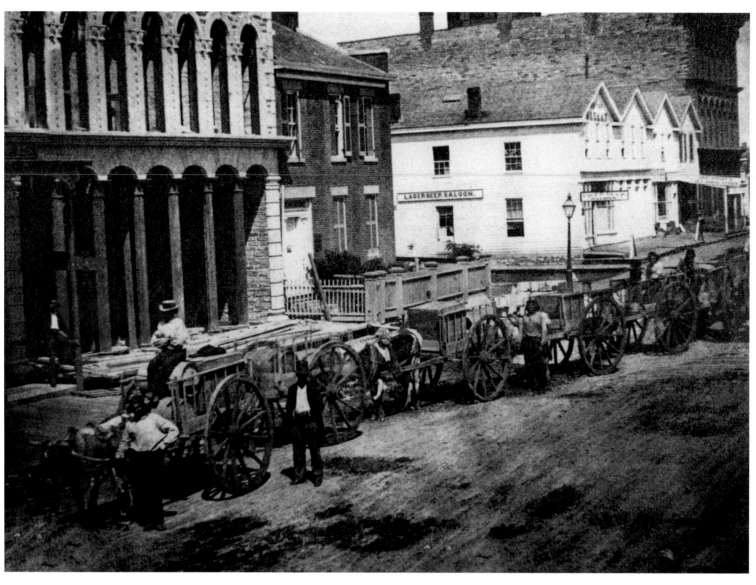

This Red River train is seen at Third and Washington in 1858. The carters, as they were called, were usually Metis, descendants of French voyageurs and Ojibway, who had created a distinctive culture of their own. They came from their northern homelands annually, laden with furs to be sold or traded for supplies that were hauled back over well-known trails.

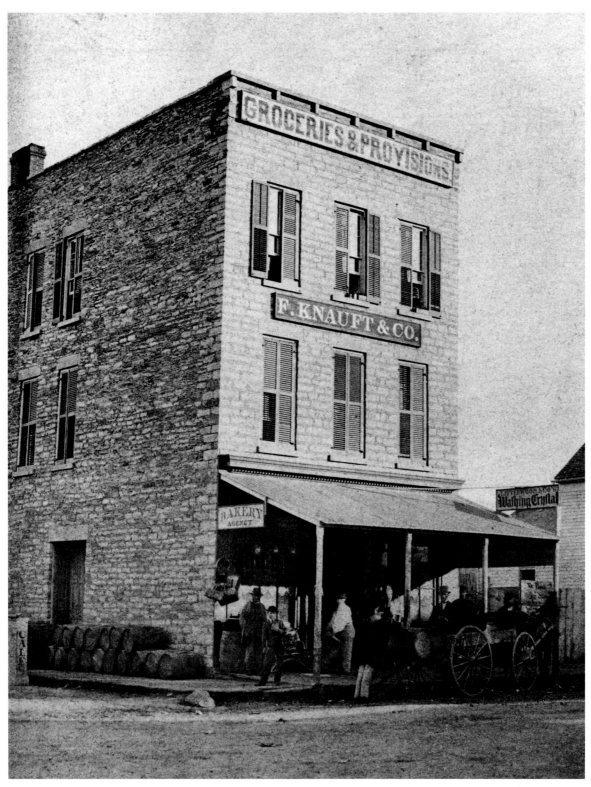

By 1862, when this photograph was taken, St. Paul had spread to East Seventh and Olive, on the eastern outskirts of downtown. Ferdinand Knauft had his large limestone building there, housing groceries and other provisions. Knauft, a German immigrant, was elected to the City Council in the 1850s.

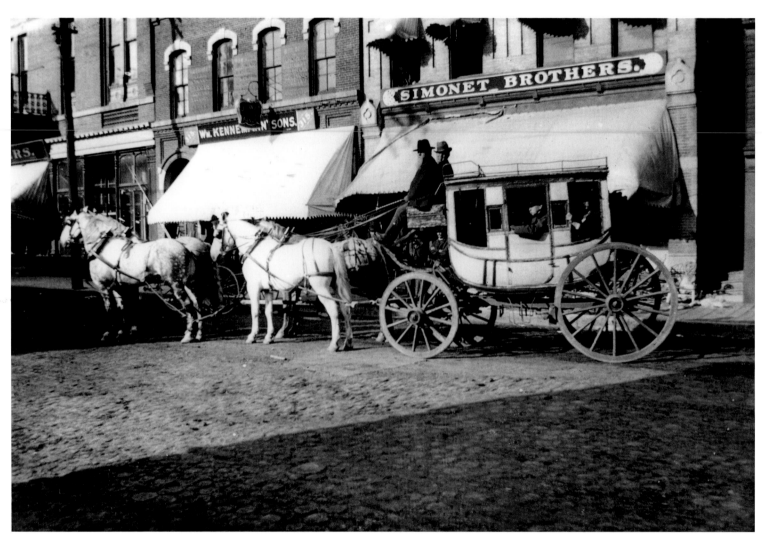

Before the railroad era, stagecoaches were often useful for overland travel where the river was distant or when the Mississippi was frozen over. Different companies competed for business starting in the late 1840s. Posing for the photographer in 1864, this outfit was the first to run between Stillwater and St. Paul.

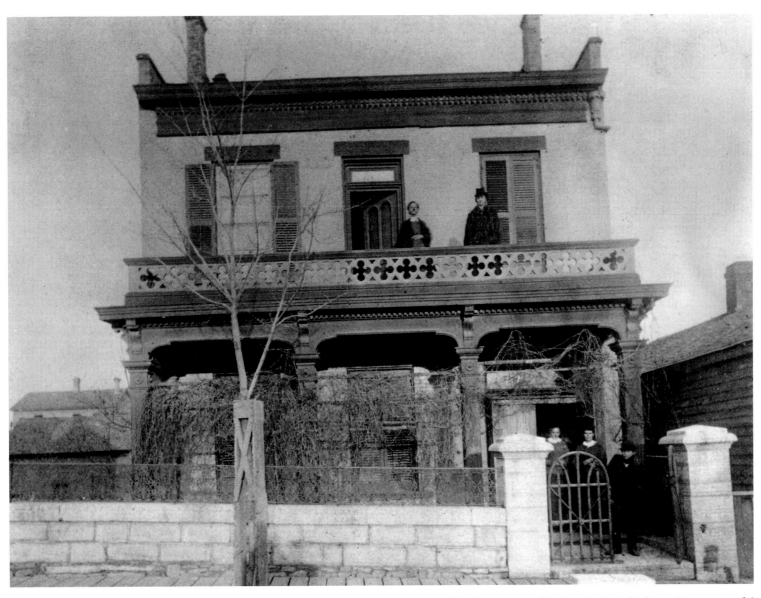

The home of Louis Robert at Eighth and Robert, as it appeared around 1865. He arrived in the city in 1844, becoming a successful fur trader and civic leader. He was largely responsible for St. Paul's becoming capital of Minnesota. By 1853, Robert was engaged in the steamboat trade and at various times owned five different launches.

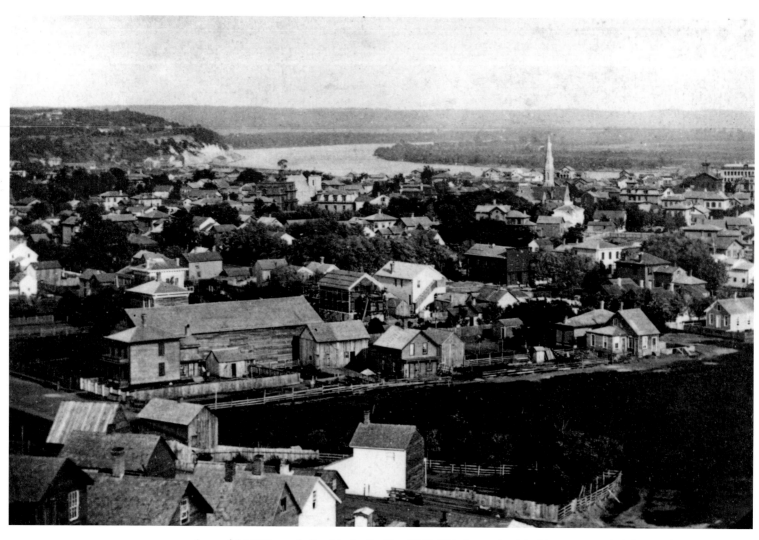

Around 13,000 people lived in St. Paul by 1865. This "carte-de-visite" image, recorded during that year, shows a bustling city with small frame houses starting to creep up St. Anthony Hill. In the background, just below the curve of the Mississippi River, is the thriving Lowertown area.

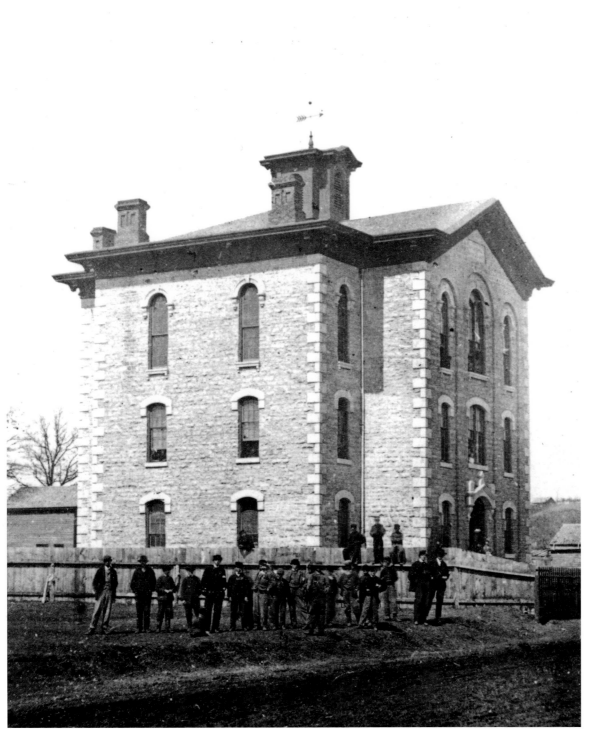

Students and teachers gather outside Franklin School a year after its 1864 construction. Built at Broadway and Tenth, it contained fourteen rooms and a tall fence, which hides the outbuildings from the camera. Starting in 1866, St. Paul High School held classes here until it got its own building.

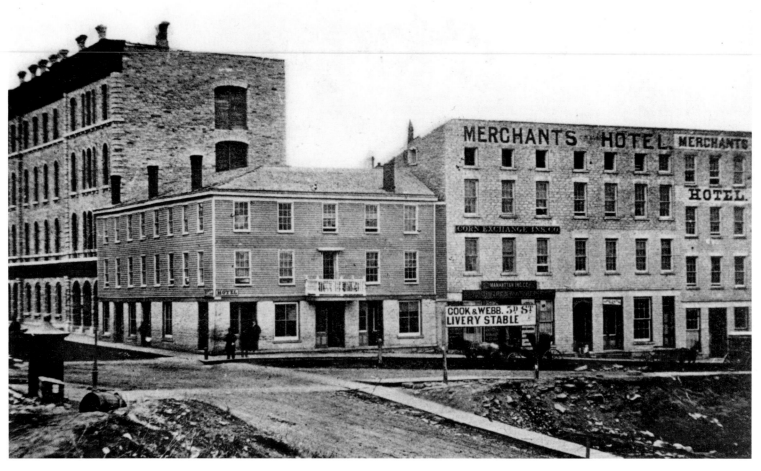

By the 1860s, most of the larger buildings in St. Paul were built of fire-resistant stone, usually quarried locally. Merchant's Hotel and a nearby stable are shown in 1867 at Third and Jackson, near the busy lower landing. Augustus Knight, the city's first resident architect, provided the designs.

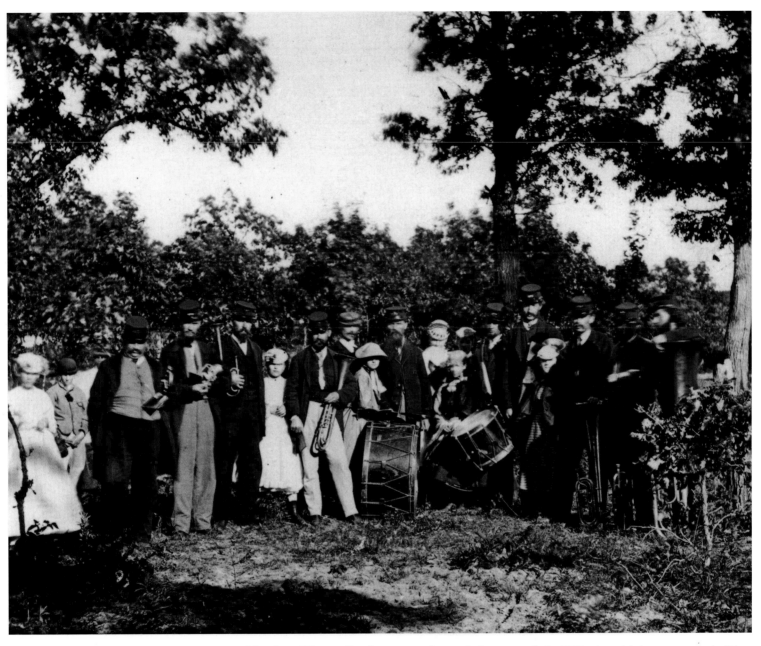

The Great Western Band was a popular musical group early in 1869 when this image was made. They frequently performed in St. Paul and nearby towns. Leader George Seibert arrived in 1857 and became the city's first resident composer. His best-known piece was "The Aker Waltz," which honored a Minnesota Civil War general killed at Shiloh.

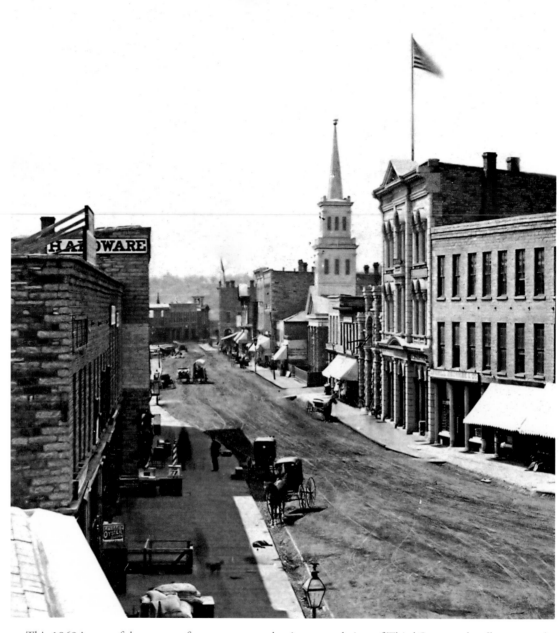

This 1869 image of downtown, from a stereograph, gives a good view of Third Street and well portrays the early, walking city, with its characteristic mixture of different kinds, sizes, and shapes of buildings.

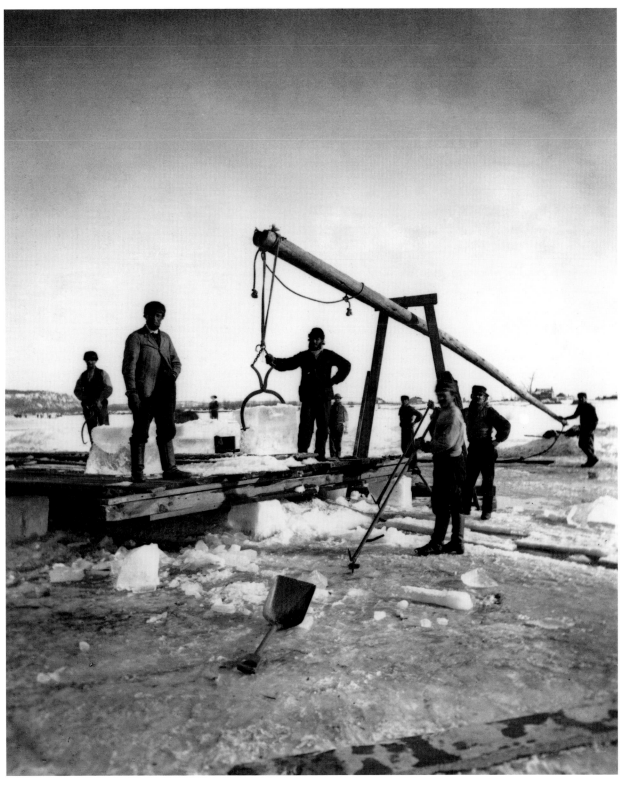

A team of men is shown harvesting ice on the Mississippi in 1869. It was cut in the winter, stored in warehouses, and packed in sawdust to keep it from melting during the warm months. When people became aware of river and lake water as possible sources of contagion, and ice-making technology was devised, this means of cooling and refrigeration was abandoned.

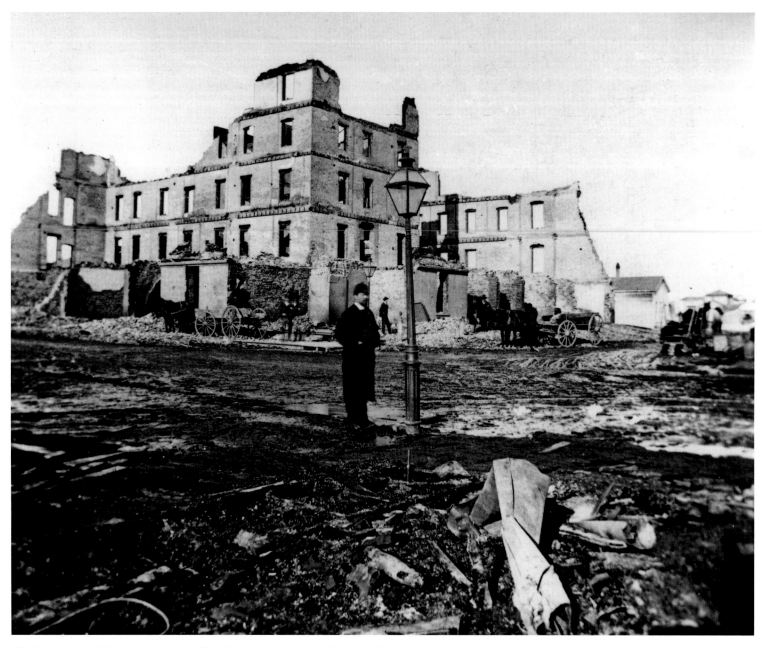

The International Hotel, called the Fuller House when it was built in 1856, was a prominent lodging and meeting place at Jackson and Seventh. These are the ruins after a dramatic fire in February 1869 burned it to the ground. Fortunately, all 200 guests escaped without injury.

THE CITY ON RAILS

(1870–1918)

Starting in the early 1870s, new forms of transportation transformed the city. The railroads linked it to the vast hinterlands, and downtown St. Paul developed a sizable warehouse district. Railroad jobs attracted immigrants seeking a better life. Most were Eastern Europeans with little money who joined the unskilled labor force. Italians, Poles, Jews, Czechs, Lebanese, and others clustered into tight-knit communities and gave a new flavor to the older neighborhoods.

Streetcars made possible a great expansion of St. Paul. People no longer had to live near job sites or commercial areas. This period saw the rise of new residential communities that separated out along economic and ethnic lines. Middle-class communities developed near streetcar lines and Summit Avenue became the city's most fashionable neighborhood.

The general prosperity was not shared by all. Other neighborhoods, near industrial areas, were filled with working-class and ethnic groups. The poor, often recent immigrants, clustered together in places like Swede Hollow and the river flats. By 1880 the changes had been dramatic. The census revealed that St. Paul now had more than 40,000 people. They worshiped at nearly 50 different churches. Ten years later the city had boomed to 133,000.

Longtime rival Minneapolis moved to first place in the Minnesota population race around 1880, but St. Paul leaders remained optimistic, launching a Winter Carnival and building the Ryan Hotel to outshine Mill City's best. In addition to the outward movement of the population, there was an upward movement of buildings downtown. Elevators and new technologies permitted the construction of "skyscrapers," and urban centers began to take their modern shape.

A new infrastructure was needed to accommodate the larger populations and St. Paul added new sewers, better paving, and telephone and electric wires. Neighborhood fire and police stations were built and their staffs became paid professionals. The city created new departments, such as a board of public health. St. Paul established several new parks in the 1880s and 1890s that were linked by a parkway system. Leaders were convinced that even though the world was on the brink of war, they had brought peace and prosperity to their city.

Two children are enjoying the scenery around Trout Brook, one of several streams that once flowed through the city. The brook emptied into the Mississippi after merging with the waters of Phalen Creek. This 1870s photo was taken on the grounds of Edmund Rice's home on Mississippi Street between today's Acker and Granite.

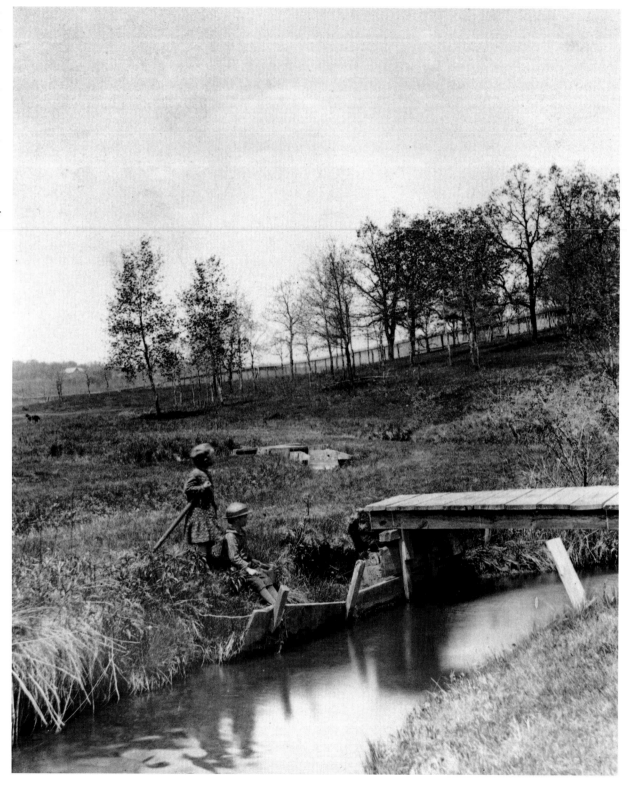

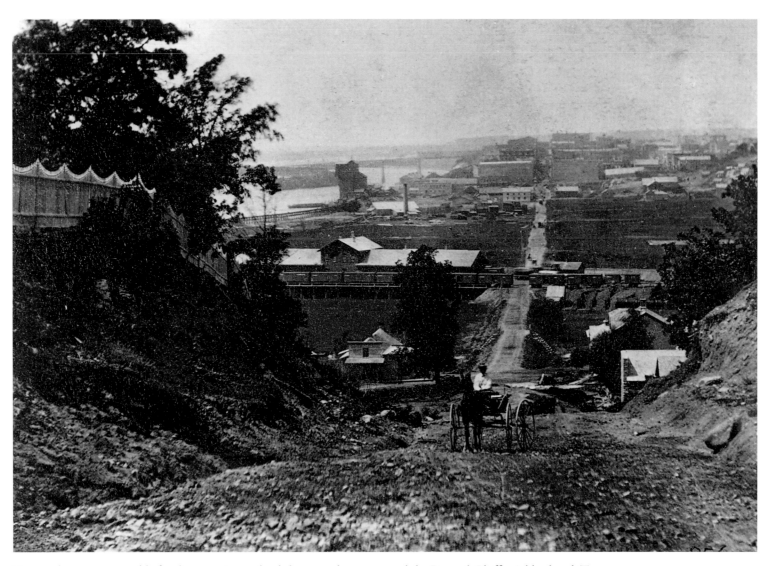

Two creeks were responsible for the extensive wetlands between downtown and the Dayton's Bluff neighborhood. To extend Third Street to the outlying community, they had to be filled in. The railroad tracks, at center in this 1870s photograph, were built above the swampland.

This overhead photo shows the city's first observance of Decoration Day on May 30, 1870. After parading through downtown, Civil War survivors trekked to St. Paul's Oakland Cemetery and decorated the graves of 60 fellow veterans. Within 50 years they were tending 800 graves on what was later renamed Memorial Day.

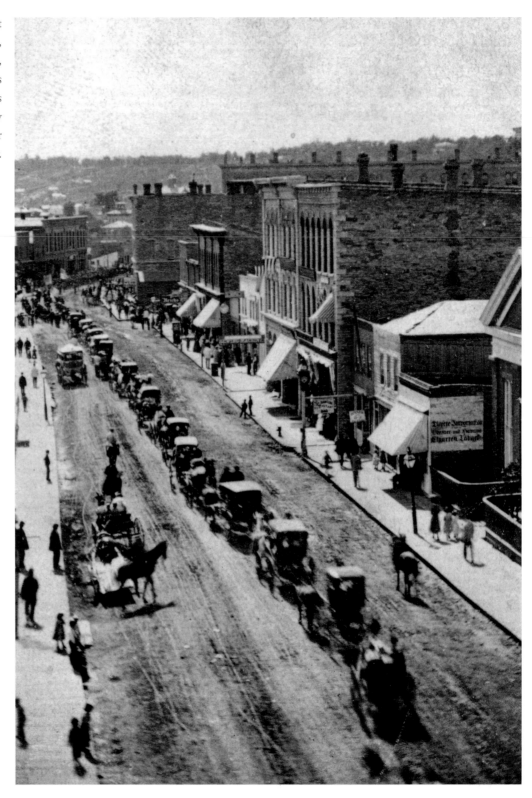

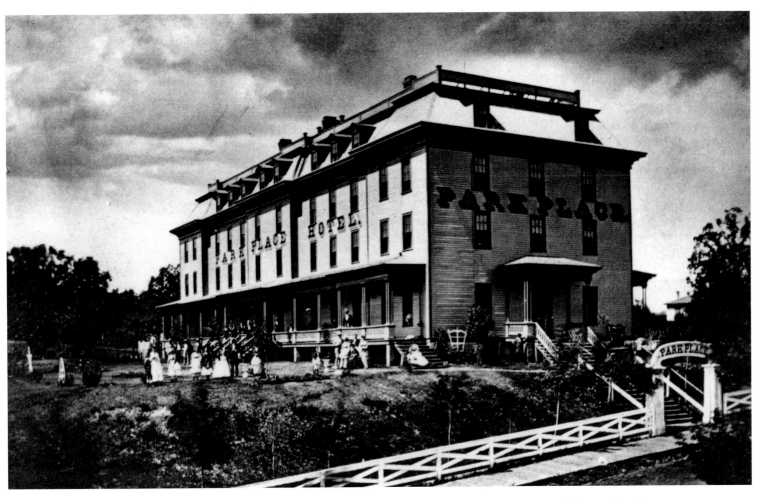

One pioneer resident remembered the Park Place Hotel on the corner of Summit Avenue and St. Peter as one of "the swell hotels of the city." The four-story frame building was nicely situated on a high hill overlooking St. Paul. However, it was not successful in the long run and was unoccupied when it burned to the ground in 1878.

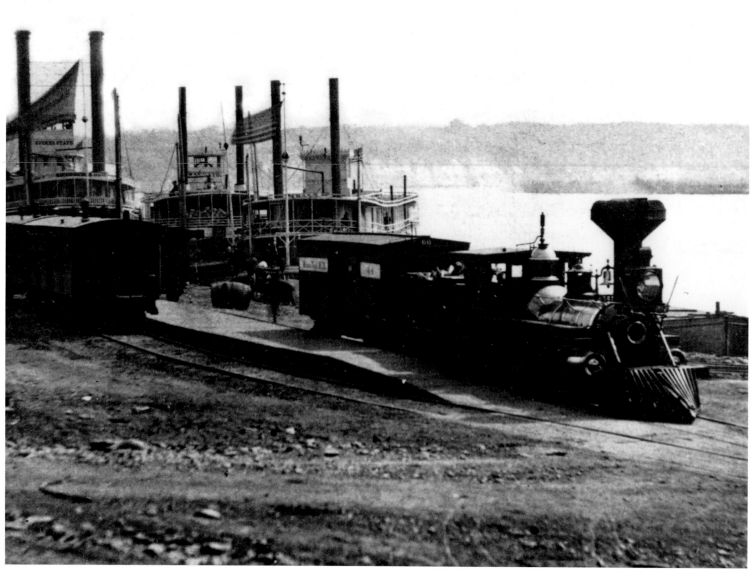

The St. Paul levee sometime in the 1870s. A steamboat crew has unloaded a train engine onto awaiting tracks. Railroads were a new form of transportation that would supplant but not totally eliminate the use of the Mississippi River as a commercial route.

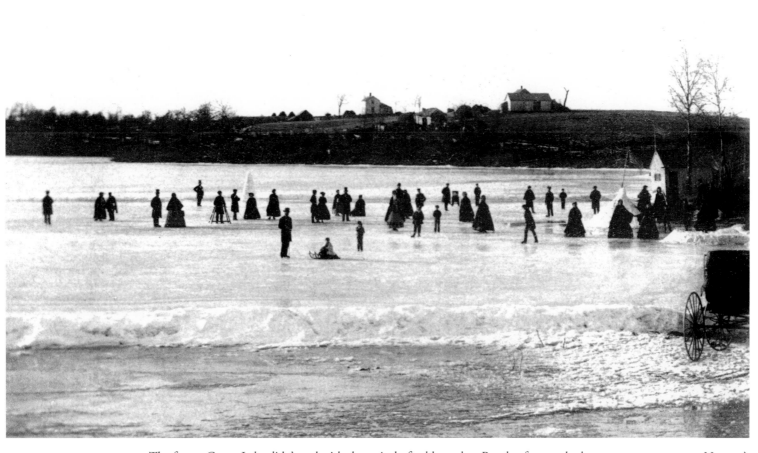

The fun at Como Lake didn't end with the arrival of cold weather. People often made the snowy venture out to Newson's Skating Park in the early 1870s to enjoy Minnesota's long winters.

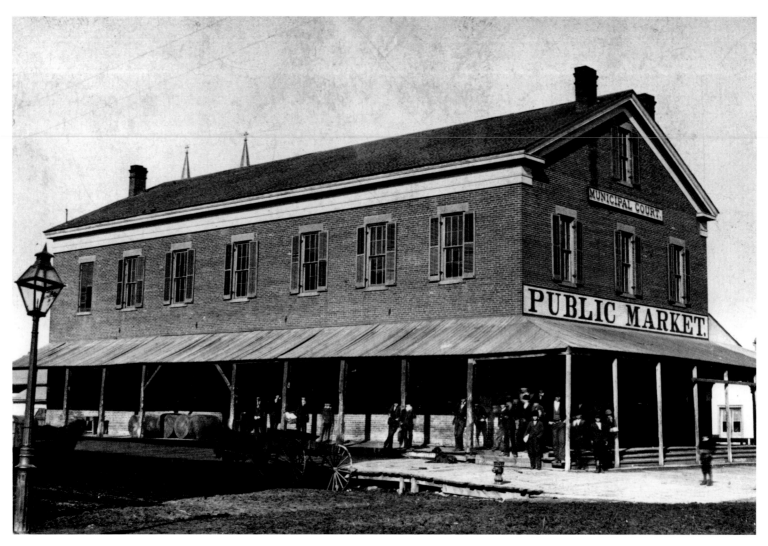

The Public Market House at Seventh and Wabasha in 1870. It had started two decades earlier in a rented space. Nearby garden farmers brought vegetables and other products to sell directly to city customers, and St. Paul's residents always looked forward to the arrival of the year's first fresh produce.

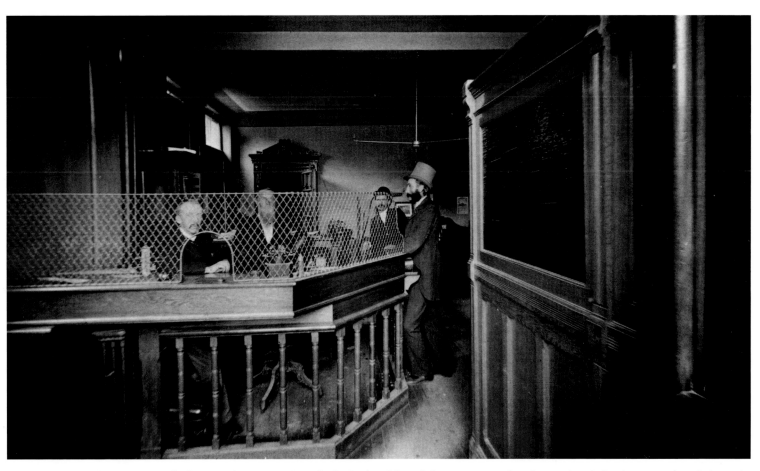

Germans were the largest ethnic group in early St. Paul and founded many stores, churches, and societies that catered to their needs. This is the interior of the National German American Bank at Fourth and Robert around 1870, opened by Frederick Willius, his brother Gustav, and other prominent businessmen.

The omnibus shown here was an early form of urban mass transit in many American cities. For a fee, the horse-drawn vehicles carried groups of people from the steamboat landing to hotels and around town. This shot on the streets of St. Paul was recorded around 1880.

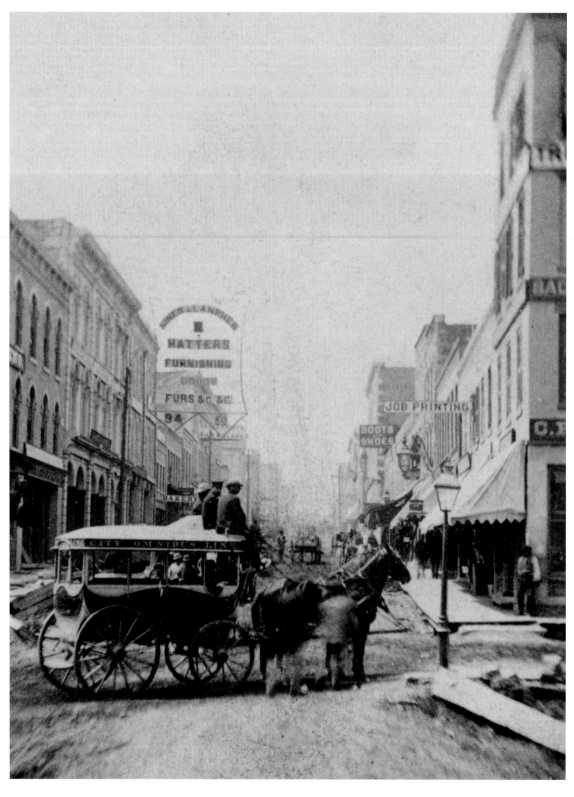

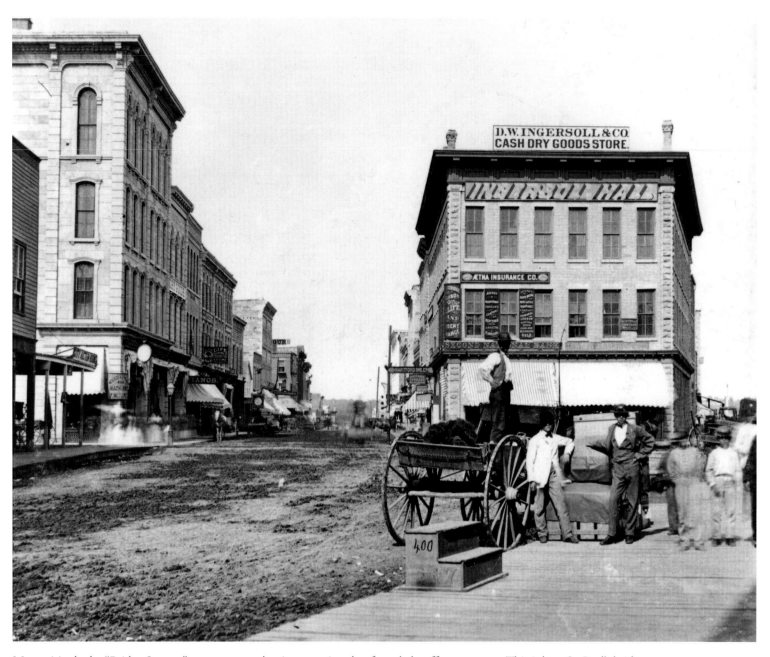

Many cities had a "Bridge Square," an area around a river-crossing that funneled traffic past stores. This is how St. Paul's bridge square, located on the north side of the Mississippi on Wabasha Street, appeared in 1871. The wooden steps in the foreground were used to accommodate tall wagons.

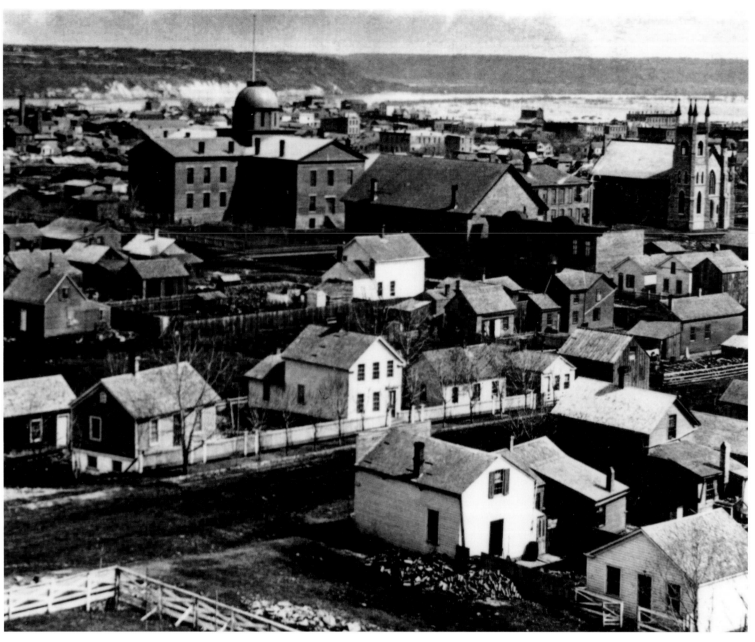

A panorama from the Park Place Hotel shows a rapidly growing St. Paul, now home to 20,000 people. This image faces southeast toward the first State Capitol with its distinctive dome sometime around 1871. In the early days, public buildings and churches downtown stood beside small-frame residences.

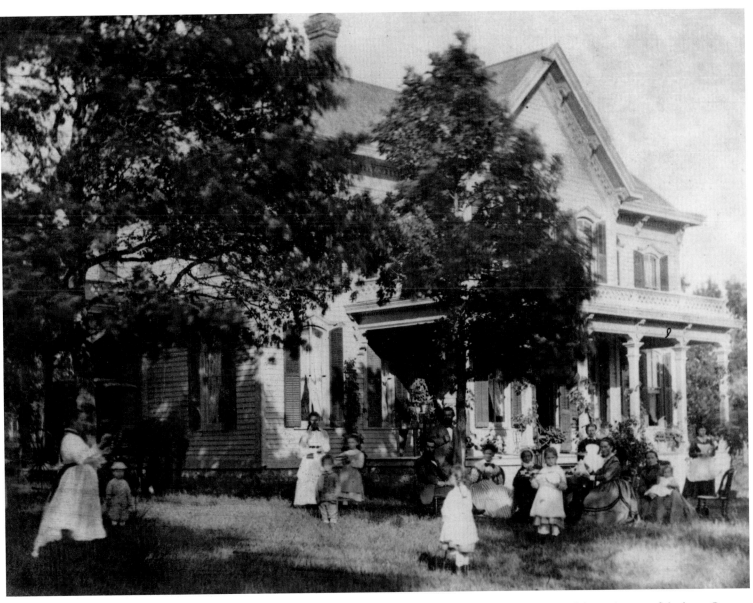

It looks like an 1871 lawn party at the Emil Munch home on the crest of Dayton's Bluff. He was one of the mainstays of the large German population in the neighborhood. Munch came to the United States from Prussia in 1849, going first to Taylor's Falls then settling in St. Paul. He served as the State Treasurer from 1868 to 1872.

Facing south on Wabasha Street from Fourth to Third Street. A maturing urban landscape had emerged by 1873, when this image was captured. Downtown now had multi-story stone and brick buildings, whose facades were given a more elegant, finished look through the use of more expensive brick.

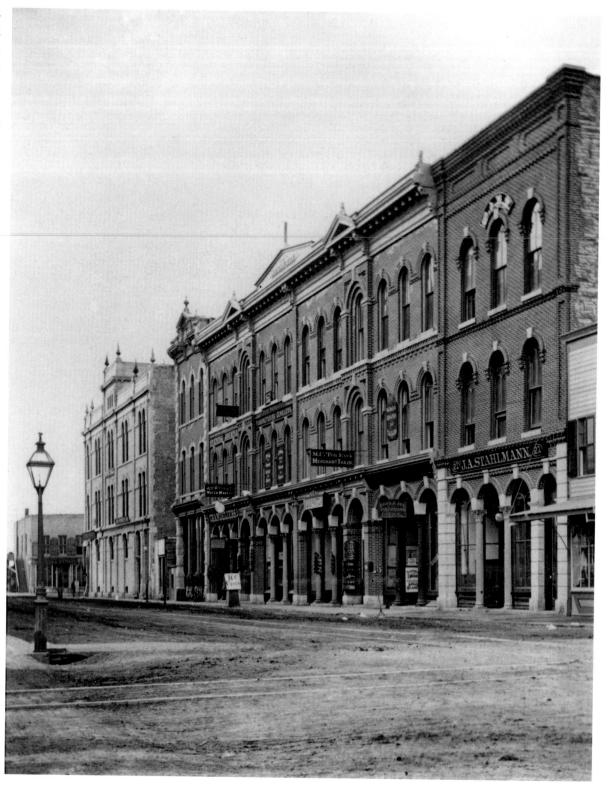

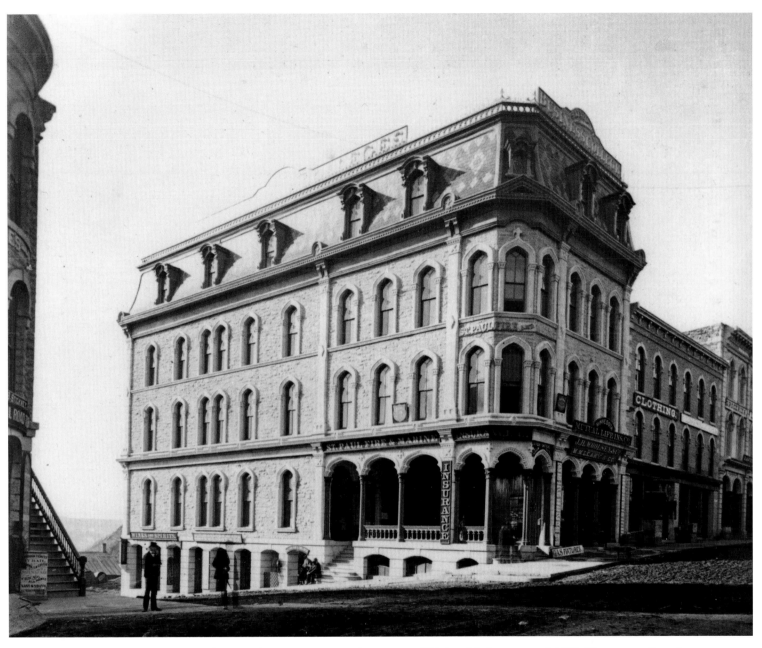

A view of the headquarters of the St. Paul Fire and Marine Insurance Company at Third and Jackson around 1875. The name reflected its dual role of providing coverage for buildings as well as for the river trade. Incorporated in 1853, it is still writing policies today as the Travelers Companies and is considered the oldest continuous business in the city.

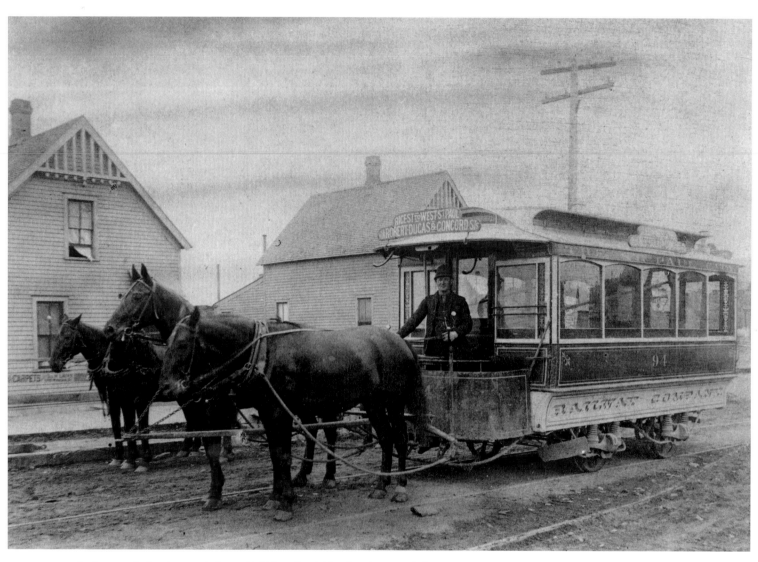

As the population boomed above 40,000 and neighborhoods expanded, it was important to have better public transportation. The city's streetcar system, started in 1872, addressed the need. Cars were pulled by horses or mules, carrying twelve or more riders at three miles an hour. Number 94, pictured here in the mid-1880s, went from Rice Street to the West Side.

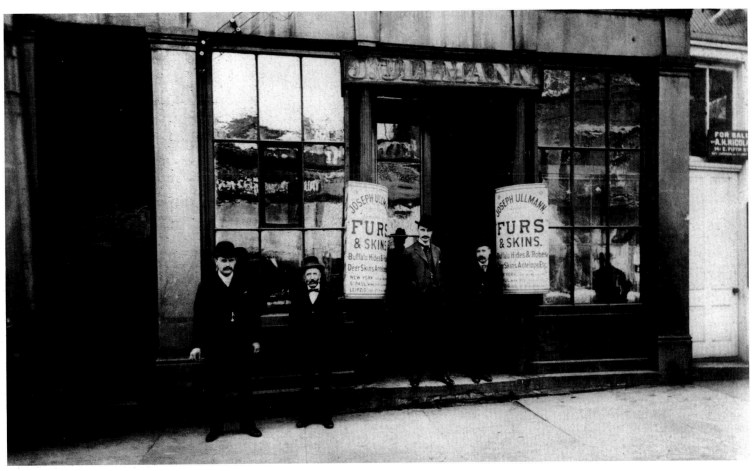

Joseph Ullmann, a Jewish immigrant from Germany, came to Minnesota in the 1850s and became a furrier. Even as the fur trade was declining in the 1870s, it remained an important part of the economy. Ullmann's store at 353 Jackson, pictured here around 1875, became so successful he opened branches in Chicago, New York, and Leipzig, Germany.

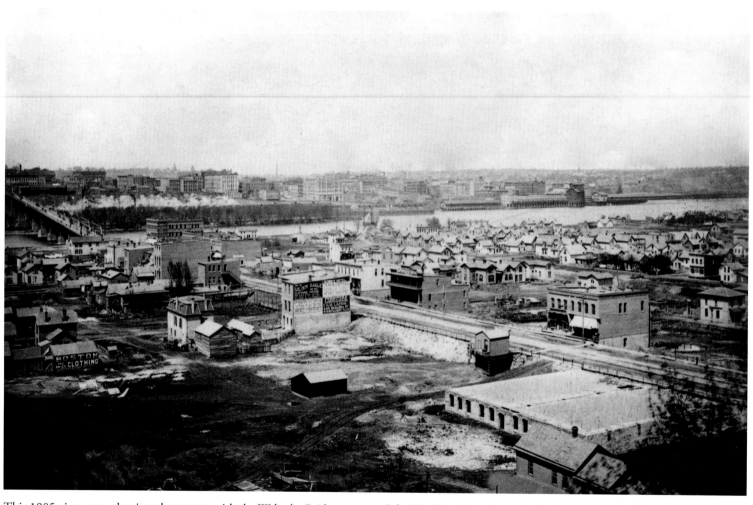

This 1885 view scans the river downtown with the Wabasha Bridge at upper-left. The West Side, shown in the foreground, had been a separate town but was annexed into St. Paul in 1874, an action that added 2,800 acres to the city. The tolls on the bridge were abolished that year.

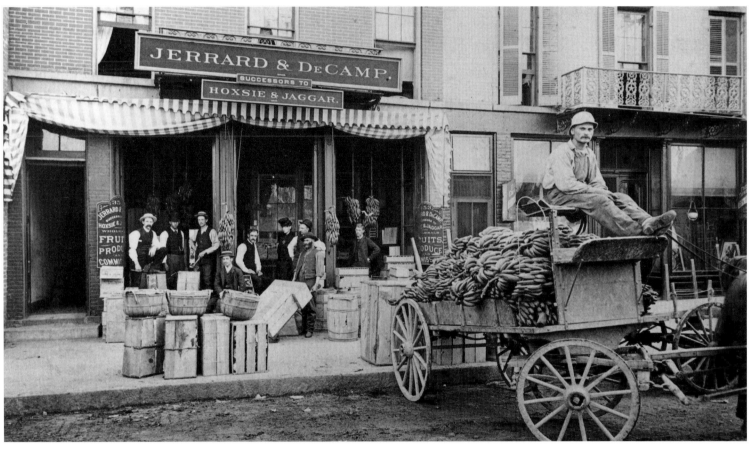

An 1886 streetscape shows the bustling activity outside Jerrard and DeCamp's, at 353 Robert Street, an important St. Paul wholesale fruit business. The bananas are likely headed for a variety of small grocery stores in St. Paul or possibly to the railroad to be shipped to other towns.

The interior of the First Baptist Church a decade after it was built in 1875. The congregation was formed in 1849 and this was their third home. It reportedly had one of the best pipe organs in the country and one local paper described the building as "the finest piece of architecture west of Chicago."

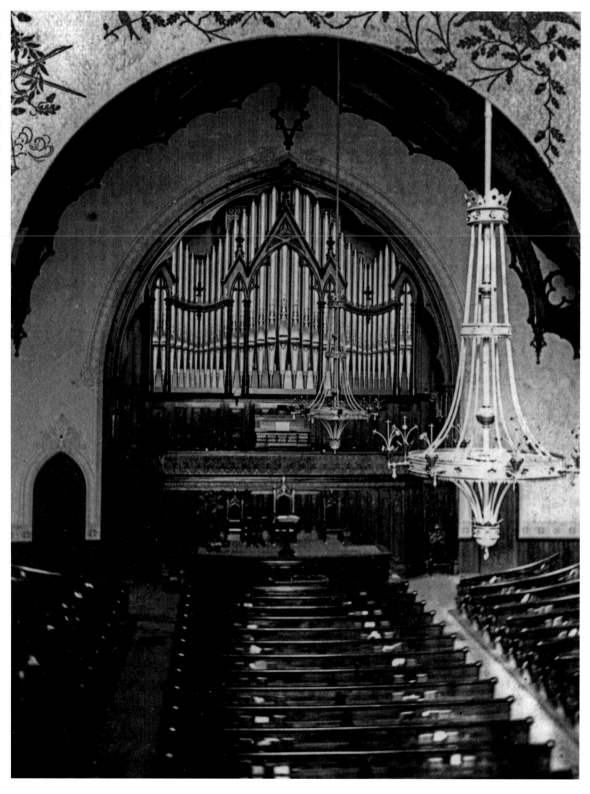

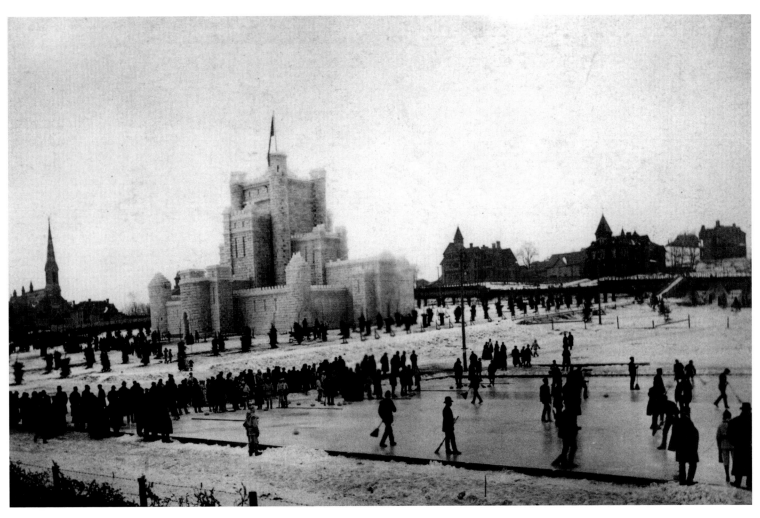

In 1886, St. Paul began the Winter Carnival to counter the perception the city was "a frigid Siberia." The week-long affair included games, parades, and a variety of other events. The structure in the background of the photo is the first of many picturesque ice palaces. The skaters in the foreground are engaged in a rousing game of curling.

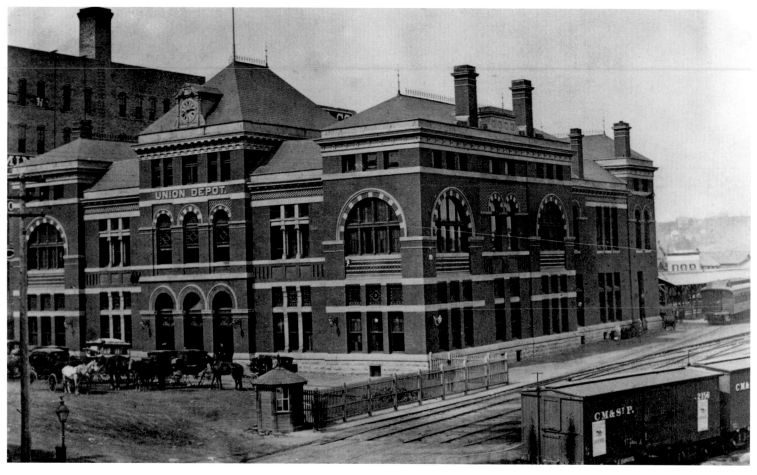

The Union Depot, built in the 1880s, was shared by all of the railroads that came in and out of St. Paul. Gathered at the entrance are several vehicles and their hawkers, competing to take people to their various hotels and negotiating prices with potential customers.

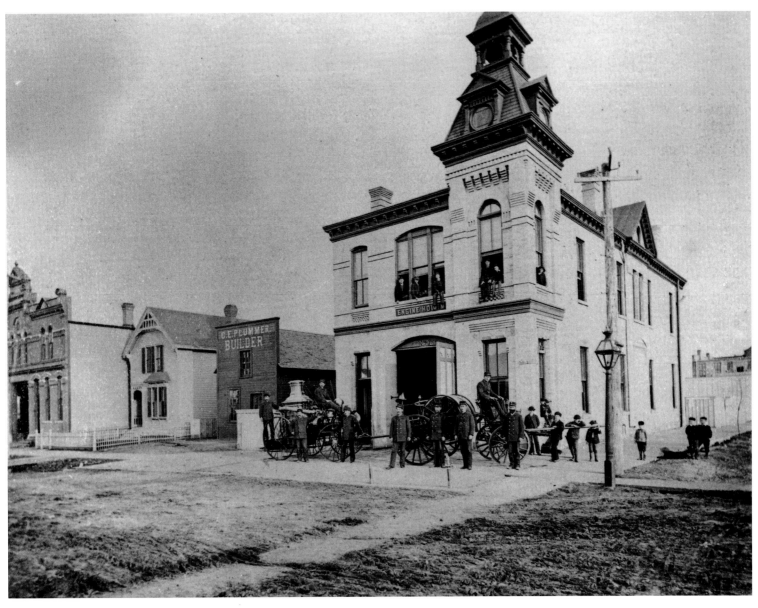

As the city expanded geographically, fire stations were commissioned to serve the outlying communities. Engine House Number Five was built in a growing neighborhood and is pictured at the corner of Selby and Mackubin in 1885, shortly after it was put into service.

The iron Lake Street–Marshall Avenue Bridge was built over the Mississippi in 1888. A local paper called the new span a "foolish extravagance," but it became one of the busiest two-lane bridges in the United States. A newer, concrete arch bridge is still a principal connection between St. Paul and Minneapolis.

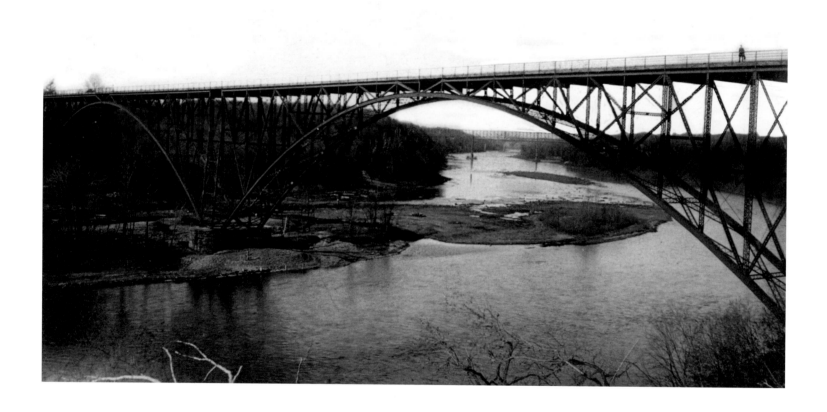

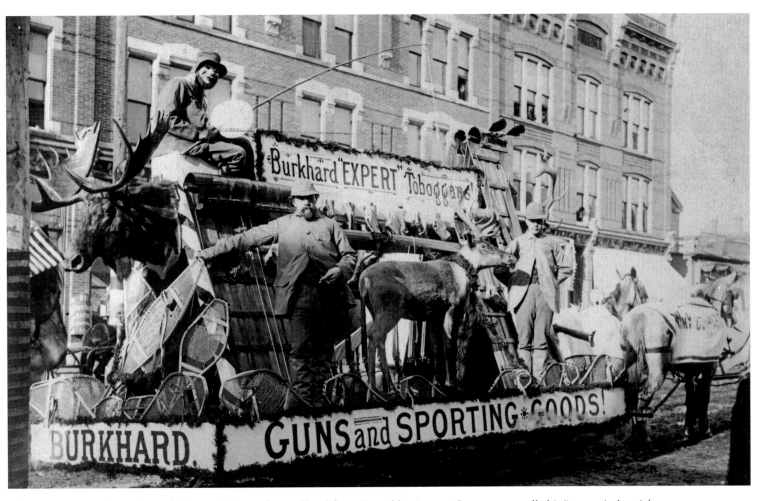

The 1888 Winter Carnival parade featured the products of local factories and businesses. One reporter called it "a great industrial exposition out for a sleigh ride." This float was the creation of William R. Burkhard, owner of Sportsman's Headquarters, a large St. Paul firm that sold athletic equipment and hunting gear.

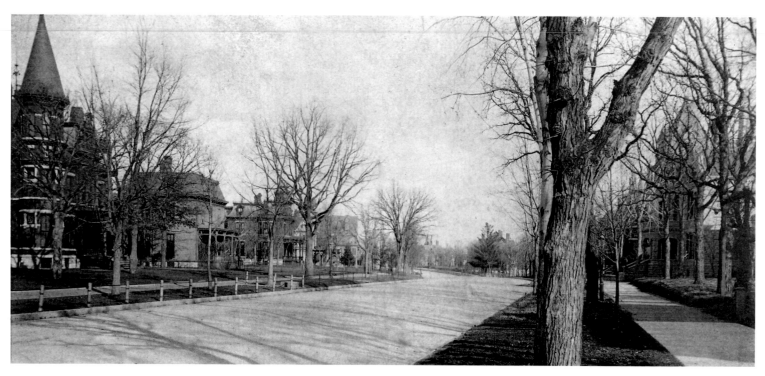

Even though F. Scott Fitzgerald called it "a mausoleum of American architectural monstrosities," most people consider Summit Avenue to be a St. Paul treasure. One of the best-preserved Victorian streets in the nation, a portion of which is shown here in 1888, it is lined with elegant homes built by the city's most prominent businessmen.

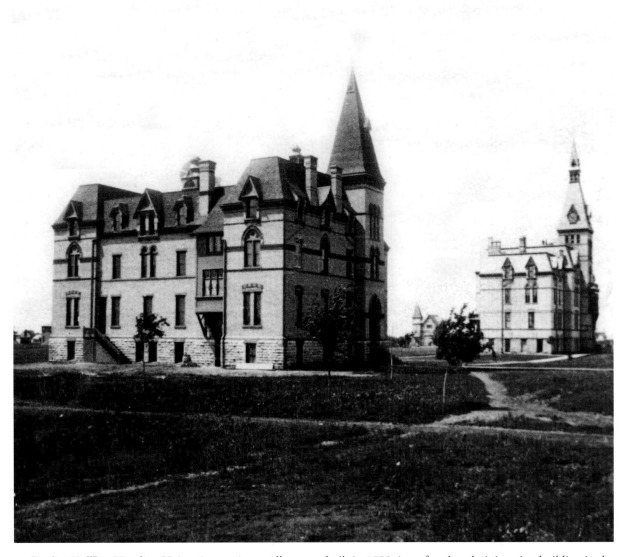

"Ladies Hall" at Hamline University, a private college, was built in 1882, just after the administration building in the background. It had a parlor, music rooms, and quarters for female professors, the college matron, and women students. It was later named Goheen Hall after a woman who mortgaged her homestead to help pay for the construction.

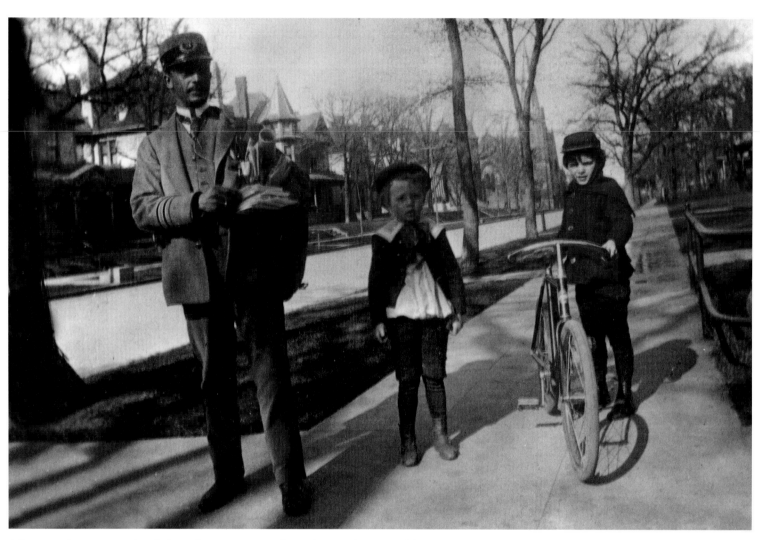

A letter carrier pauses on his daily Holly Avenue route for a photo with two neighborhood boys and a bicycle around 1890. The street was located in St. Anthony Hill neighborhood, which was developed during the Victorian Era. The homes were substantial and designed for upper-middle-class families, but were not so elegant as those on nearby Summit Avenue.

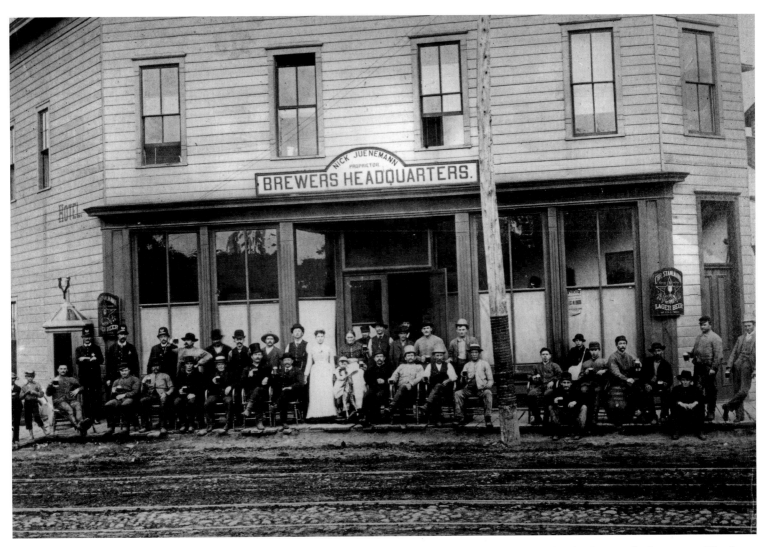

Owners, customers, onlookers, a few policemen, and two women gather outside Juenemann's Hotel and Saloon in the late 1880s. The frame building was located at 904 West Seventh along a streetcar line. It was very near the Schmidt Brewery, which possibly explains why the establishment was dubbed "Brewers Headquarters."

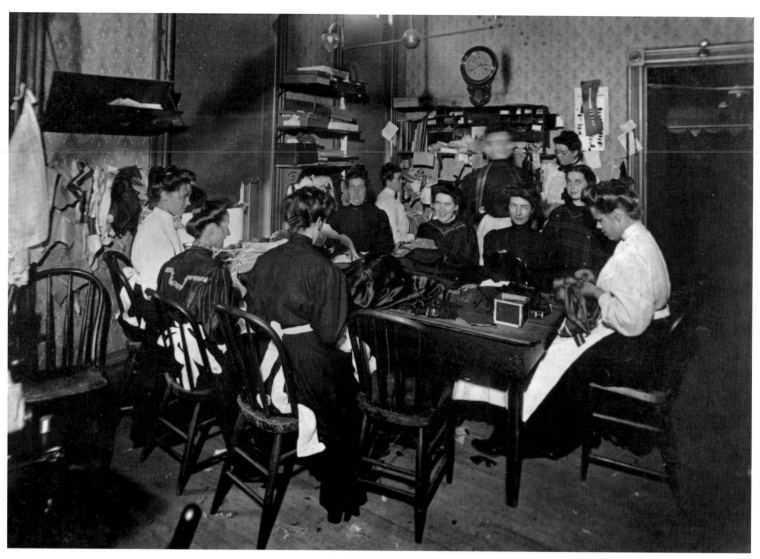

Mary Molloy, daughter of working-class Irish immigrants who came to the city in the 1850s, started her own sewing business in 1879. Within six years she had a shop that employed up to 20 seamstresses, producing everyday dresses as well as formal gowns. Molloy went to Paris once a year to keep up on fashions. This group keeps on sewing as this 1890s image is captured.

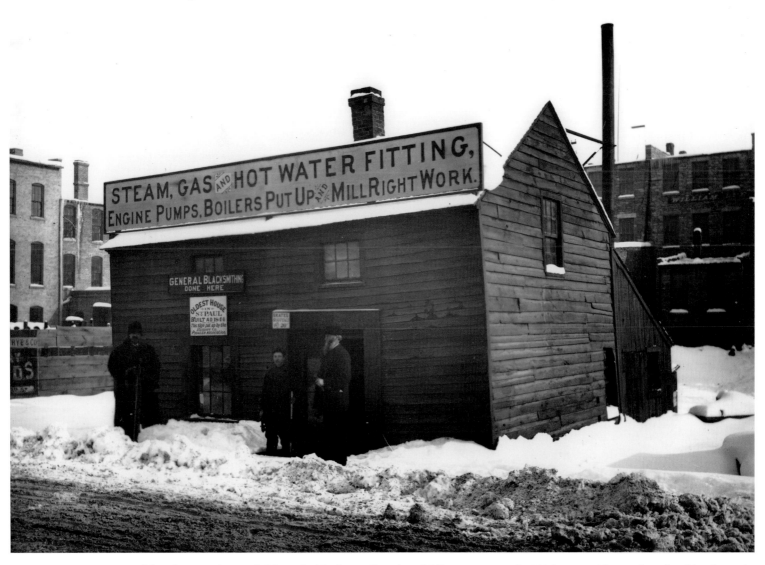

The photographer probably took this shot at Fourth and Minnesota around 1890 because this was then the oldest house in St. Paul. It was built with hand-hewn lumber by early carpenter Charles Bazille for Louis Robert and was moved from its original location on the river for commercial re-use.

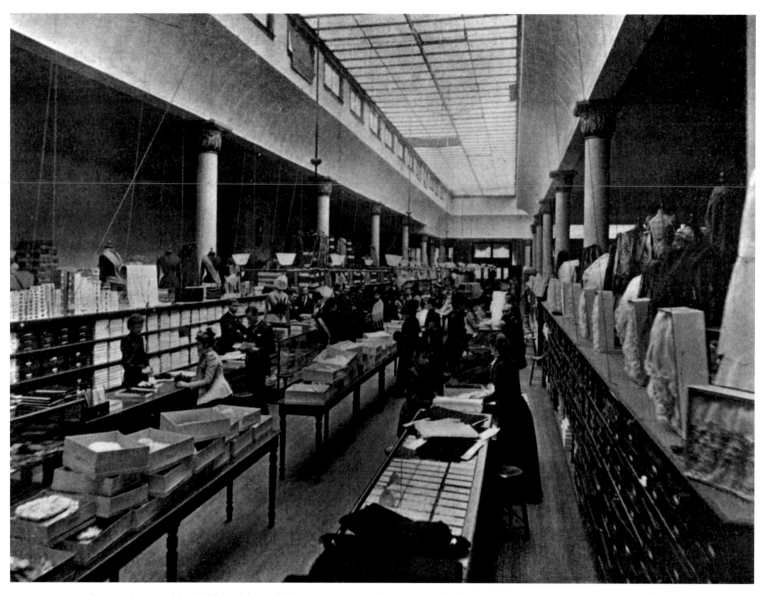

Department or dry goods stores like Field, Mahler and Company were springing up in St. Paul when this photograph was taken in 1890. They made downtown a more desirable shopping destination with a variety of areas or departments dedicated to different kinds of merchandise. Numerous clerks behind counters would retrieve the chosen goods for customers.

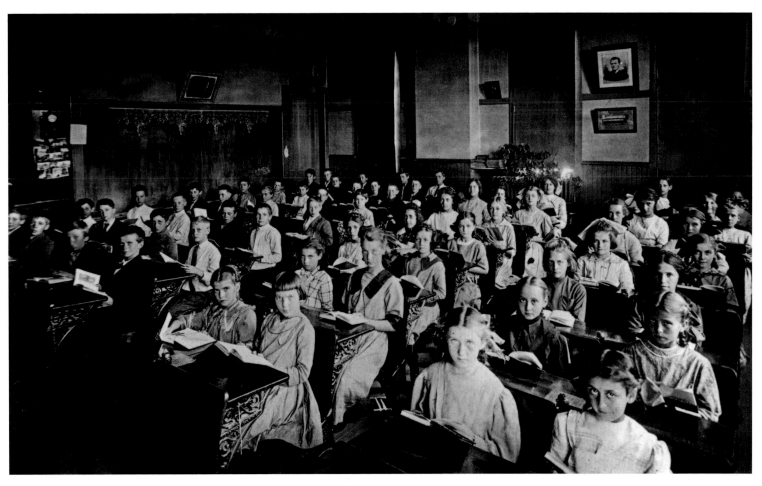

Two to a desk, boys on one side of the room and girls on the other, appeared to be the rule of the day at this parochial K-8 school. Sacred Heart was started in the 1880s by a German Catholic church on St. Paul's East Side and classes are still held there today. The school is now known as Trinity School.

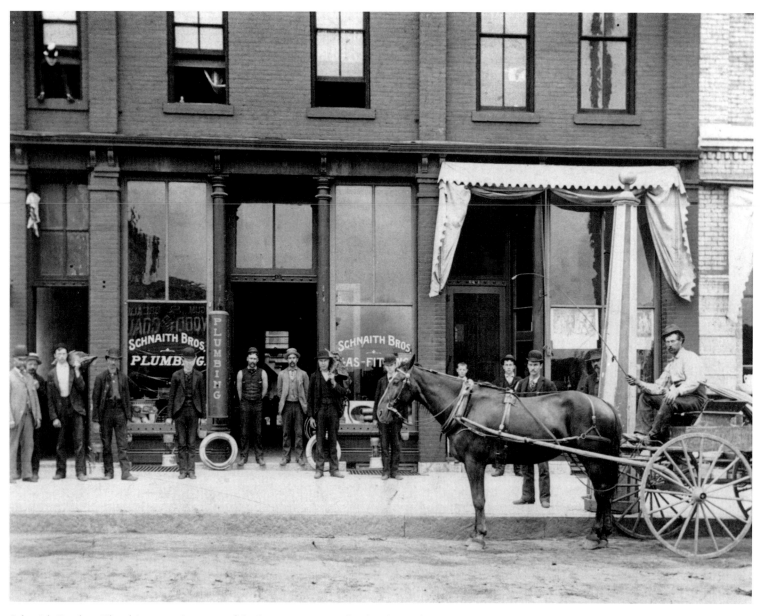

Schnaith Brothers Plumbing grew into one of the largest concerns of its kind over the years. Here it is in the 1890s offering plumbing and gas-fitting services at 439 Seventh Street on the edge of downtown.

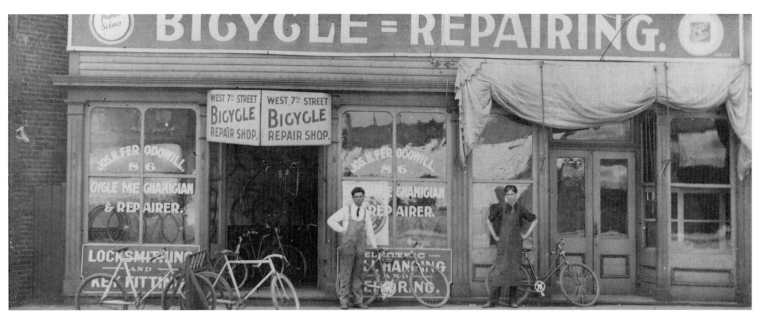

St. Paul shared in the national cycling craze that began in the late nineteenth century. Businesses to sell bicycles sprang up, people formed riding clubs, and they often looked to shops like that of Joseph H. Ferodowill to make repairs. This photograph in front of the store was taken around 1899.

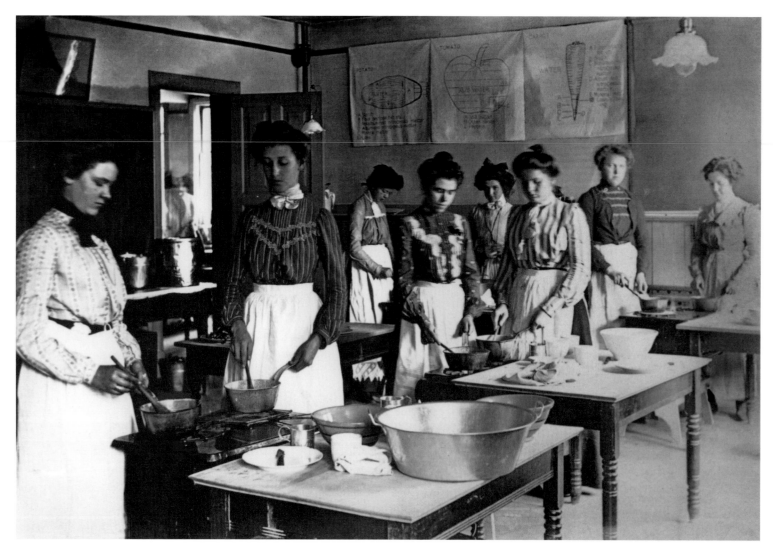

With fruit and vegetable charts on the wall, solemn-looking women students stir over a heating apparatus. They are enrolled in a cooking class at the University of Minnesota's Agricultural School in St. Paul around the turn of the century, when home economics was an important part of the curriculum.

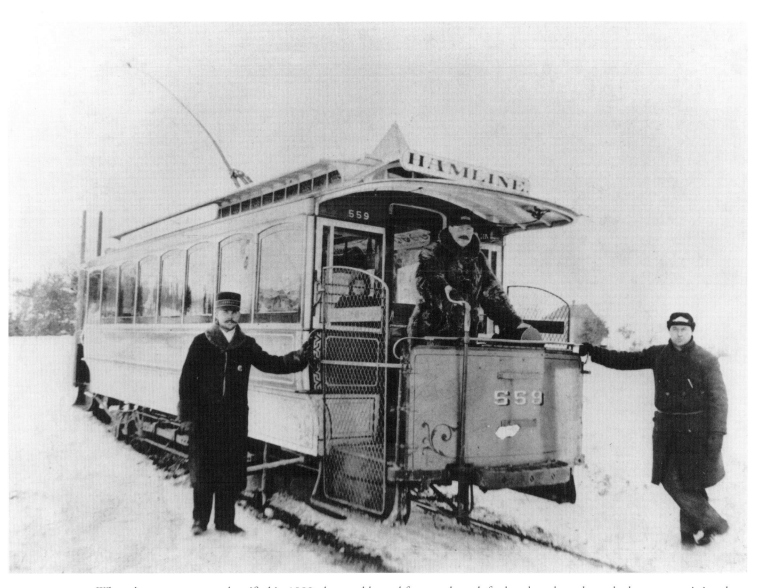

When the streetcars were electrified in 1889, they could travel faster and much farther than those drawn by horses, permitting them to serve a quickly expanding city. The electric cars were heavier, so the rails needed to be rebuilt. This is St. Paul city railway car 559, which ran on the Hamline line in 1893.

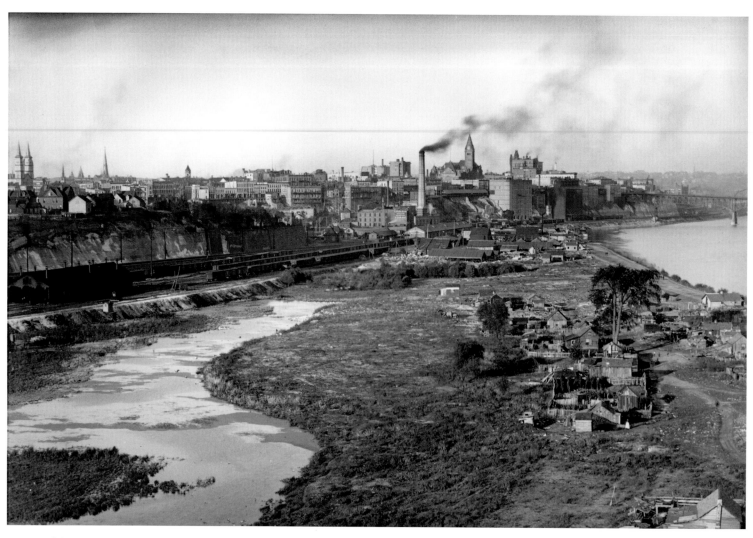

A view of downtown, across the Upper Levee area. Because of the cluster of small, immigrant homes at right, the area was often called "Little Italy." This look at the low-lying, flood-prone location in the flats of the Mississippi was made on a September day in 1894.

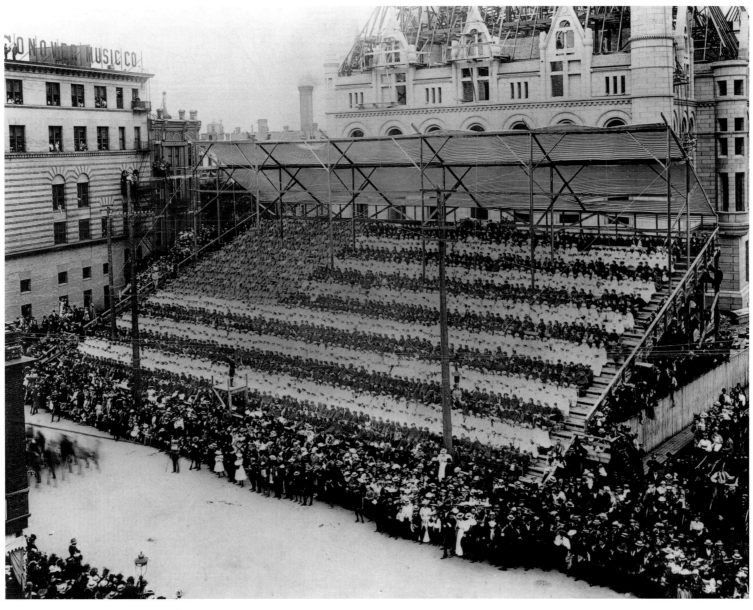

"Living Flags" were once a popular patriotic practice. To simulate Old Glory, people were instructed to dress in red, white, and blue garments and were carefully positioned. These 2,200 schoolchildren have gathered to honor participants in the Thirteenth National Encampment of the Grand Army of the Republic, meeting in St. Paul in September 1896.

Ethnic diversity was common in downtown St. Paul in 1889. The Sebastian Pellegrini Confectionery, according to notes accompanying the photograph, was the first store built on Seventh Street. Its neighbor was Finkelstein's pawn shop. Three years later these frame structures would be replaced with a department store.

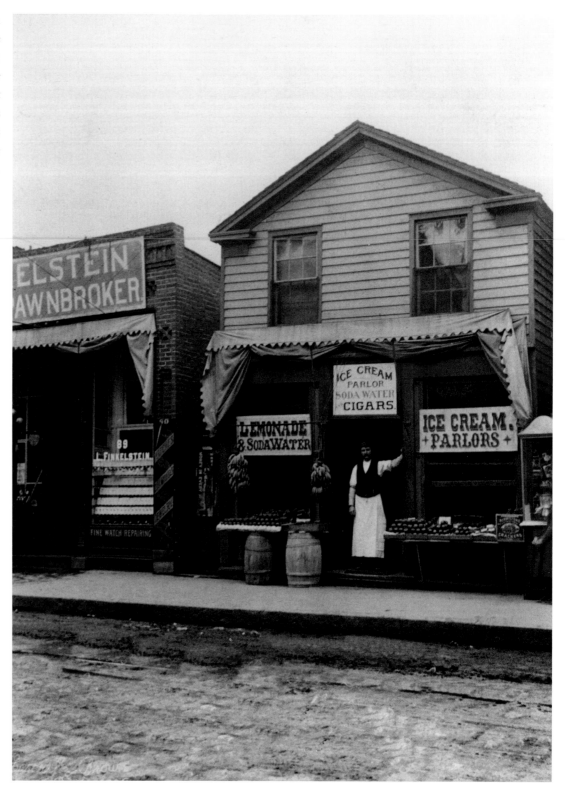

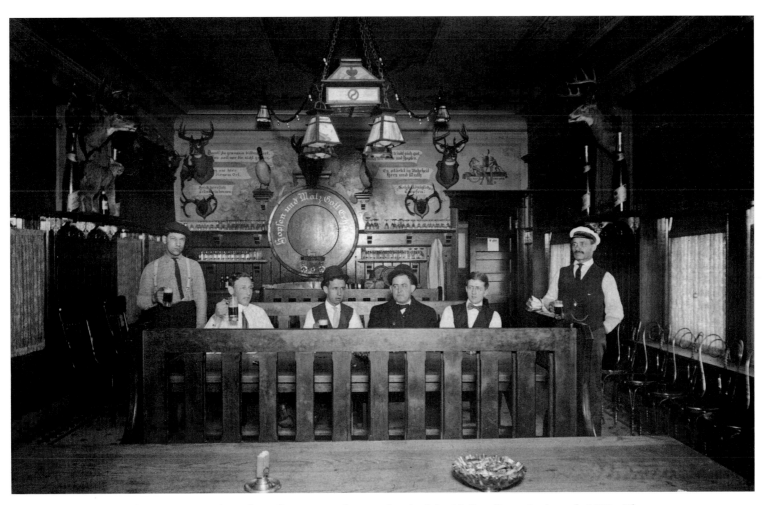

Among animal heads and German artwork on the walls, a group of men enjoy the Schmidt Beer Room in the early 1900s. The brewery's castlelike complex was located in the West Seventh neighborhood. It survived Prohibition by producing a variety of non-alcoholic beverages. After the repeal of prohibition, Schmidt became the seventh-largest beer maker in the nation.

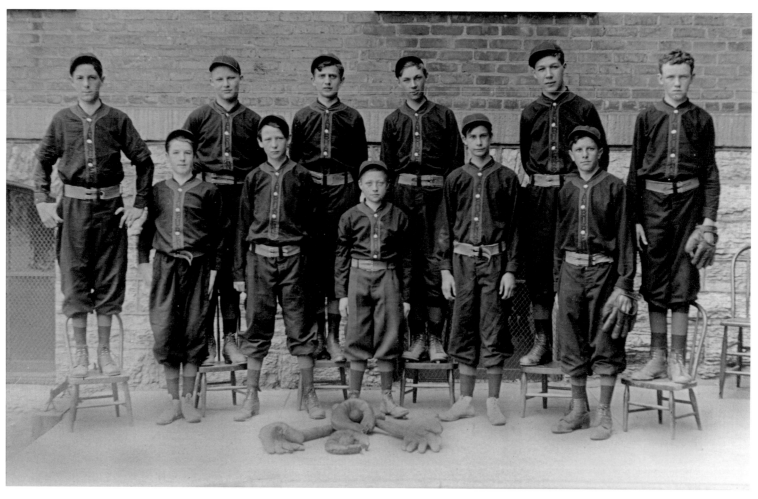

Starters on the Van Buren School baseball team from St. Paul's East Side look intently forward and appear to be ready to take on all comers here in 1901.

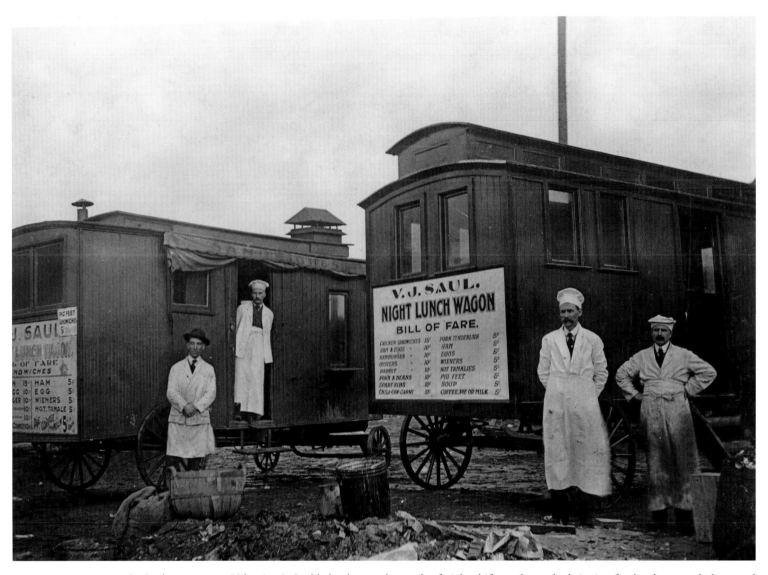

St. Paul restaurateur Valentine J. Saul helped serve the needs of night-shift employees by bringing food to large workplaces and industrial sites. Available foods included ham and eggs, sandwiches, hot dogs, soup, chili, oysters, pigs feet, and, of course, coffee. These unique traveling kitchen wagons were photographed around 1900.

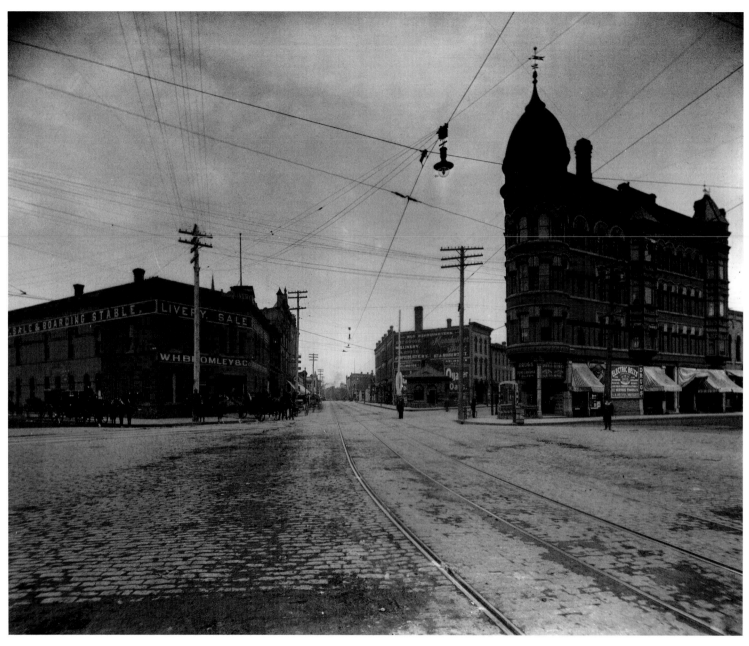

Seven Corners was the name given to a commercial area on the western edge of downtown St. Paul where several streets came together. The photographer, who was aiming east on Seventh Street around 1903, also captured the overhead streetlights, power and telephone poles, and streetcar tracks.

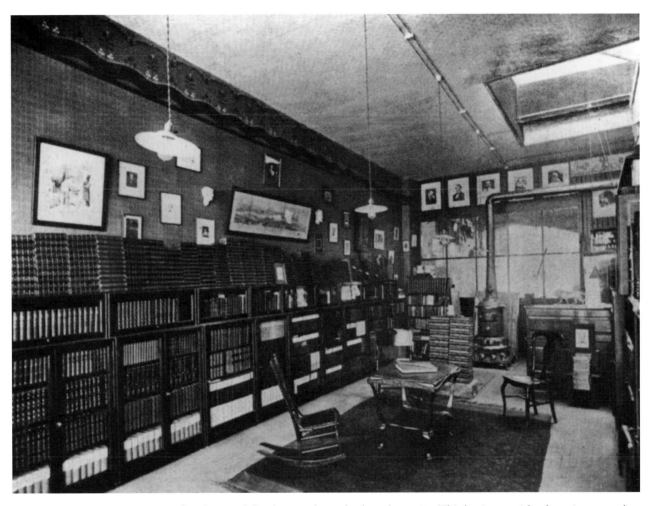

St. Paul has always been a city of readers, with bookstores dating back to the 1850s. This business, with a large inventory but no customers on this day in 1902, was run by Edgar Porter and was located at 104 East Fourth.

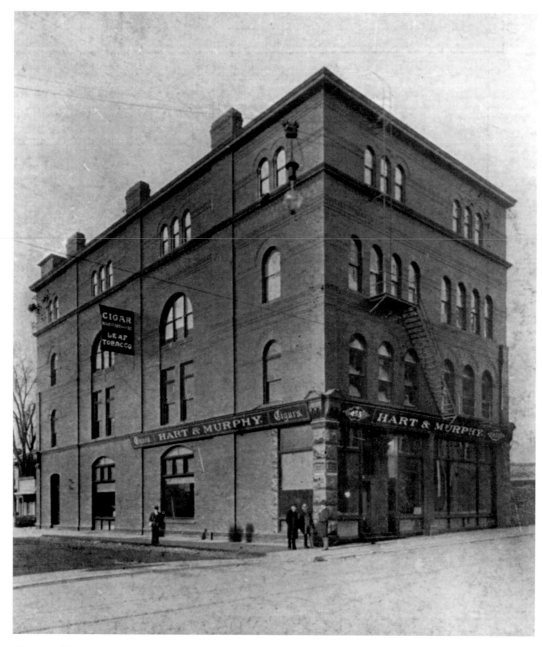

Cigar-making was once big business in St. Paul, and many workplaces downtown were devoted to the enterprise. This is a 1902 photograph of Hart & Murphy, manufacturers of tobacco products at 455-457 Jackson.

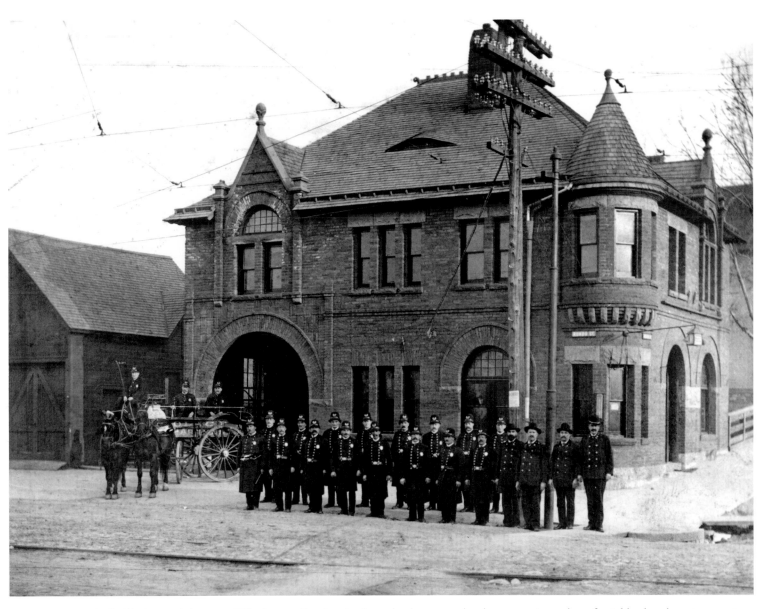

As St. Paul grew, it became difficult to police the city from the downtown headquarters. A number of neighborhood precinct stations were added in the 1880s, among them the Rondo Street Police Station, located at Rondo and Western. The men and a wagon are lined up outside around 1900.

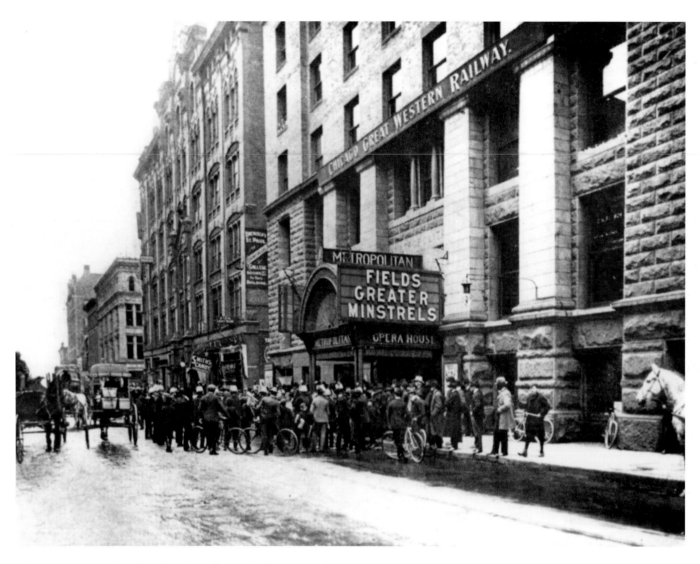

A large group is gathered on the sidewalk outside the Metropolitan Opera House in May 1902. The theater, at 100 East Sixth, hosted opera performances by touring companies, but the shows were more often popular music, vaudeville, variety shows, and the occasional minstrel troupe. Tickets for first-class New York shows were said to be double the usual price.

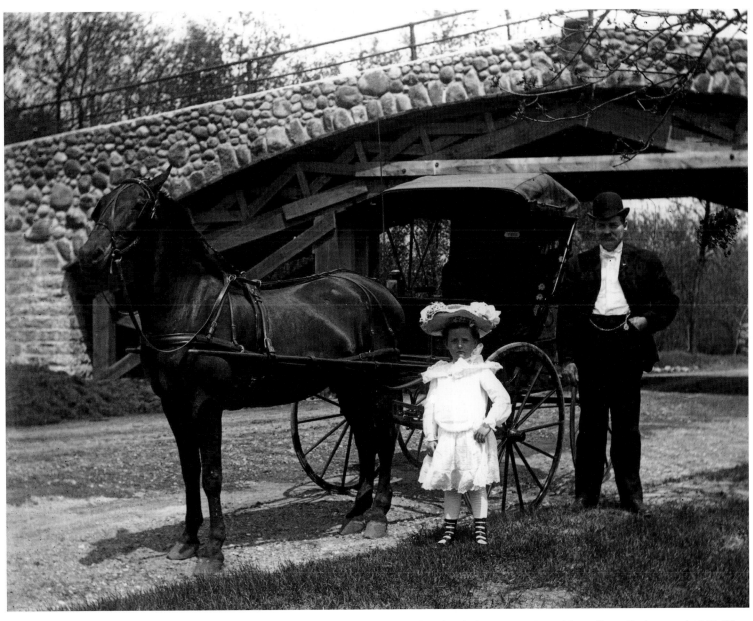

Elmer Ray and his daughter Emma take a break during a carriage ride to Como Park around 1903. They probably arrived there by way of one of the new parkways. These boulevards and the large parks they linked were designed by famed landscape architect Horace Cleveland.

A streetcar passes the Germania Life Insurance Company on Fourth Street around 1904. Because of anti-German sentiment during World War I, the statue of the goddess Germania that rested between the two towers would be removed and the structure would be renamed the Guardian Building.

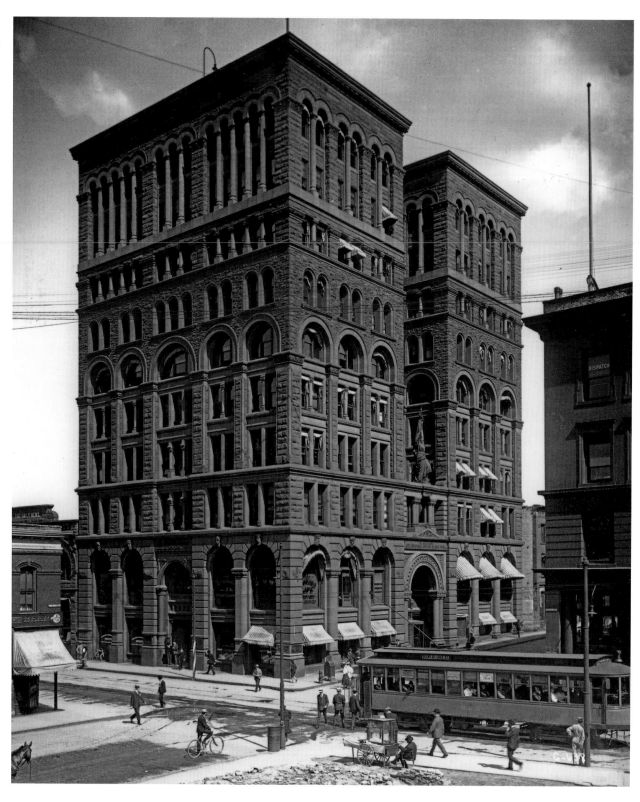

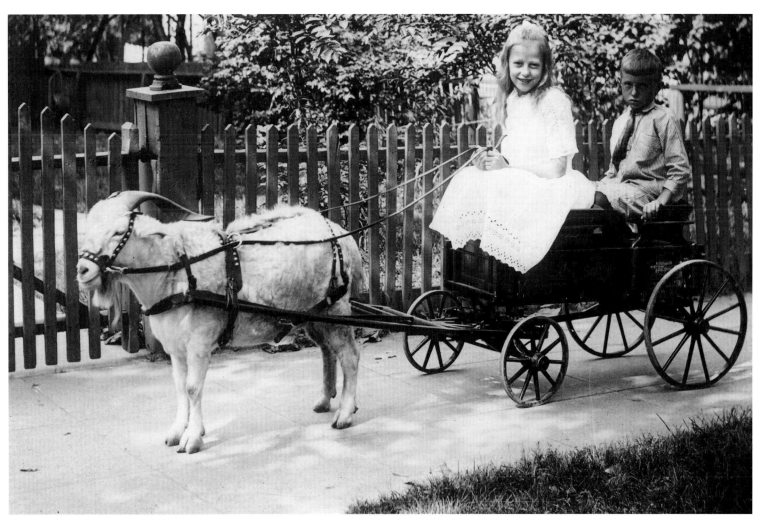

The girl is beaming, but the boy looks a little apprehensive. This sort of photograph was very popular in St. Paul in the early part of the twentieth century. Cameramen traveled around the city with a goat and cart or perhaps a donkey and offered to take photos of children for a small fee.

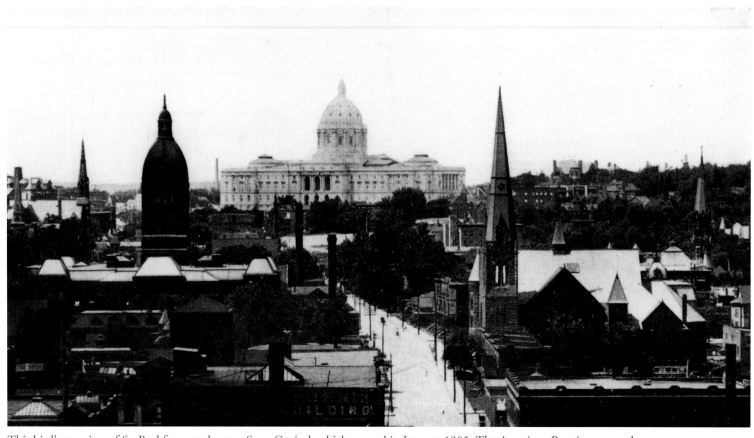

This bird's-eye view of St. Paul features the new State Capitol, which opened in January 1905. The American Renaissance–style building, designed by local architect Cass Gilbert, required 12 years to plan and construct. Although classical in spirit, the building was thoroughly modern with all-electric lighting, a state-of-the-art heating plant, and telephones.

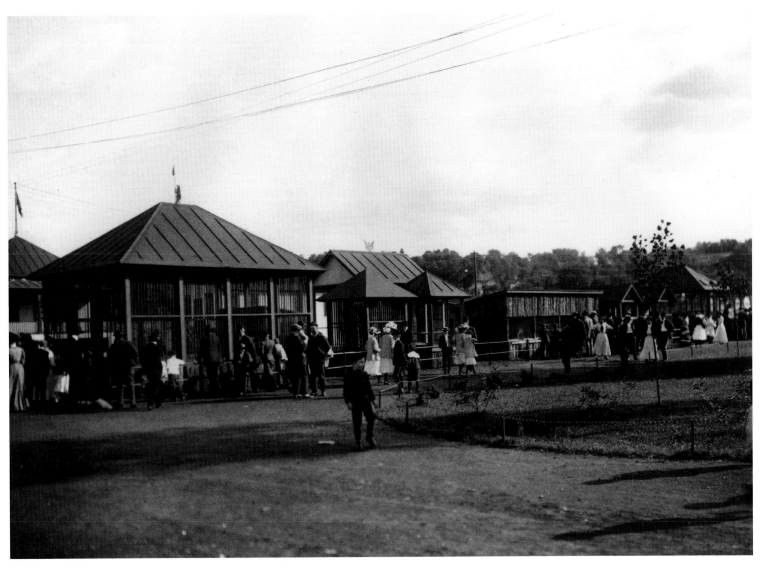

St. Paul residents turn out to spend a leisurely afternoon looking at the caged animals on Harriet Island around 1905. The animals were sometimes threatened by spring floodwaters on the low-lying land and had to be rescued. They were eventually housed at a new Como Zoo.

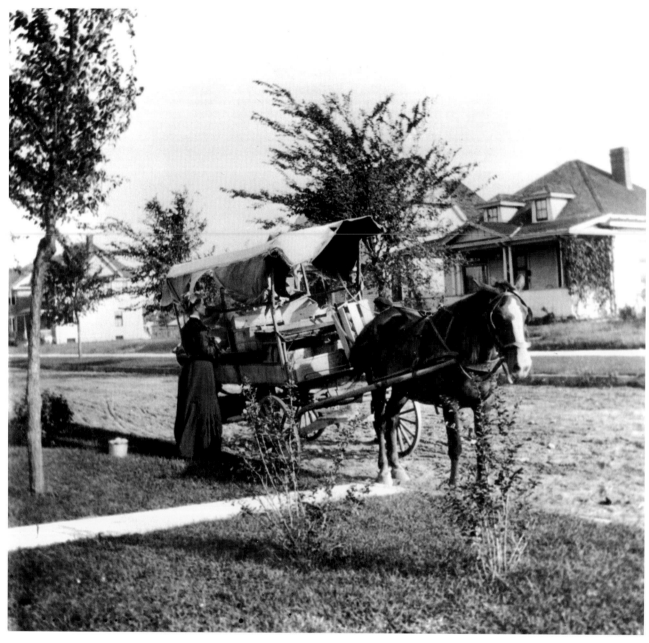

Long before today's shopping centers, there were people who traveled St. Paul purveying a variety of merchandise and services. Here at 1033 Lincoln in 1904, a woman has come from her home to look over the produce offered by the vegetable man.

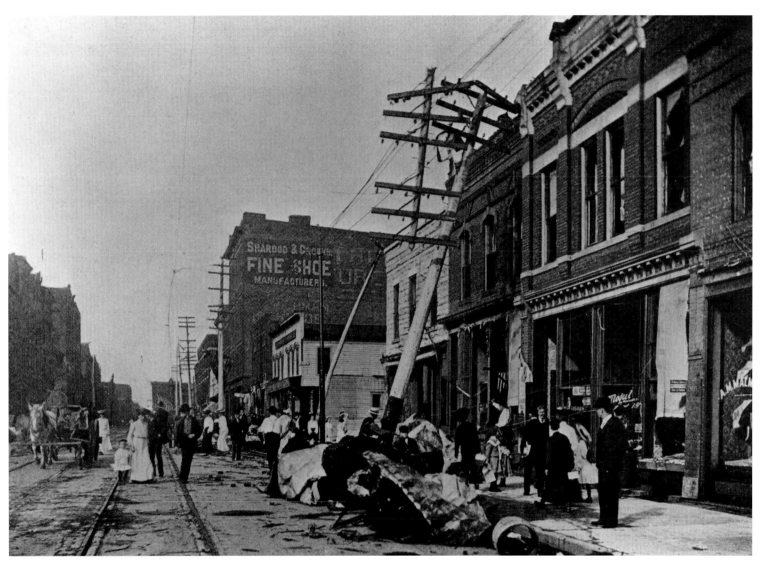

Cyclone damage in 1904, in this view east on Eighth from John Street. The damage left by dramatic weather events was often photographed. The winds this time were so intense that a significant portion of St. Paul's iron High Bridge collapsed into the Mississippi River and had to be rebuilt.

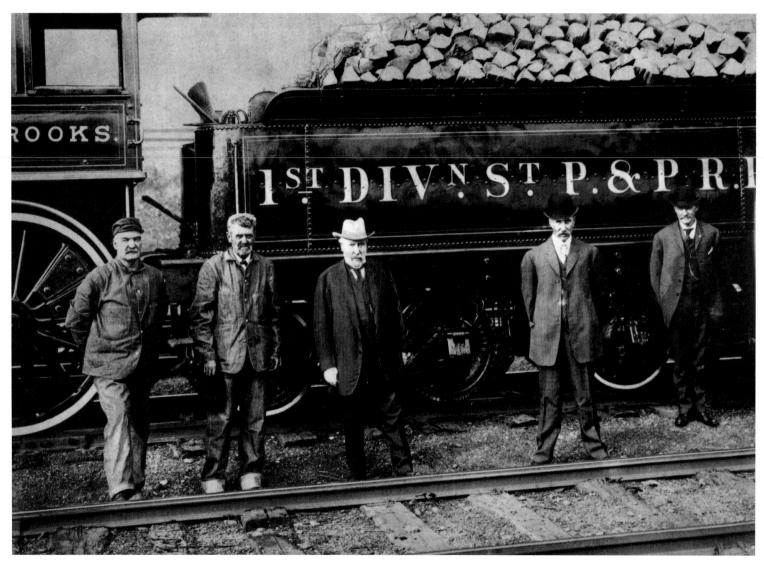

Two legends of railroading are seen together in this 1907 photograph. In the background is the *William Crooks,* the first locomotive to operate in Minnesota, shuttling between St. Paul and Minneapolis in 1862. Railroad magnate James J. Hill poses in a white hat with the fireman and engineer of the refurbished engine, along with two onlookers.

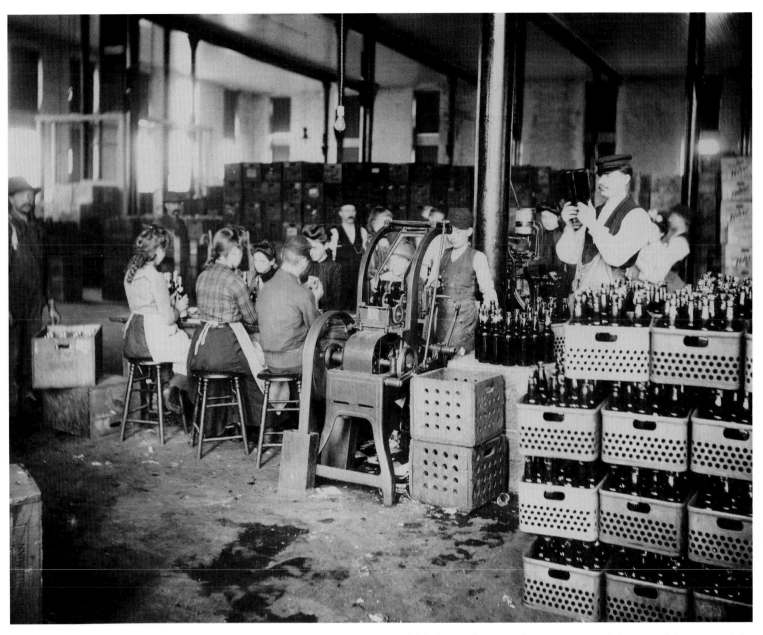

Men and women are engaged in the fine art of bottling and labeling at the Hamm's Brewery around the turn of the century. The company was founded in 1865 by German immigrant Theodore Hamm. Except for the years of the Prohibition era, the family made beer in St. Paul continuously for more than a century.

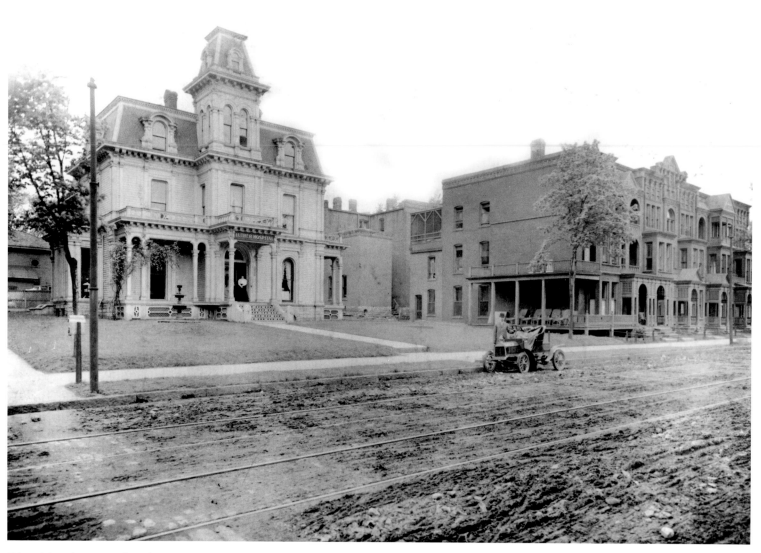

Eduard Boeckmann, a famed Norwegian-born physician who moved to St. Paul in 1887, was instrumental in the founding of Luther Hospital. When this photograph was taken, around 1905, the hospital was located in an old residence at 397 East Tenth. It would later become St. Paul Hospital.

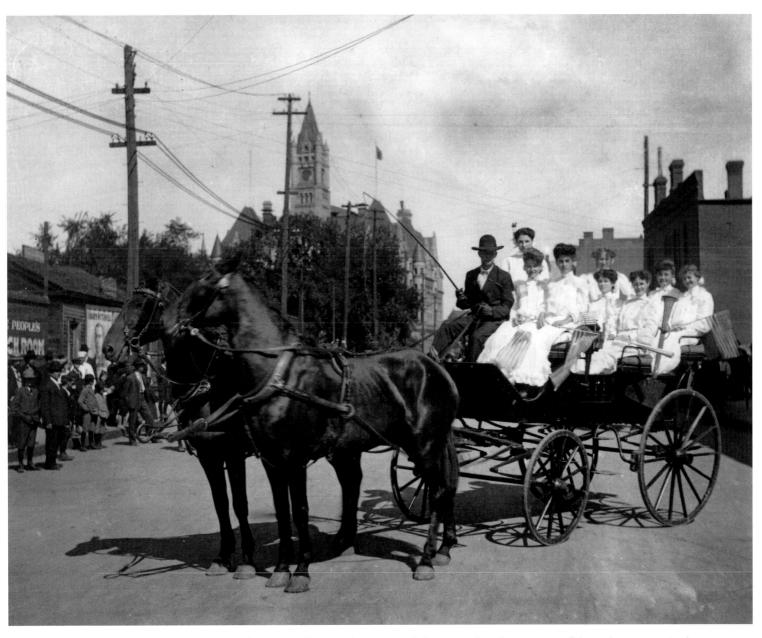

The St. Paul Trades and Labor Assembly started in 1882 and three years later became one of the earliest groups in the country to celebrate Labor Day with parades and picnics. United Garment Workers Union members, dressed head-to-toe in white, ride in a carriage during the 1905 event.

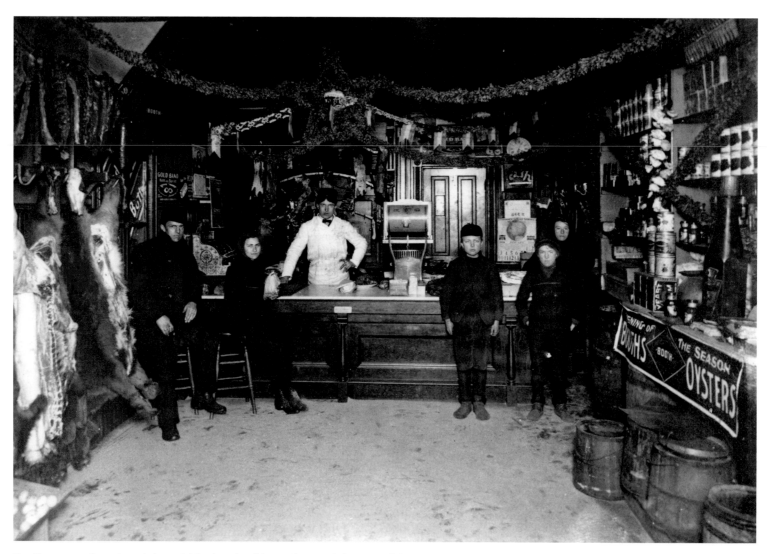

Small meat markets dotted the neighborhoods of St. Paul around the turn of the century and were usually separate from grocery stores. Before the era of modern home refrigeration, they needed to be easily accessible, since frequent shopping was necessary. Richter's Butcher Store, shown here around 1904, was located at 676 Blair.

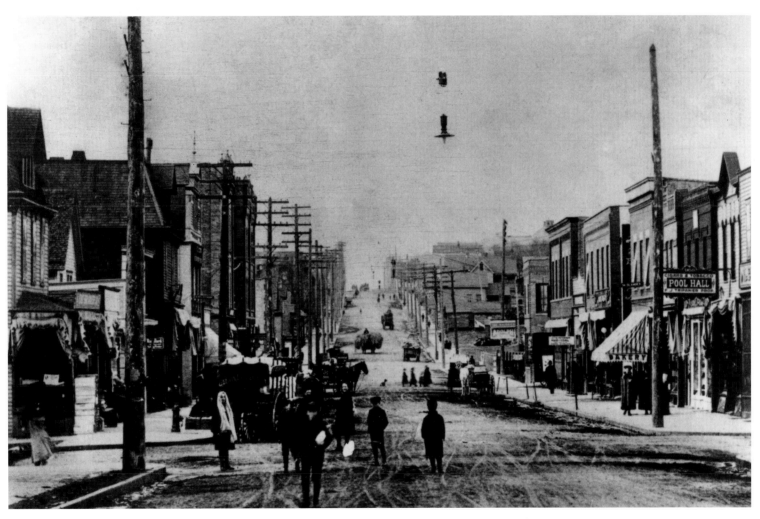

Payne Avenue facing north from Case Street, around 1905. A typical neighborhood business district developed during the streetcar era, it featured a line of stores on either side of the street that served local residences. At this time, the community was heavily Scandinavian.

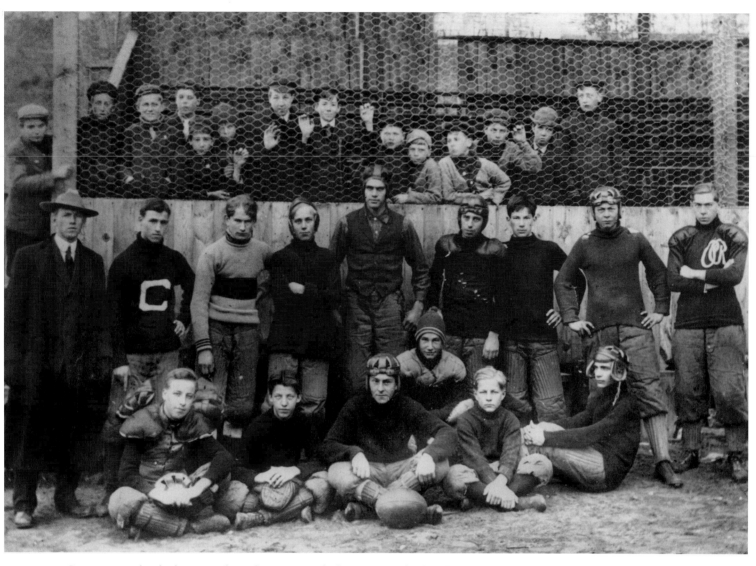

Supporters and onlookers peer through protective chicken wire at a football field. The Cleveland High School football coach is preparing his team in the fall of 1909 for what could be a rugged game.

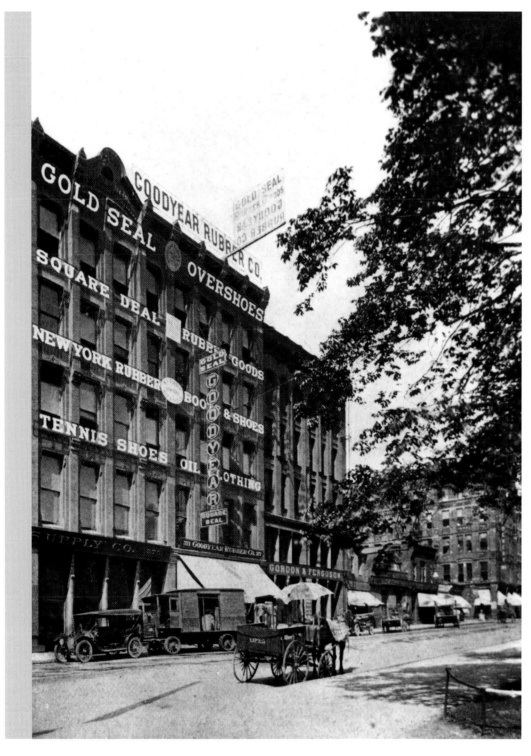

The camera is trained on the Goodyear Rubber Company on the west side of Sibley Street between Fifth and Sixth. Many of the other businesses that also fronted Smith (now Mears) Park around 1909 manufactured apparel and footwear. According to its conspicuous signage, this concern featured overshoes, boots, tennis shoes, and other items.

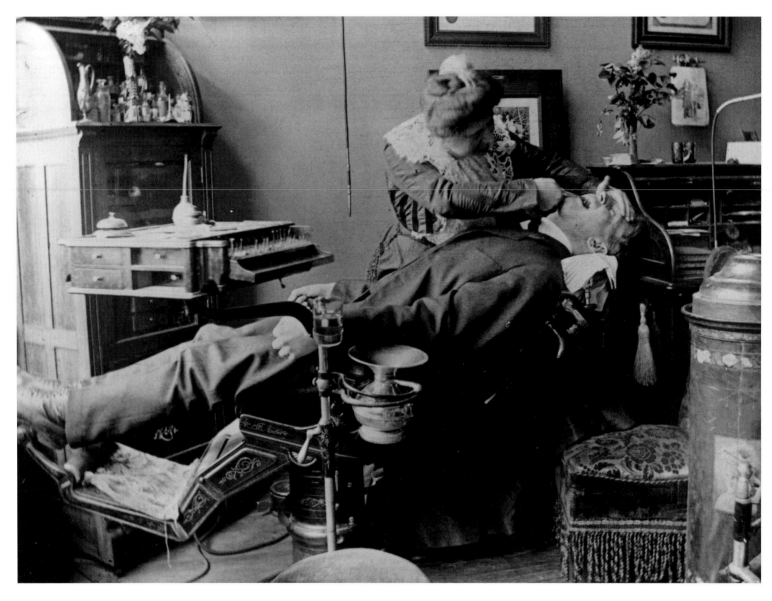

Dr. Olga A. Lentz was one of the few licensed women dentists of her day in any part of the country. Here she is extracting a tooth in her St. Paul office. This indoor image provides a rare look at dental equipment and practice in 1910.

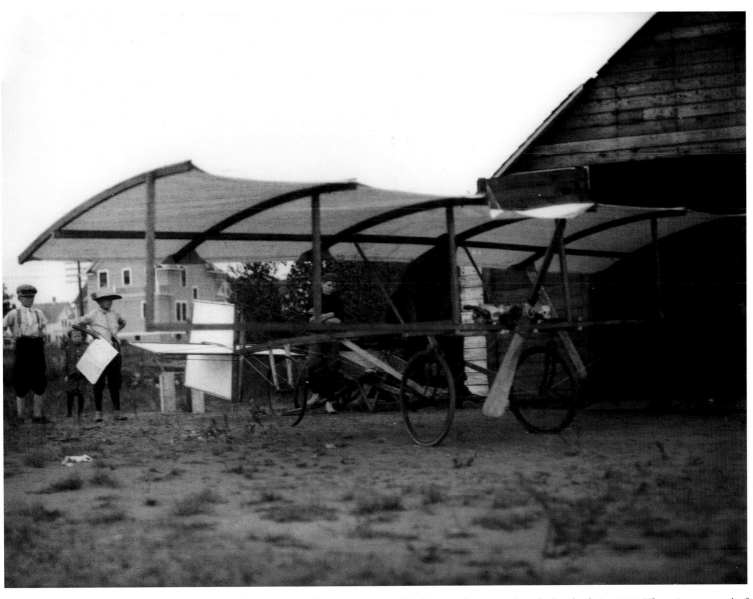

Fred Parker of 665 North Snelling Avenue proudly displays the monoplane he has built in 1910. There is no record of whether or not it ever became airborne.

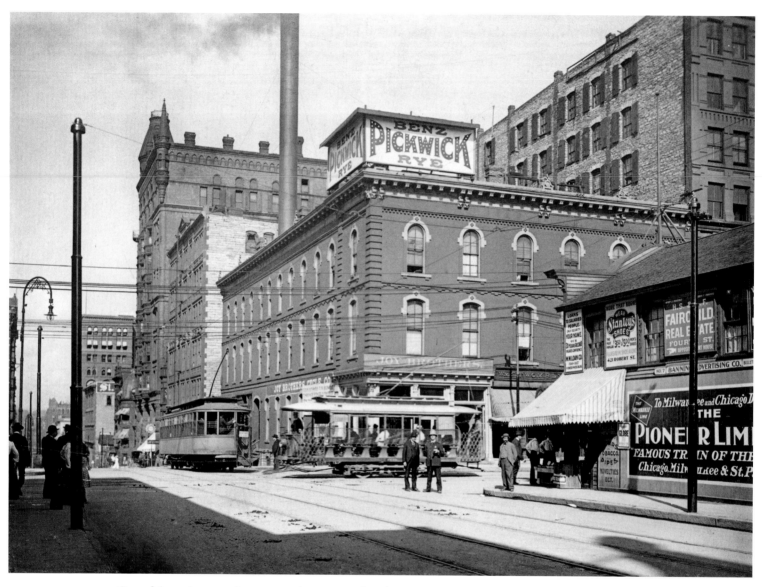

One of the early open-air streetcars that were used in the summer is seen here, at the junction of Wabasha and Fourth streets, in 1910. On the tracks approaching the photographer is one of the new enclosed cars built locally, using a design meant to hold up well during Minnesota's harsh winter weather.

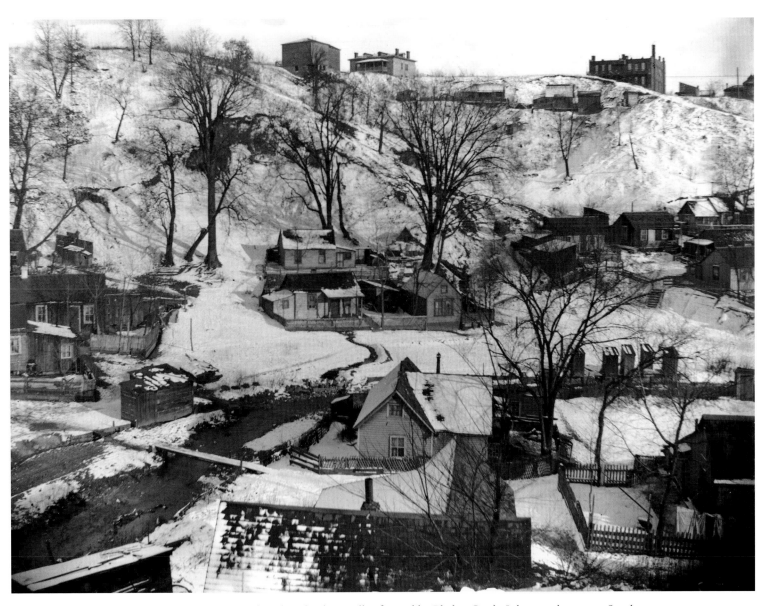

Starting in the 1860s, Scandinavian squatters gathered in the deep gulley formed by Phalen Creek. It became known as Swede Hollow. Over the years, Italian, Mexican, and other immigrants occupied the small houses and raised families without benefit of indoor plumbing or electricity. The Hollow is captured here around 1910 in a rare, quiet moment.

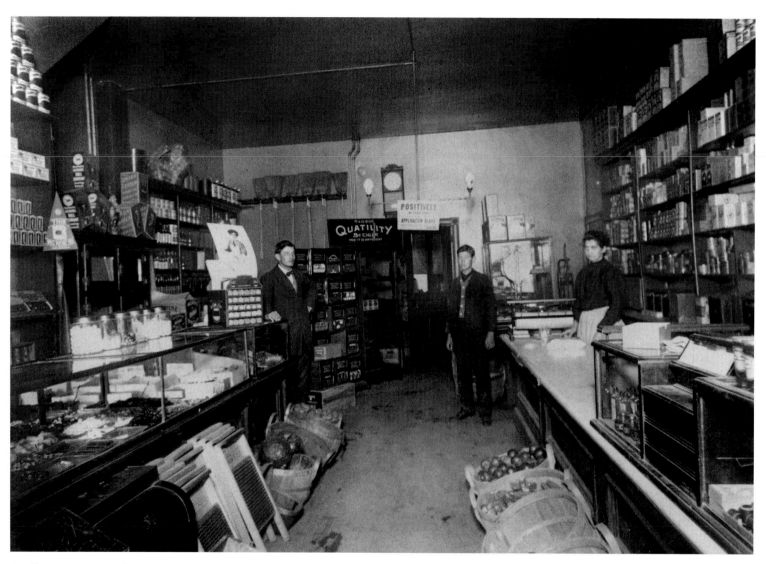

Small grocery stores, often on street corners, were common in St. Paul's neighborhoods in 1910. This photograph depicts the interior of Banken Brothers, with the family proprietors standing among bushel baskets of apples and cabbages, displayed on the floor beside washboards and other merchandise. Banken Brothers was located at 1136 Rice Street in the city's North End.

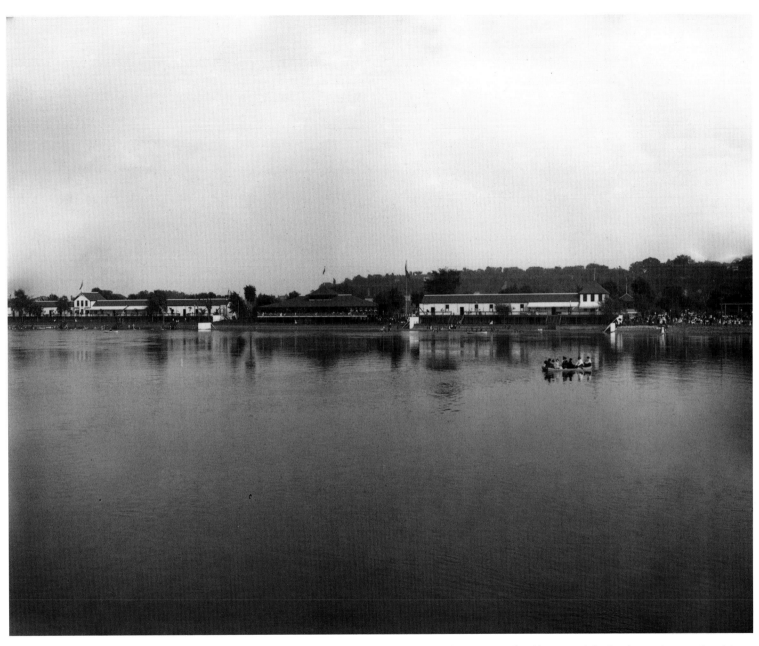

This panorama shows the extent of development of public facilities on popular Harriet Island by 1910. The land was given to the citizens of St. Paul by Dr. Justus Ohage to provide the city with recreational space. There were, among other amenities, picturesque paths, a large pavilion overlooking the river, public baths, and a beach area.

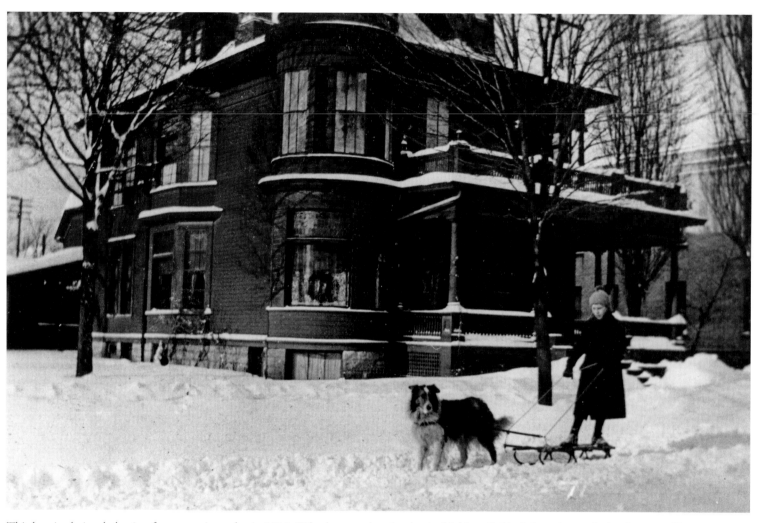

This boy is obviously having fun on a winter day in 1911. Who knows what the dog is thinking. Behind the pair stands the Otto Kueffner home at 63 North Milton in one of the city's more prosperous neighborhoods, just off Summit Avenue.

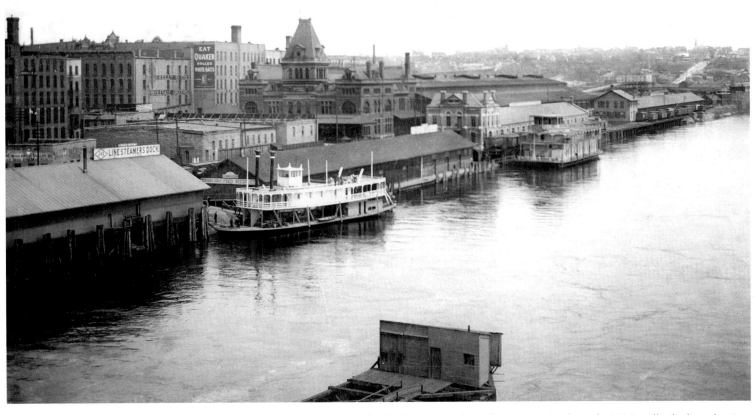

Although the tower of the railroad depot is now prominent on the skyline, a great deal of commerce in the early 1900s still relied on the river for transport. This is a glimpse of the lower landing, facing east across the Mississippi.

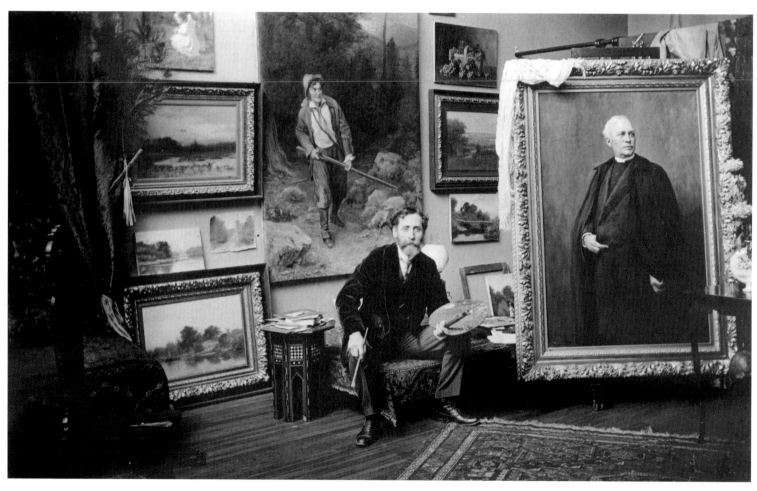

Inside the studio of artist Nicholas Brewer, one of the city's most prominent painters, in 1910. In addition to landscapes, he was sought after for his quality portraits. To Brewer's right is a huge oil of Archbishop John Ireland, obviously meant to be a key feature of this photo.

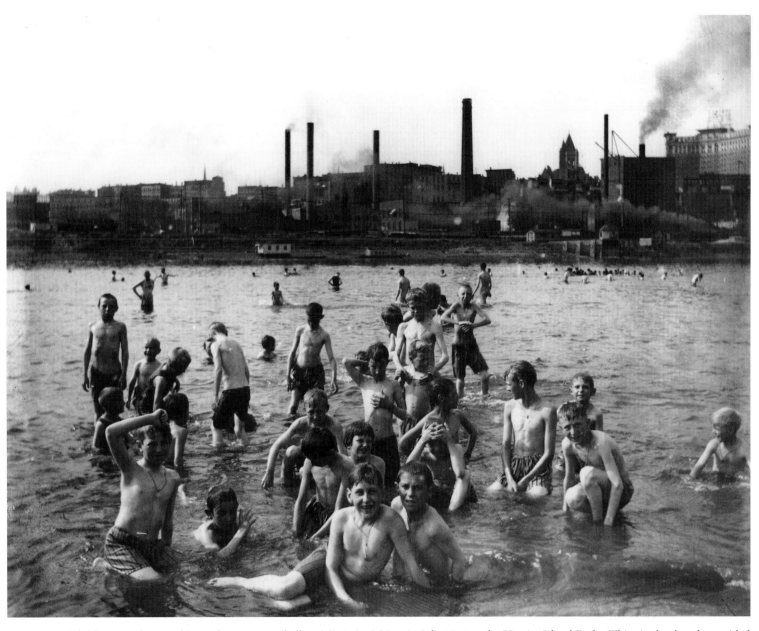

Children are shown taking a dip in a very shallow Mississippi River in July 1912 at the Harriet Island Baths. This city landmark provided free public baths and swimming opportunities to some 15,000 visitors to the beach every year. As river pollution increased, its popularity decreased and it closed in 1915.

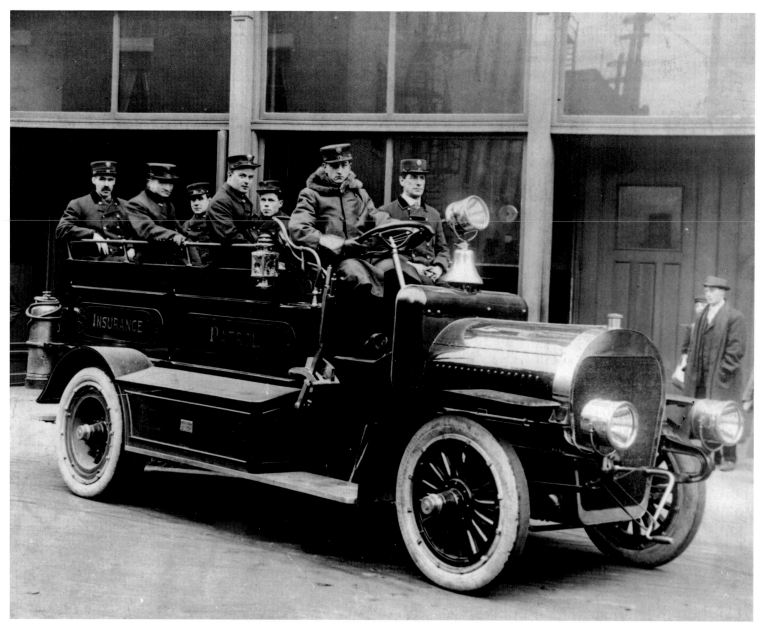

Insurance patrols began to appear in many large cities in the late 1880s. They worked alongside firefighters to protect property from fire and water damage in burning or threatened structures. The St. Paul Insurance Patrol, shown ready for action in 1912, operated until the 1930s when the city fire department assumed their duties.

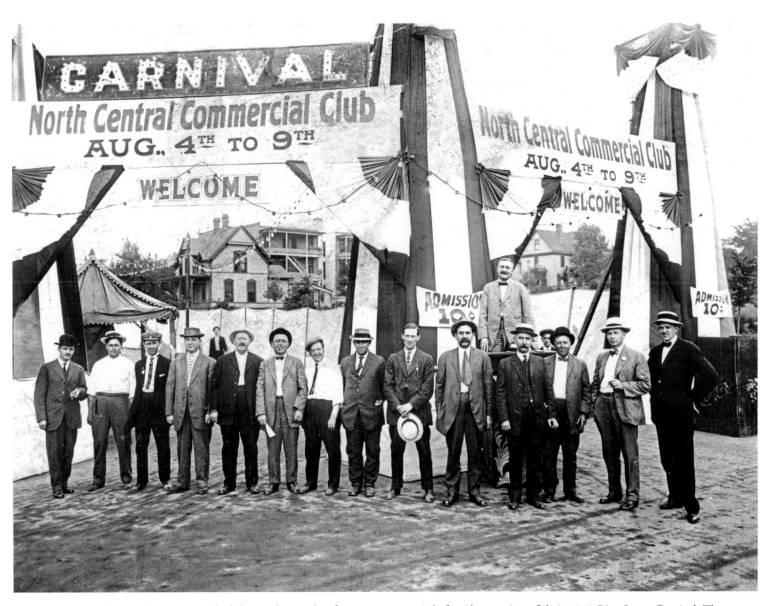

North Central Commercial Club members gather for a group portrait before the opening of their 1913 Rice Street Carnival. There were several other such local groups in the early 1900s. Led by the business community, the clubs were composed of neighborhood boosters who worked for civic improvements. Their buildings became social and cultural gathering places.

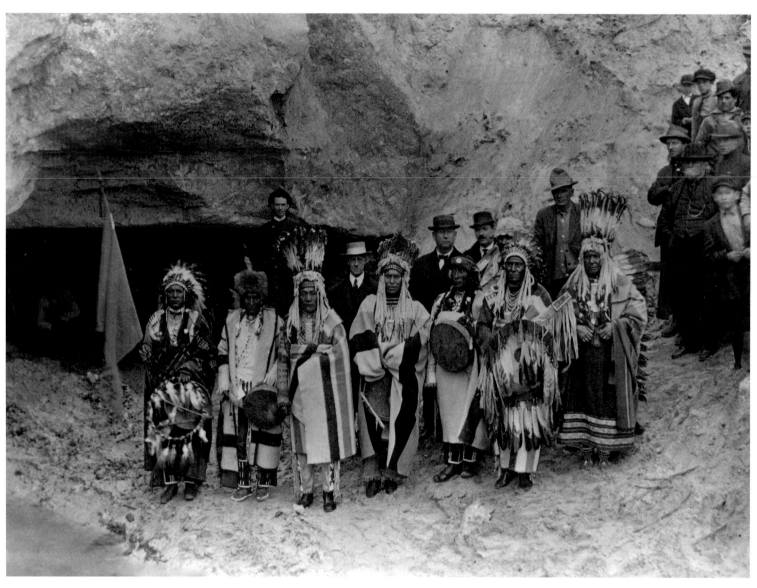

This legendary cavern was called "Waken Tipi" by the Dakota and "Carver's Cave" by the English explorer who named it for himself in the 1760s. By the late nineteenth century, its location had become an unknown, but in November 1913, the landmark was uncovered after a year-long search. A group of Montana Blackfeet who were passing through St. Paul were photographed with other onlookers shortly after the cave's re-opening.

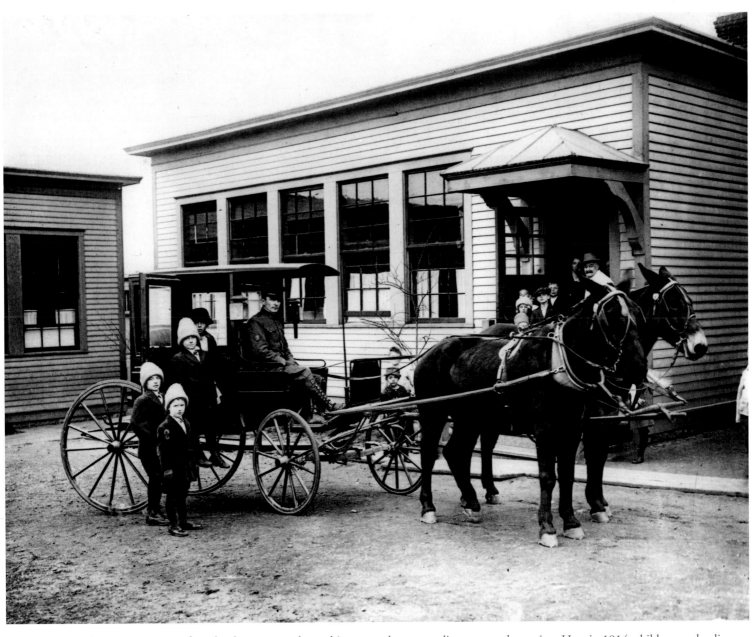

Providing transportation for schools appears to be nothing new where great distances need covering. Here in 1914, children are loading up in a horse-drawn school bus in front of Homecroft School on Edgecumbe Road near Munster.

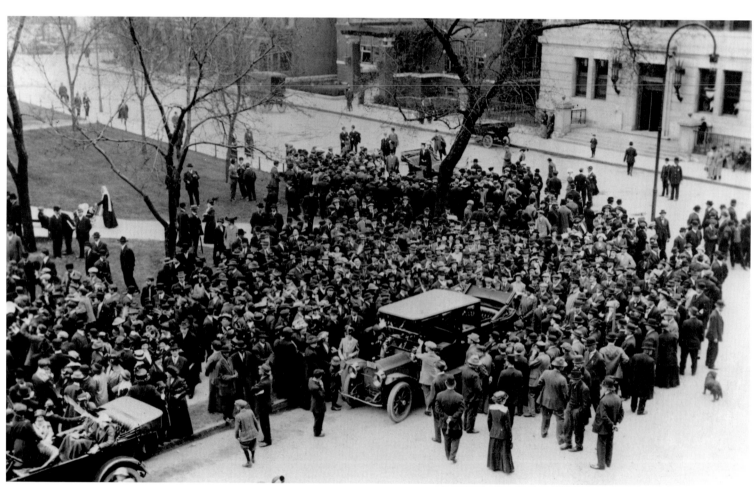

A large crowd is gathered for a women's suffrage rally at Rice Park in 1914. Through such events, marches, speeches, and appeals to elected officials, women worked to gain the vote. The Minnesota Legislature ratified the proposal in September 1919, and in 1920, the Nineteenth Amendment to the U.S. Constitution guaranteed women their long-sought political right.

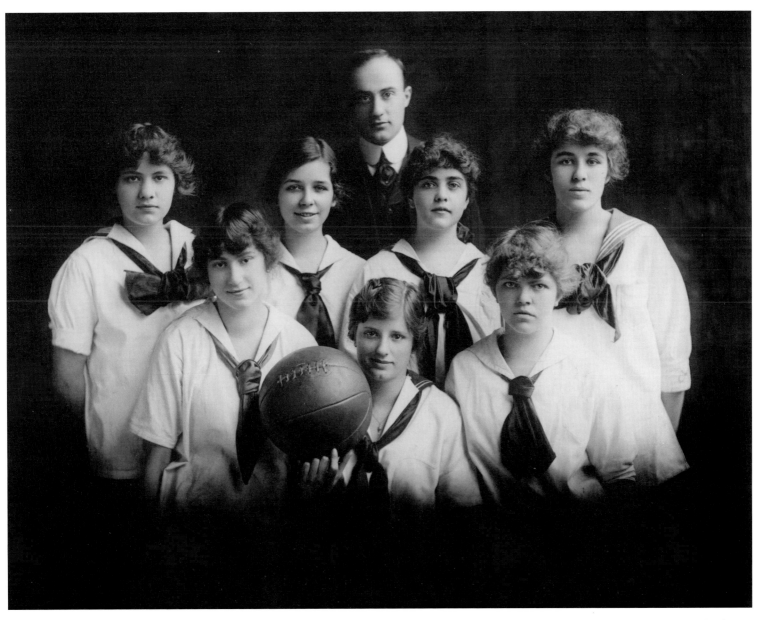

Before declining in the early part of the twentieth century, girl's sports flourished throughout Minnesota. The St. Paul Johnson High School girl's basketball team seems happy with their 1915 season. They won seven of their nine games, barely losing the city championship to arch rival Central High by a score of nine to six.

The Warren Apartments, at 661 Grand Avenue, west of Dale Street. On a streetcar line, and just south of Summit Avenue, this street held a large number of St. Paul's early multi-unit buildings meant to attract upper-end renters. Today the property looks almost the same as it did in 1915, with the unfortunate exception of the porches, which are now missing.

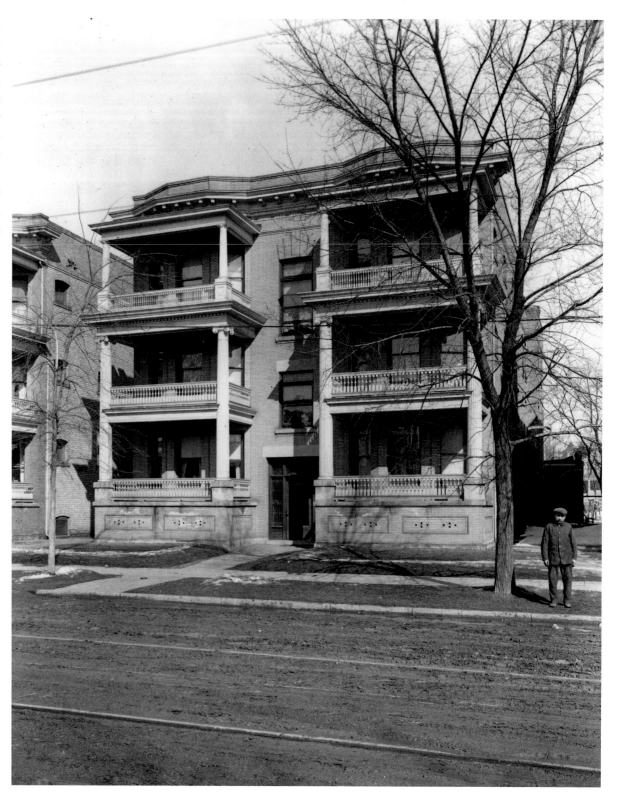

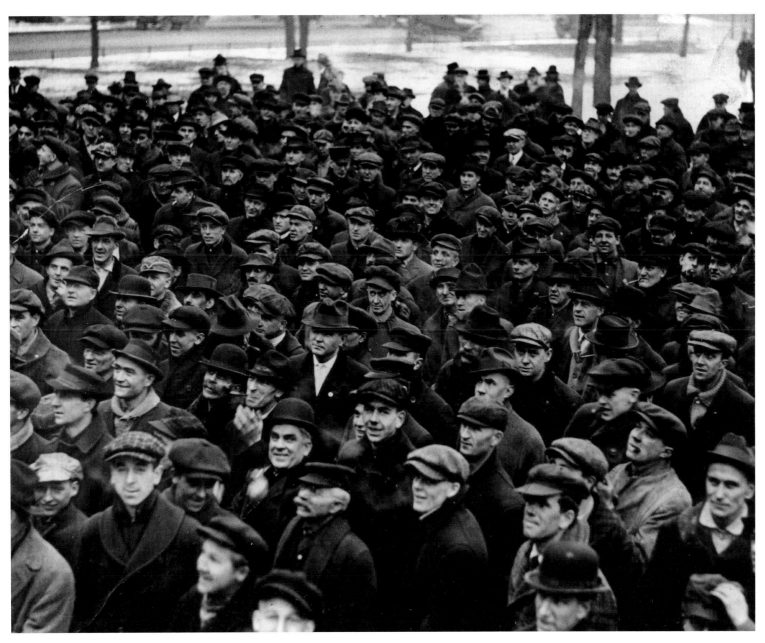

The walk-out started in October 1917. When the streetcar company refused to negotiate, angry workers filled the streets of St. Paul. They later returned, but left again in November when the company threatened to fire anyone wearing a union button. After this image of the overflow meeting at City Hall was recorded, arrests were made, the strike was eventually broken, and hundreds of men lost their jobs.

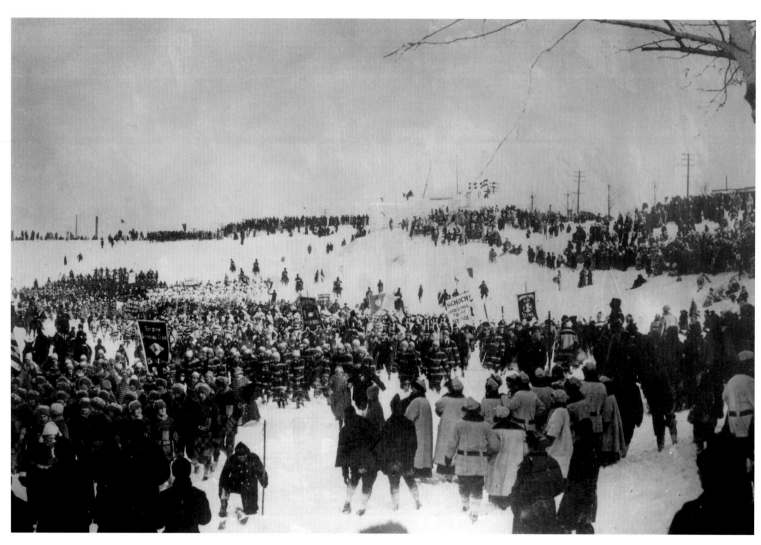

A 1917 Winter Carnival gathering at the Town and Country Club. Formed in 1888, it is the first golf course in Minnesota and the second-oldest in the nation. It was also a spot for social gatherings and a center for tennis. The club moved to its present home near the Marshall Avenue Bridge over the Mississippi River in 1890.

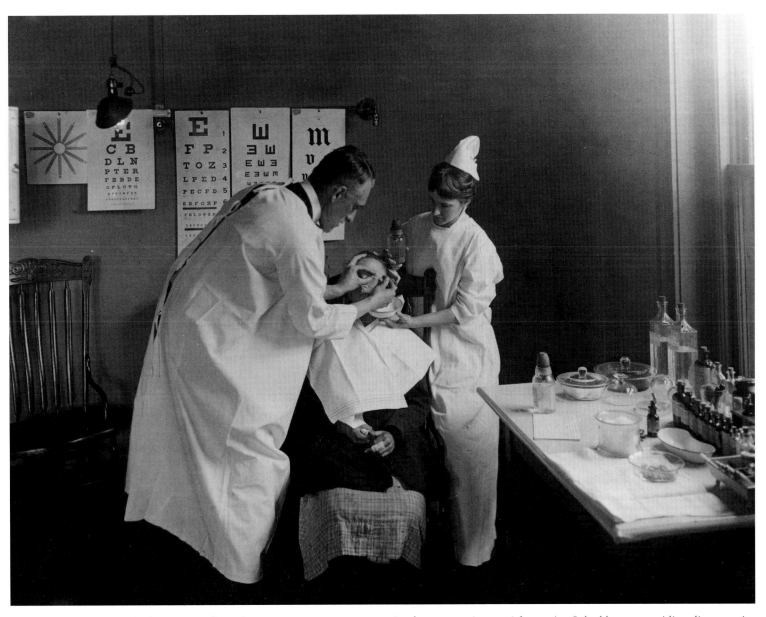

United Charities was formed in 1892 to promote cooperation between various social agencies. It had begun providing direct service itself by the time this 1916 photo was taken. Medical and dental clinics and a free legal aid department for indigent persons were available. Dependent families could also receive emergency food, fuel, and clothing.

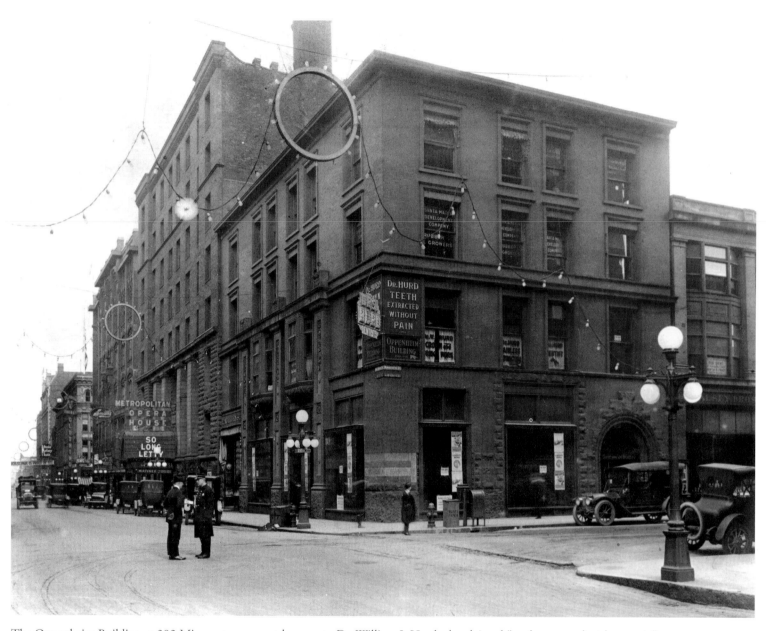

The Oppenheim Building at 392 Minnesota was rental property. Dr. William J. Hurd who claimed "teeth extracted without pain" must have been a favored tenant with his large electric sign on the building's corner. Above him was the Santa Maria Development Company, self-described rubber growers, and a fourth-floor law office. The street-level floor appears empty, its windows plastered with "For Rent" signs and 1917 Liberty Bond posters.

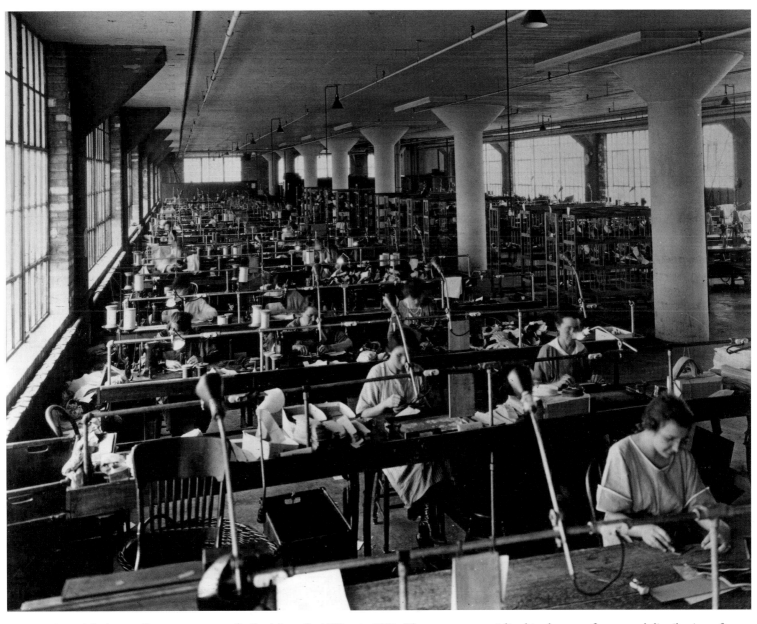

Foot, Schulze, & Company came to St. Paul from Red Wing in 1881. The company specialized in the manufacture and distribution of more refined "city" shoes. The company was first housed at Third and Wacouta, but later moved to this new building, constructed in 1916 at Robert and Tenth. At its peak, close to a thousand people, most of them women, labored in this massive workplace.

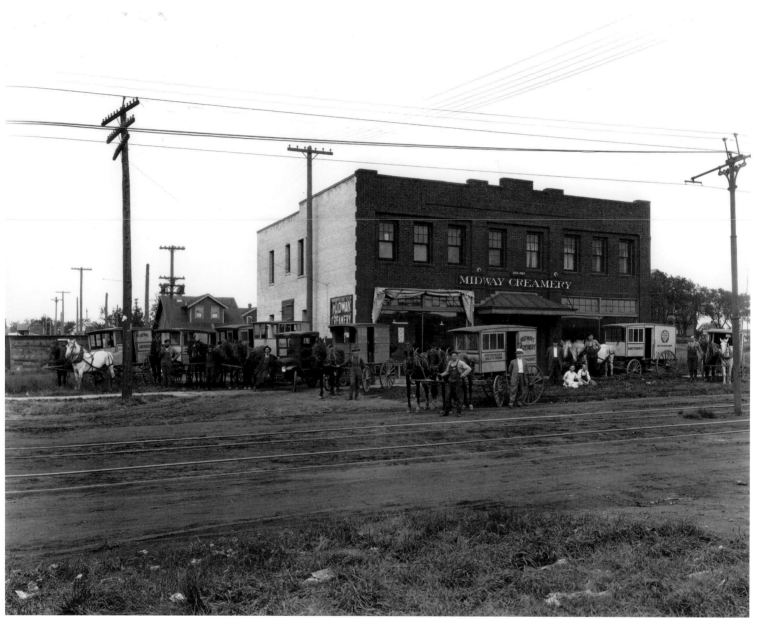

The Midway Creamery, located on the corner of Como and Snelling in 1915, was one of the numerous businesses that provided services and goods to the residents of this developing area. It appears that several milk wagons are preparing to run their routes, delivering dairy products door-to-door.

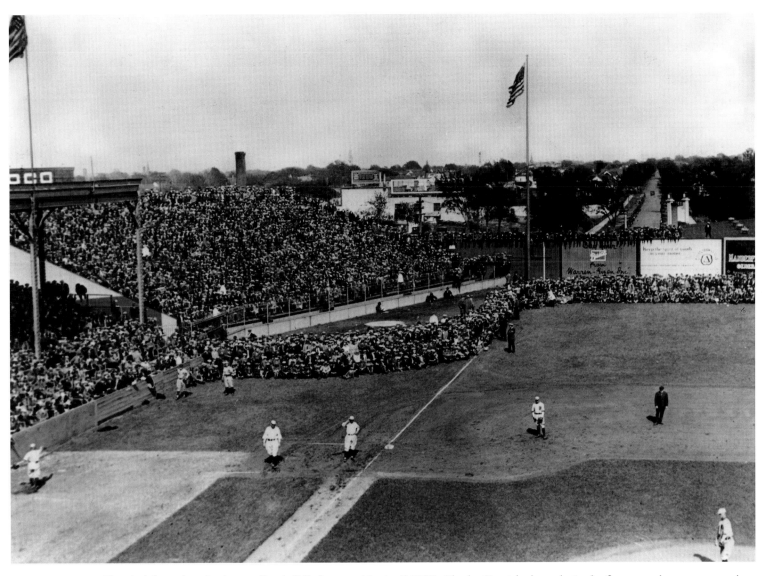

The city's legendary Lexington Baseball Park opened in April 1897. Charles Comisky brought in the first team, but soon moved on to Chicago. By 1902, the structure was home to the St. Paul Saints, who, along with arch rival Minneapolis Millers, were charter members of the new American Association. This is one of their well-attended games in 1916.

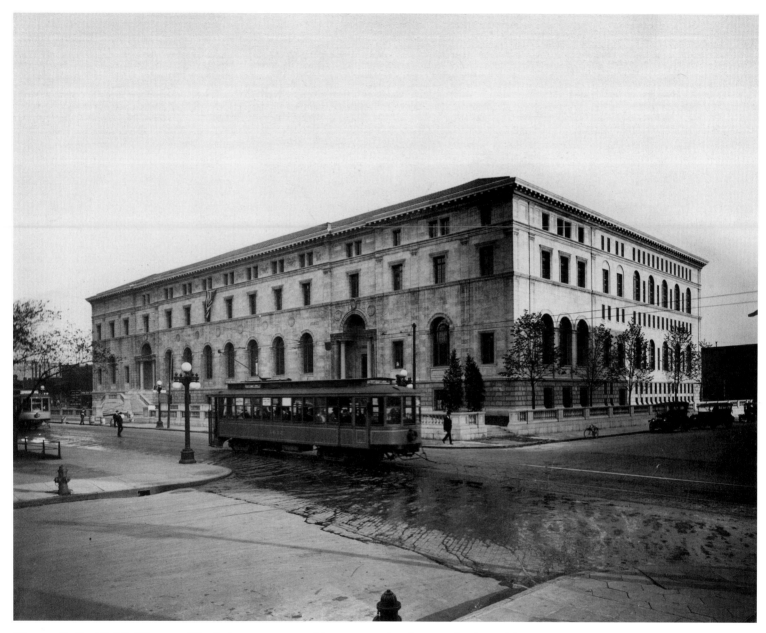

The new St. Paul Public Library at Rice Park was constructed between 1914 and 1917. The classical building was centrally located and obviously easy to reach on foot, by bicycle, on the streetcar, or in an automobile. James J. Hill contributed funds for a business reference library in an attached wing. The structure was put on the National Register of Historic Places in 1975.

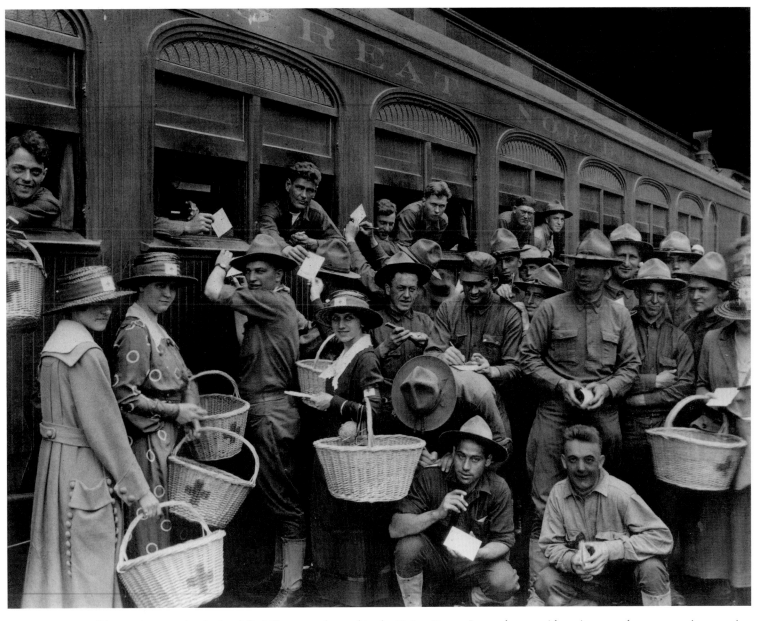

The canteen, run by the local Red Cross, was located in the Union Depot. It was there to aid servicemen who were coming or going on the trains during the First World War. The volunteers obviously had a lot of work to do this day in 1917.

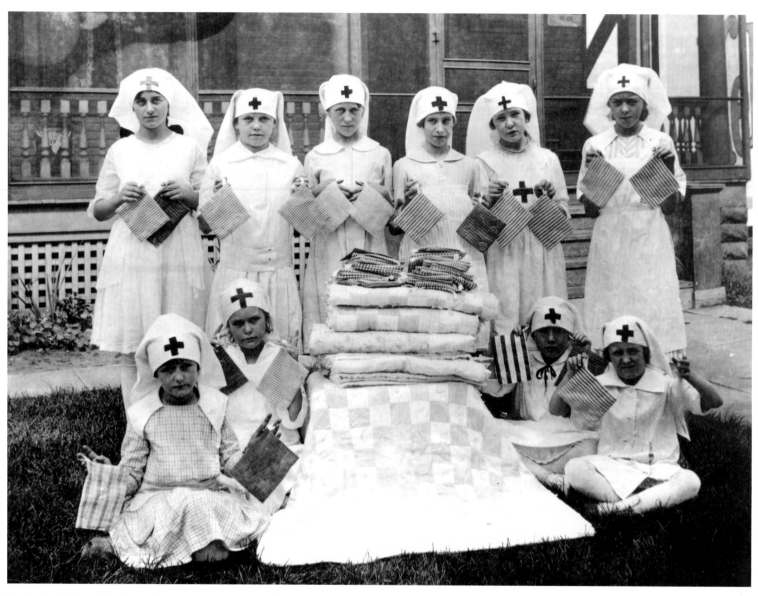

Junior Red Cross girls dressed in miniature nurses uniforms, proudly display the potholders and quilts they helped make as part of St. Paul's World War I effort.

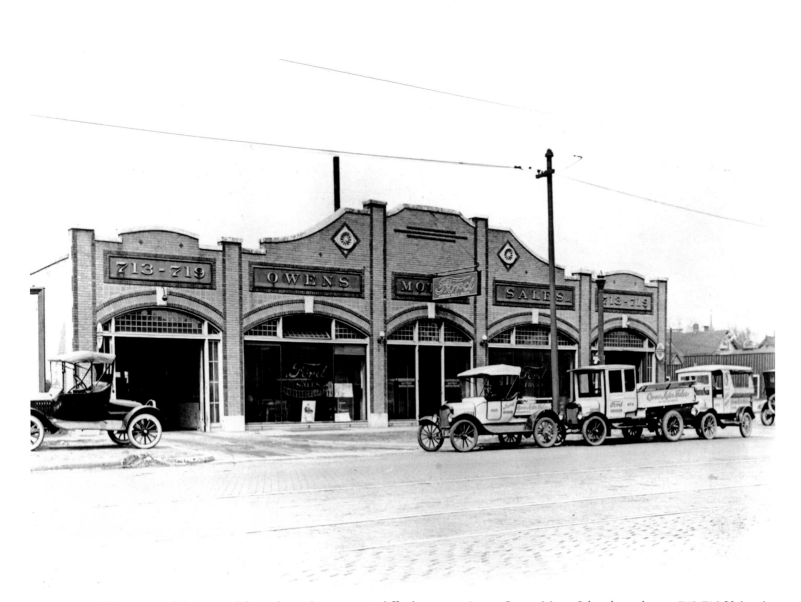

The impact of the automobile on the city's economy is difficult to overestimate. Owens Motor Sales, shown here at 713-719 University Avenue around 1918, was one of the early car dealerships in St. Paul. Increasing car ownership spurred many other spin-off businesses, including repair shops, auto parts stores, filling stations, storage garages, and tire centers.

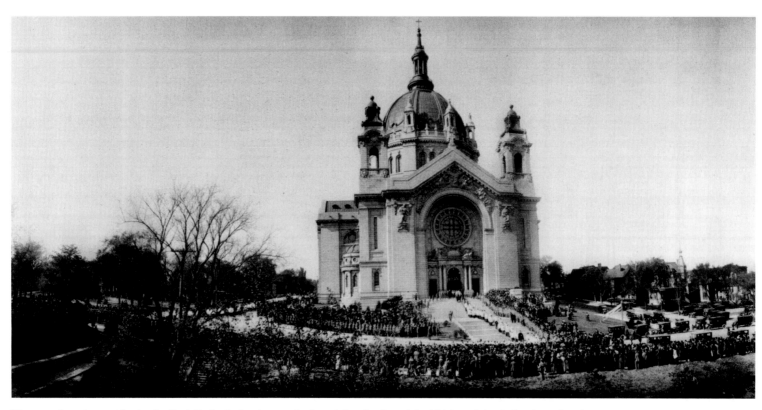

Thousands wait outside the St. Paul Cathedral to honor the last rights for famed Archbishop John Ireland on October 2, 1918. He served the city's Catholic community starting in 1867 and became an archbishop in 1888. Ireland was a civic activist, founding St. Thomas University and St. Paul Seminary, and was responsible for building this magnificent cathedral, which held its first mass on Easter in 1915.

The City in Transition

(1919–1945)

The First World War was a watershed event that marked the start of a new era for the city and ushered in a more individualistic and materialistic culture. The economy was soaring, women gained the vote, and there was a housing boom. Prohibition brought bootlegging and criminal activities. Although St. Paul was seen as an open city where gangsters roamed the streets, there were far more important forces at work.

The automobile was one of them. Downtown workers and shoppers wanted convenient parking, and the city began to make accommodations as car ownership increased. Downtown structures were razed to provide spaces and the first ramps were built. Cars also spurred residential development in areas that had been underserved by the streetcar. Housing sprang up on the East Side, in neighborhoods like Hazel Park, and in Highland Park around the new Ford plant. Apartments and duplexes were becoming more common.

By 1920, St. Paul was home to 235,000 people, but the pace of growth was slowing. Culture was changing and writers like F. Scott Fitzgerald were documenting "the jazz age." Movies and sports were all the rage and radio programs had a huge following.

Because of federal restrictions there was little foreign immigration, but American citizens were moving, from rural areas to the city. The African-American community was growing, becoming highly concentrated in the Rondo area.

The Depression ended the housing boom and threw thousands of citizens out of work. Many men and women worked in jobs created by the Works Progress Administration (WPA) and other federally funded programs. The lack of money meant little new housing and the deterioration of older dwellings.

Then the Second World War jump-started the economy. People streamed into the metropolitan area, seeking employment at war plants, and women and minorities joined the work force in large numbers. Employment was high, with most of the nation's resources funneled into the military effort. On the home front, Americans did their best to conserve needed resources. This generation had struggled for three decades, but confidence rose as they prepared to enter the postwar world.

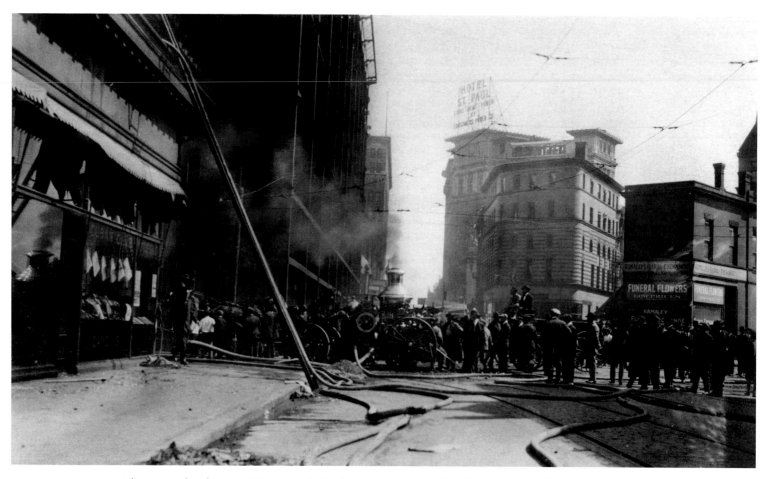

A large crowd gathers in 1919 to watch this fire at St. Peter and West Seventh Street. Fire department vehicles including a steam pumper are on the scene. The multi-story Hamm Building, under construction at left-center, may be involved, but it appears that the commotion focuses on the building at far-left.

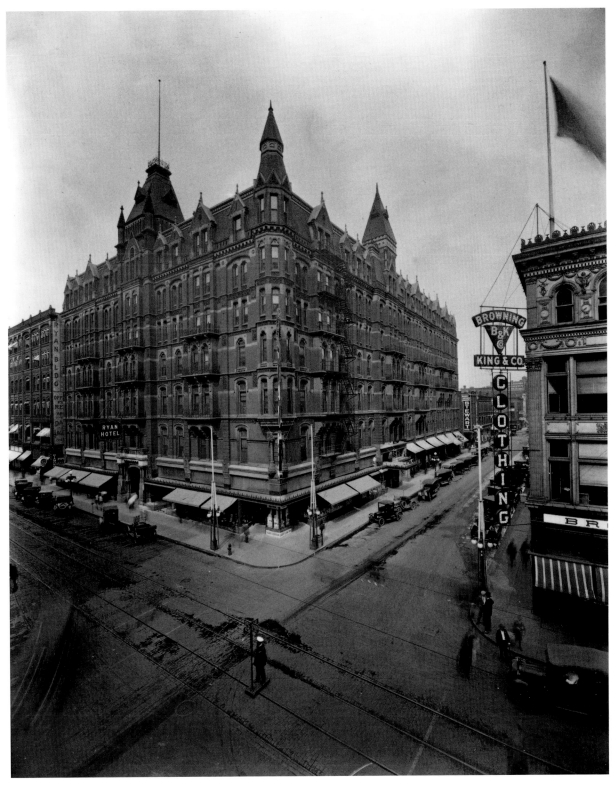

When the Ryan Hotel opened in 1882, one paper called it "the most conspicuous building in the city." It was still a high-quality lodge when photographed at Robert and Sixth around 1919. The figure in front in the middle of the street is a policeman directing the ever-increasing traffic. This magnificent structure was demolished in 1962.

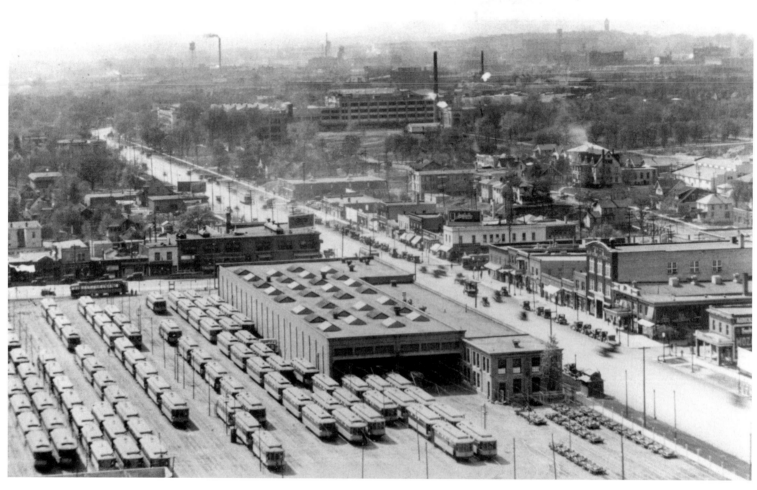

This is how one of the busiest streets in St. Paul looked in the 1920s. The photo shows the intersection of Snelling and University, where the streetcar barns were located. The view west shows the Midway area, a mixture of commerce and industry with adjacent residential neighborhoods.

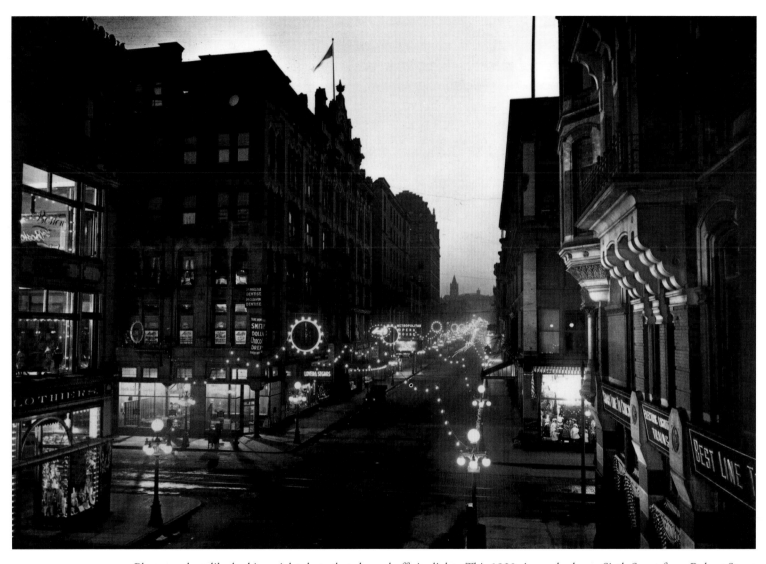

Photographers liked taking night shots that showed off city lights. This 1920s image looks up Sixth Street from Robert Street toward the Metropolitan Opera House.

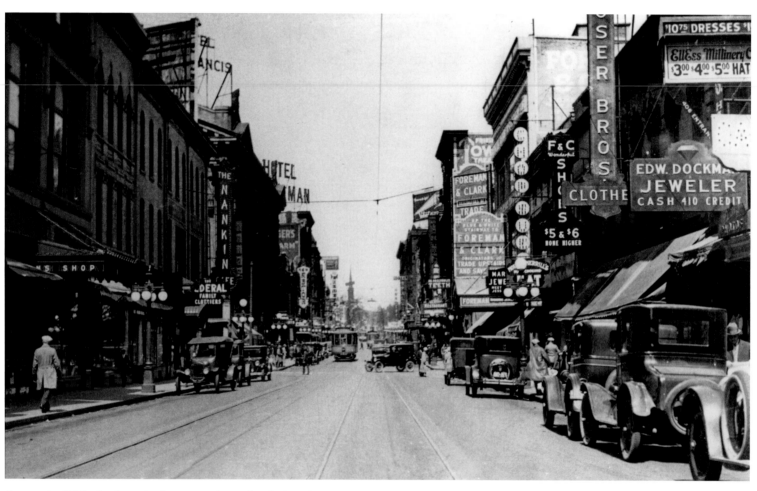

A maturing Wabasha Street in downtown St. Paul is flush with commerce in the early 1920s. Pedestrians mix with automobiles and streetcars while electric signs above the sidewalks promote everything from clothing to food and jewelry.

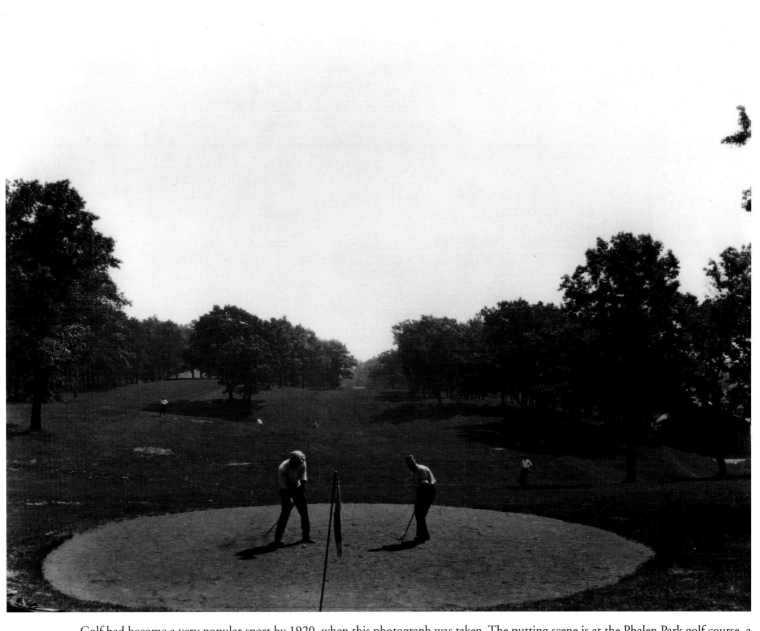

Golf had become a very popular sport by 1920, when this photograph was taken. The putting scene is at the Phalen Park golf course, a public links on St. Paul's East Side, developed and run by the city of St. Paul.

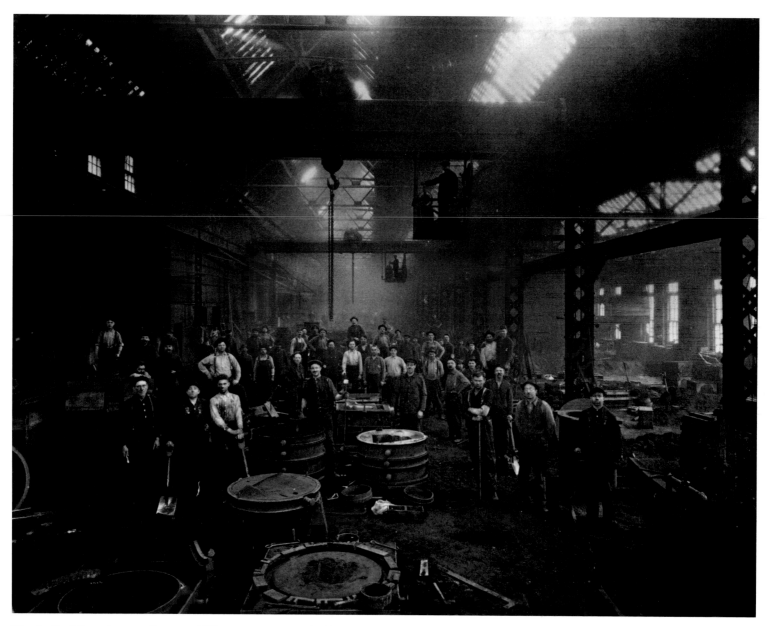

The St. Paul Foundry near Como and Western avenues was built in 1901 in the working-class neighborhood known as Frogtown. It was the largest of many railroad-related industries and businesses that grew up in the area, employing many recent immigrants. The company bragged they always had "3,000 tons of steel shapes in stock."

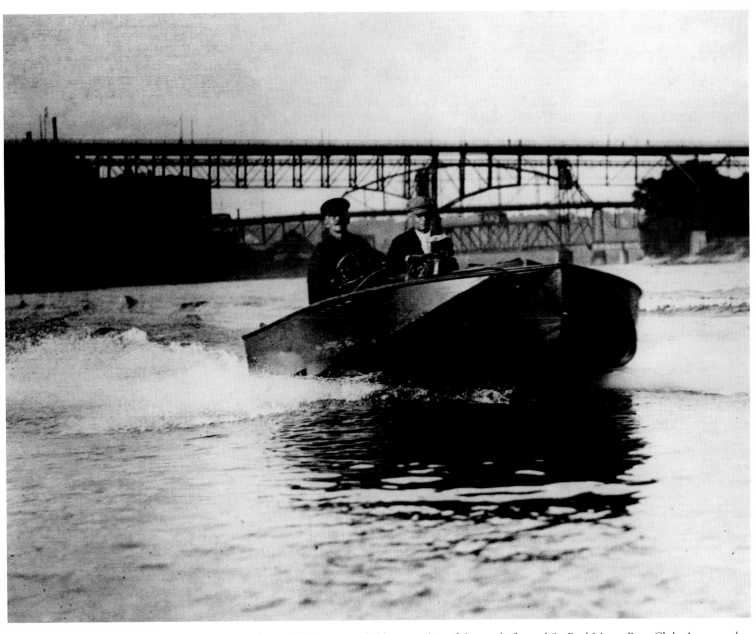

George E. Taylor in his first speedboat, the *Firefly*. He was probably a member of the newly formed St. Paul Motor Boat Club. Among other things, the group had a docking area in the 1920s on the south side of the Mississippi, across from downtown.

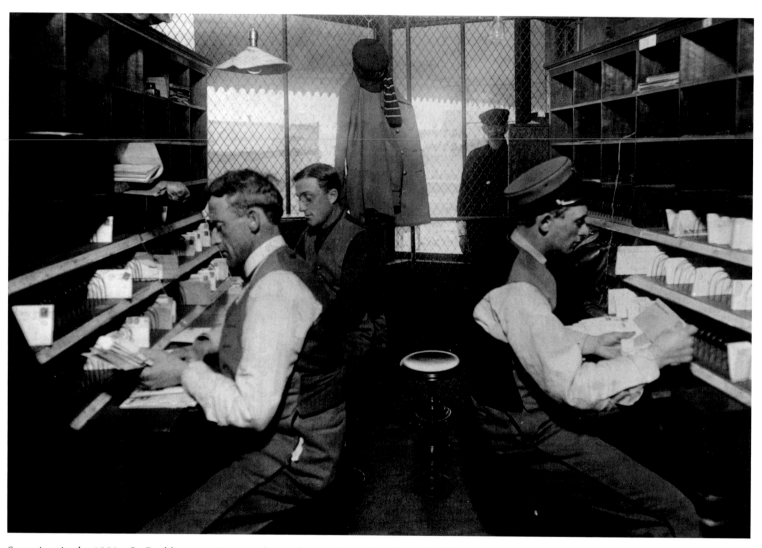

Sometime in the 1920s, St. Paul letter carriers sort the mail so that it can be efficiently delivered.

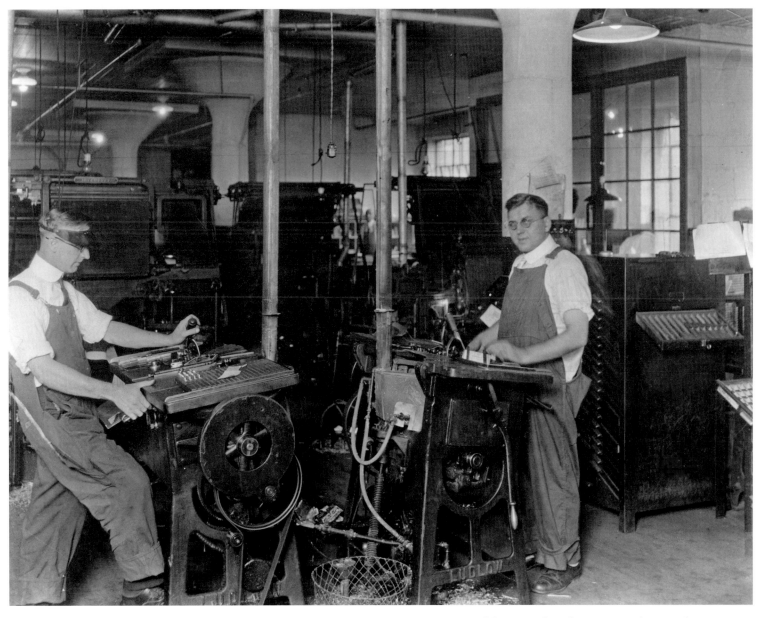

Two men are hard at work setting type. They are shown in the composing room of the *St. Paul Daily News* around 1920. The newspaper was continuously published from 1900 to 1938.

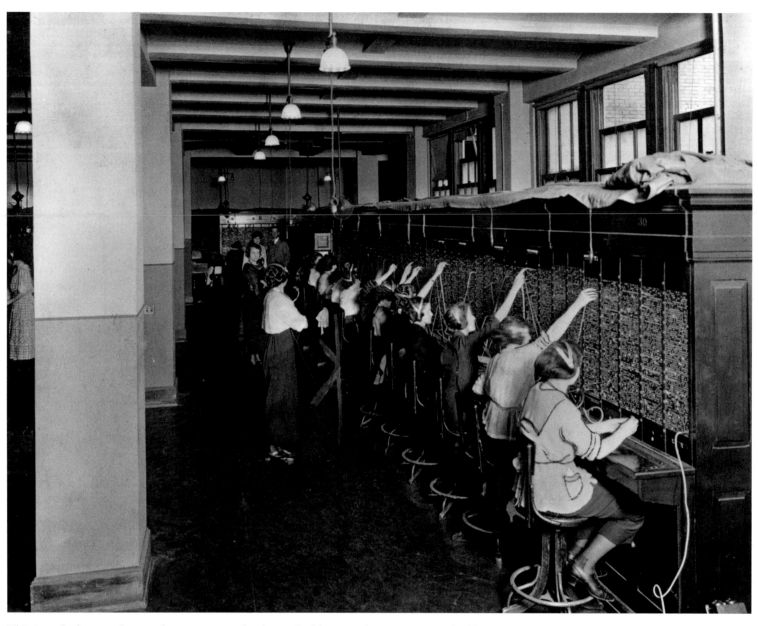

This is a telephone exchange where operators, closely watched by a standing supervisor, asked "number please" and then made plug-in connections for St. Paul callers. They were part of a quickly growing telecommunications industry in the 1920s.

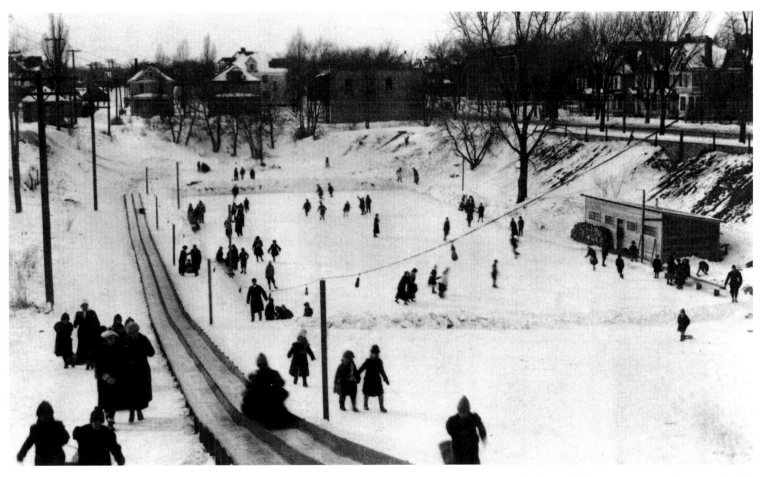

A large group of neighborhood people and their friends enjoy winter sledding and skating at a privately run rink. The Oxford Club, complete with its warming house and lighting for evening fun, was located near Grand and Lexington and was a well-used facility in the 1920s.

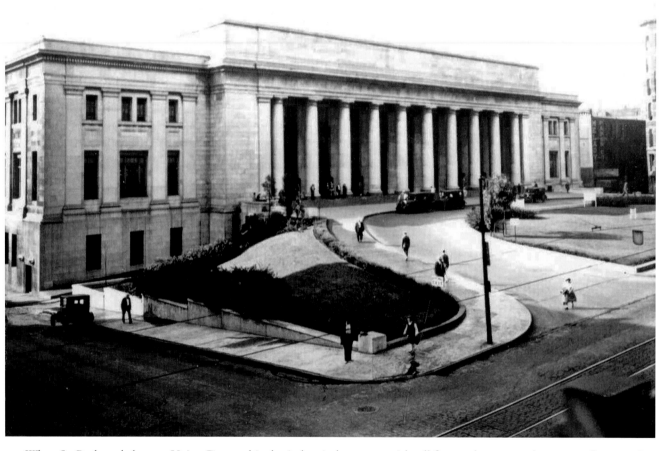

When St. Paul needed a new Union Depot, this classical revival structure with tall front columns was the answer. Construction began in 1917 but was delayed during the war. The depot didn't come into service until 1923 and is shown here two years later on a busy Fourth Street. It was added to the National Register of Historic Places in 1974.

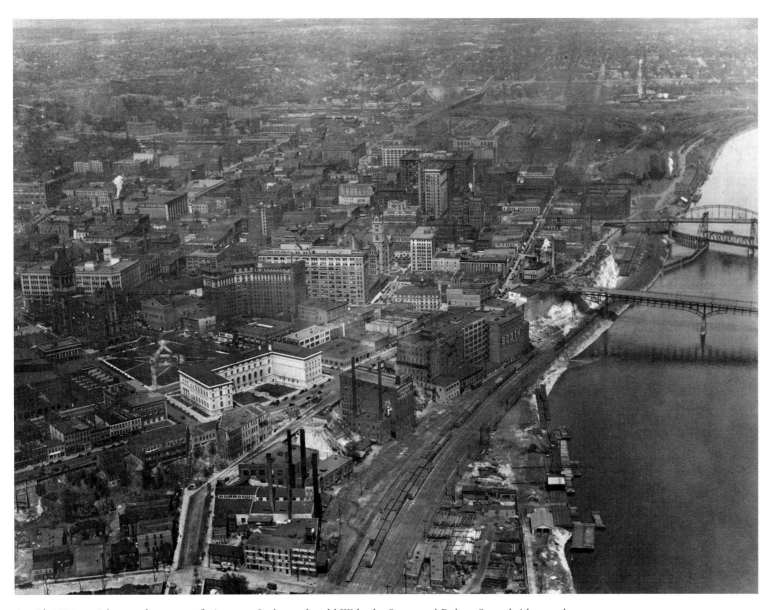

A mid-1920s aerial scans downtown facing east. It shows the old Wabasha Street and Robert Street bridges and was taken before roads ran along the riverfront.

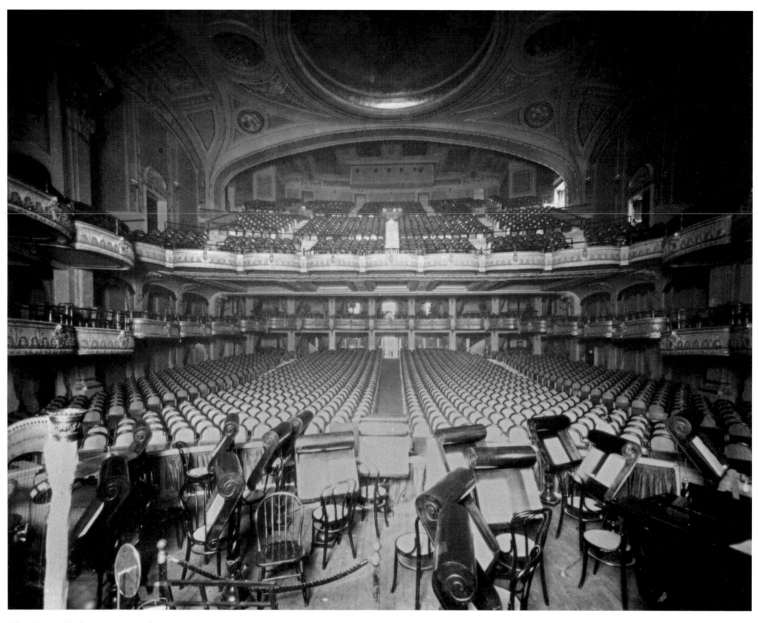

The Capitol Theater, located downtown at 18-26 West Seventh Street, was a relatively short-lived single-screen theater, opening in 1920 and closing around 1929. One of its proud features was a huge Wurlitzer organ, installed in 1926.

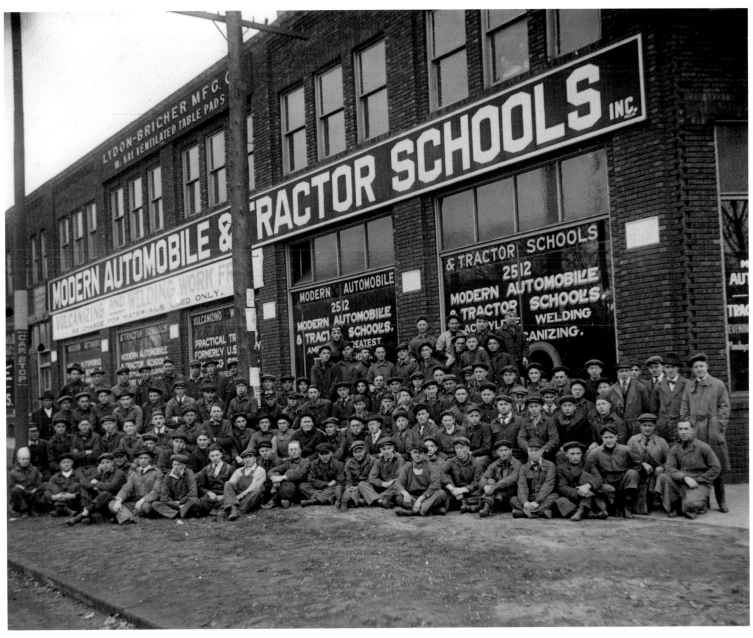

Students pose in the 1920s in front of the Modern Automobile and Tractor School, located at 2500 University Avenue in St. Paul's Midway area. This distribution center was a logical place to train people in the use and repair of motor vehicles, which had become so important to the city's wholesaling and jobbing businesses.

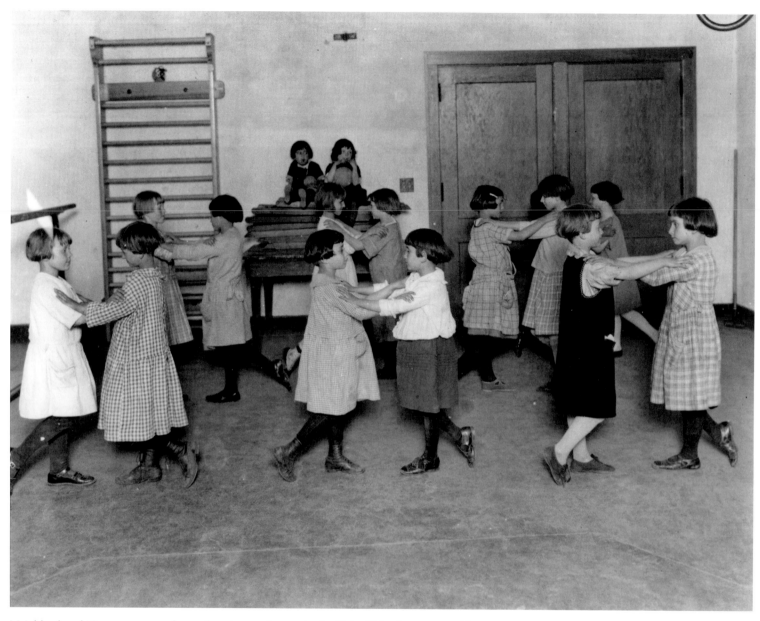

Neighborhood House was one of several settlement houses in the Twin Cities. It was started by a Jewish woman's group to aid needy immigrants on the West Side. In addition to financial help, they offered "Americanization" and English classes, taught life skills, and, at least in the 1920s, held dancing classes for children.

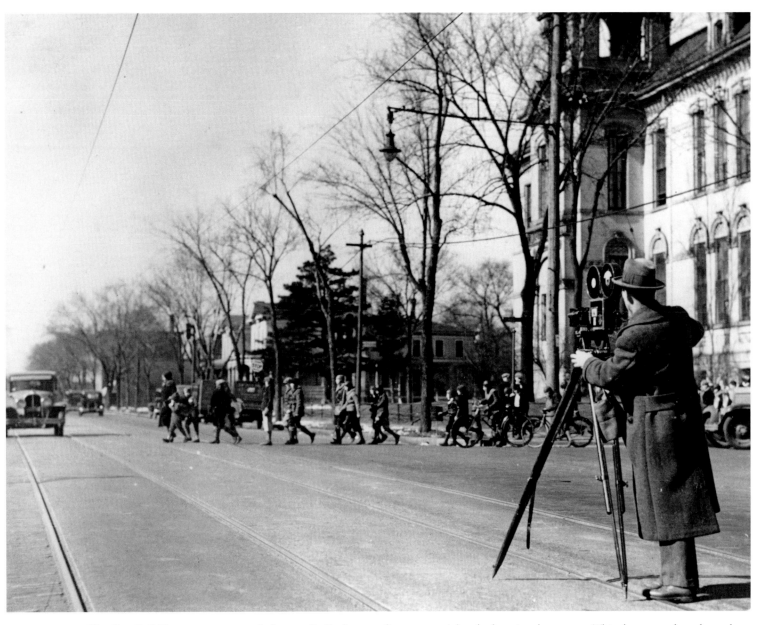

The Ray-Bell film company recorded many St. Paul scenes for commercial and educational purposes. This shoot may have been done to create interest in school patrols. This safety measure was the idea of Cathedral School principal Sister Carmela, whose building was surrounded by busy streets. Her kids were first sent out with their flags on February 1, 1921.

F. Scott Fitzgerald is a jazz era icon in St. Paul. He wrote his first novel, *This Side of Paradise,* published in 1920, on Summit Avenue. His legendary drinking hurt his career, but he completed three other novels and wrote dozens of short stories. Although Fitzgerald died believing himself a failure, critics today see him as one of the most important writers of the twentieth century.

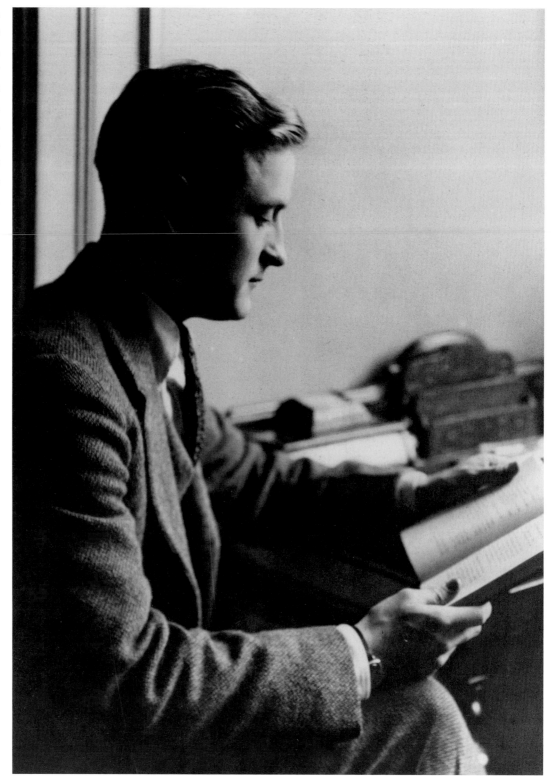

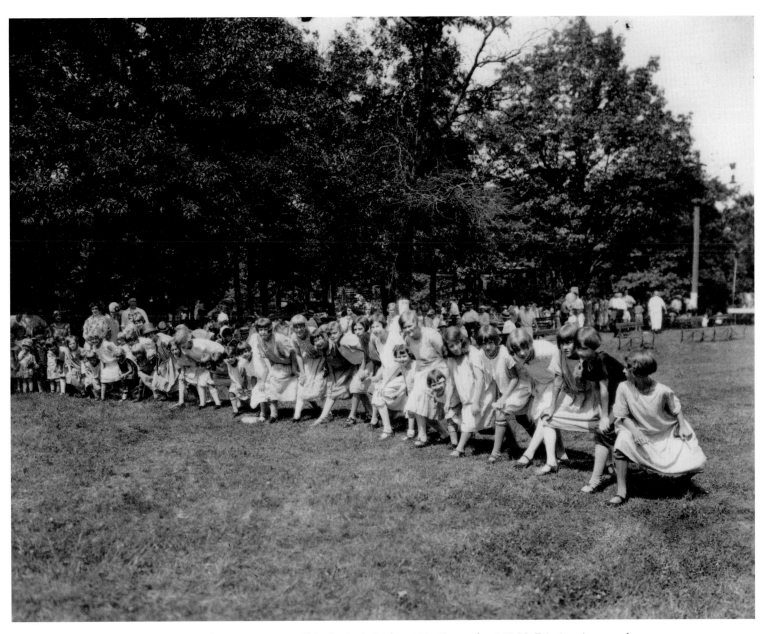

Girls ready themselves to compete in a foot race at a Newell Park picnic in the 1920s. Located at 900 N. Fairview Avenue, the ten-acre site was dedicated in 1908. It was named for Stanford Newell, a member of the first St. Paul Park Board and U.S. Minister to the Netherlands from 1897 to 1906.

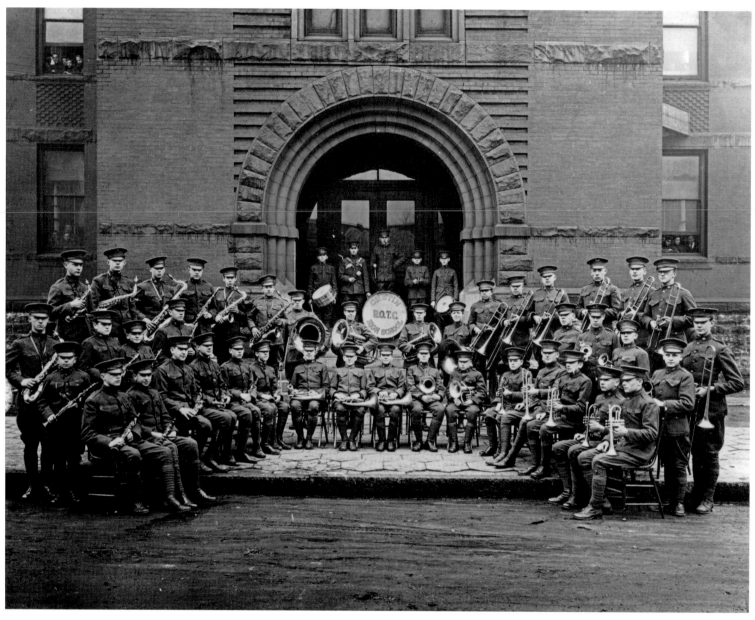

The Cretin High School Reserve Officers' Training Corps Band around 1922. Cretin was founded as a secondary school for boys in 1871 by the Christian Brothers and named for Joseph Cretin, the first Catholic Bishop of St. Paul. In 1987 it merged with a local girl's school and is now a co-educational institution named Cretin-Derham Hall.

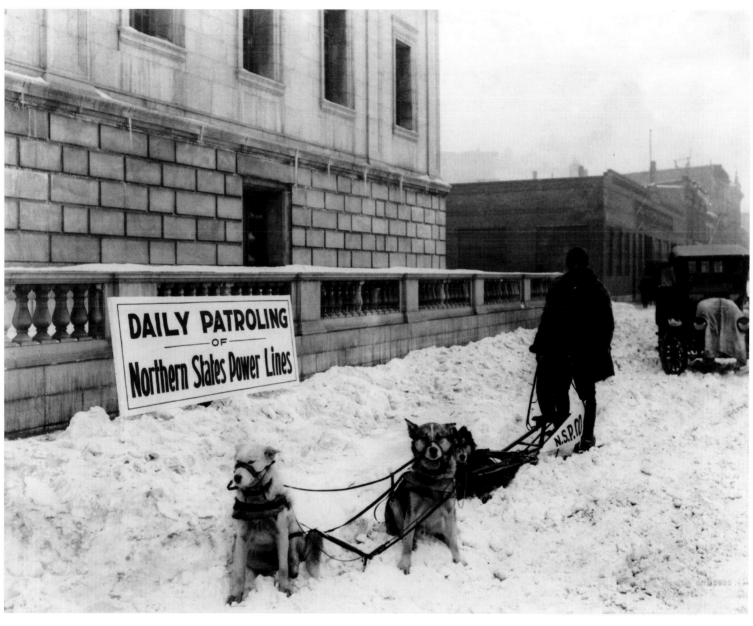

Northern States Power Company used a dogsled to make daily patrols of power lines during heavy winter weather and especially after ice storms. It is shown here in a newspaper publicity shot in downtown St. Paul in the early 1920s.

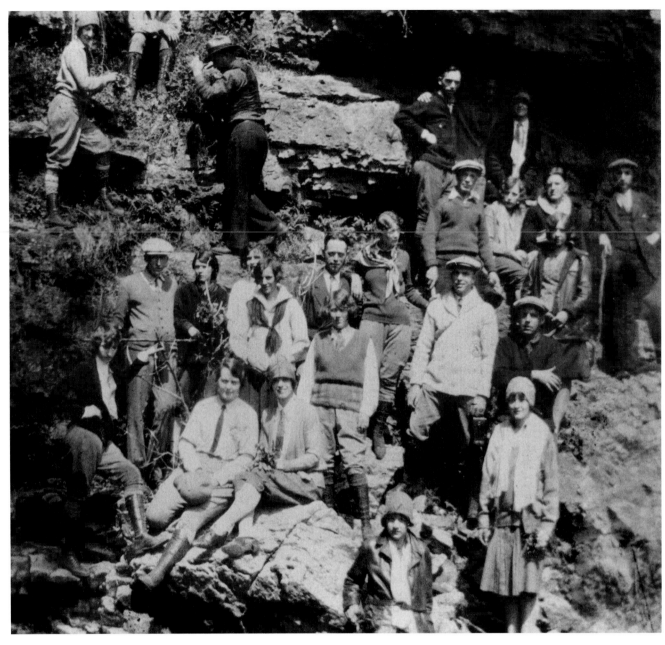

Somewhere on the outskirts of the city, members of the St. Paul Municipal Hiking Club pause in front of limestone bluffs for an early 1920s portrait.

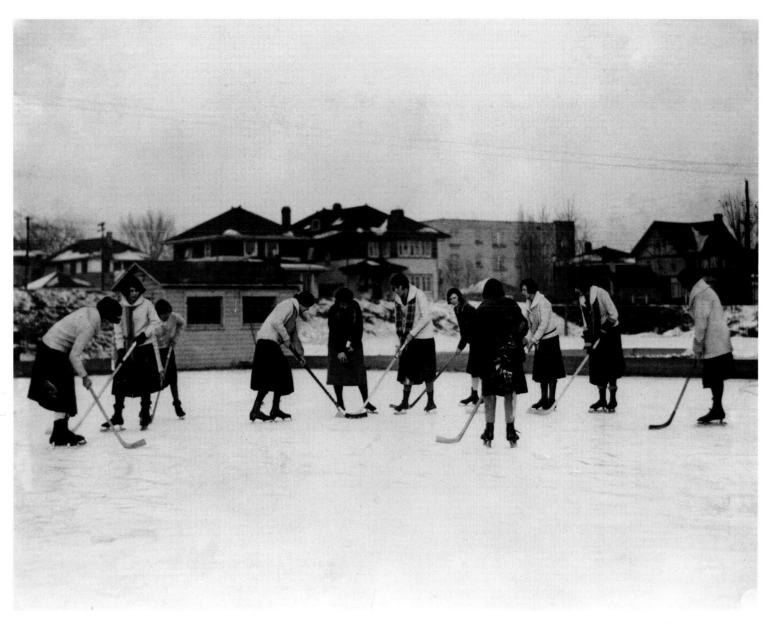

A group of students concentrate on honing their ice hockey skills. They attended St. Paul's Oak Hall, a private finishing school for young ladies that Miss Backus ran on Holly Avenue. The camera has caught their practice work on a Goodrich Avenue rink in 1925.

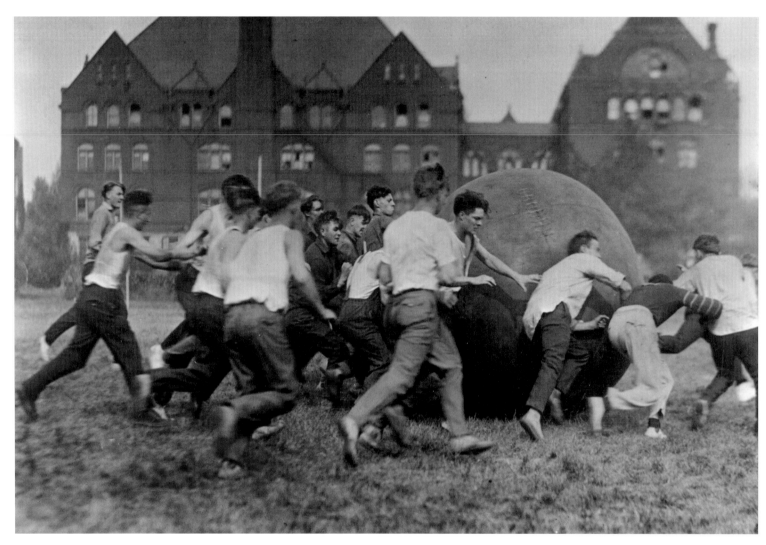

Macalester, a private liberal arts college, was several decades old when this 1923 photograph was taken. Students are engaged in pushball, a game played with a six-foot rubber sphere. Each side tried to shove the sphere across the opponent's goal line. The tradition ended after 20 years, when the ball burst, but was recently revived for an alumni gathering.

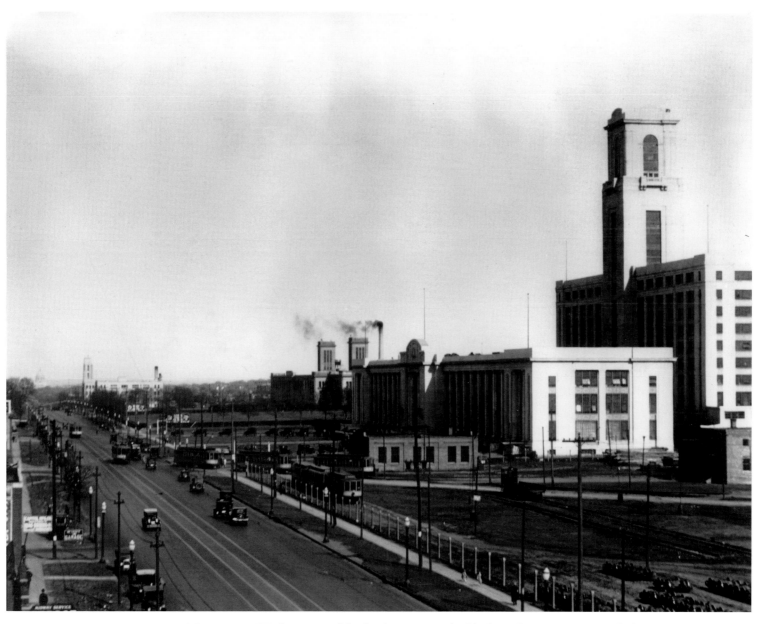

Montgomery Ward was one of the first businesses to build a large shopping store outside downtown. The recently built retail sales and mail order shipping center towers over University Avenue around 1925. Streetcars have been provided with a convenient spur to load and unload passengers.

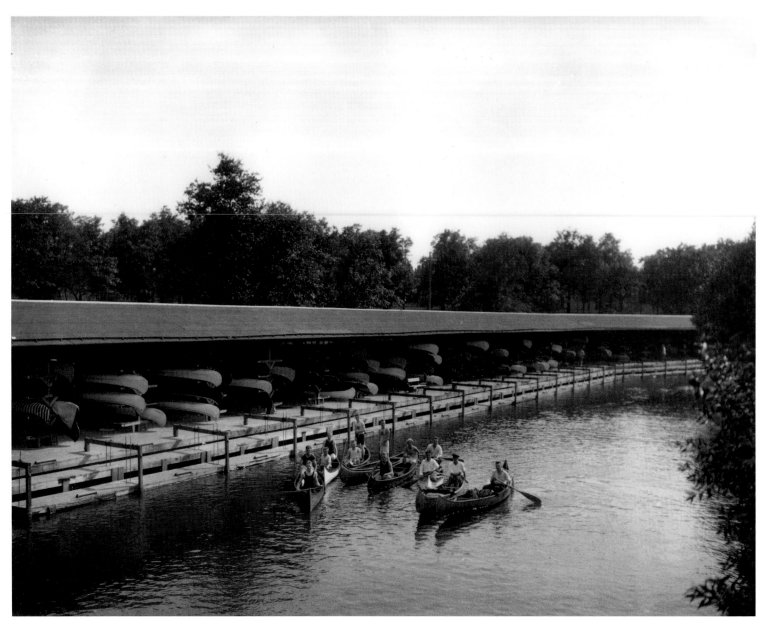

Floating around on lakes was a very popular pastime in St. Paul, evident in this 1925 image of canoe racks in Phalen Park. One could rent a vessel by the hour, and the water was often filled with paddlers. Canoeing was one of the many attractions made available by the city parks department.

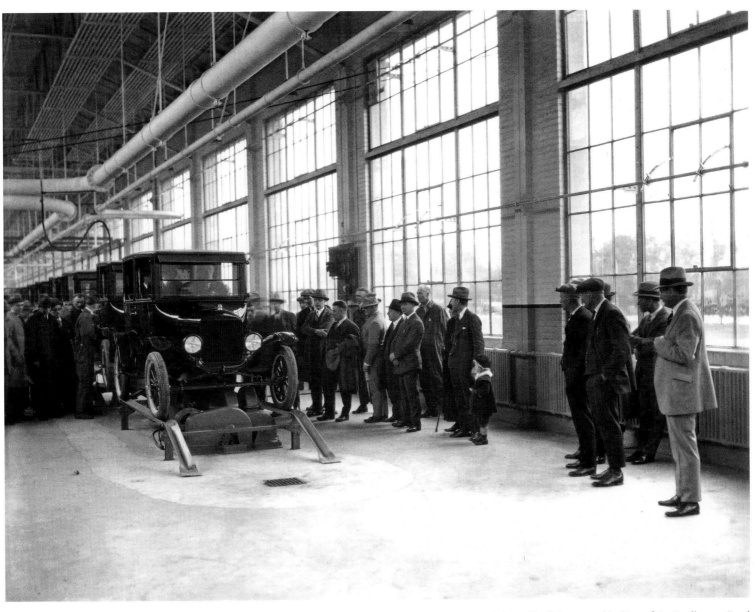

A corporate group looks on with satisfaction as the first automobiles roll off the assembly line of St. Paul's new Ford plant in 1925. The new company provided manufacturing jobs and was a key factor in the early development of the Highland Park neighborhood where it was located.

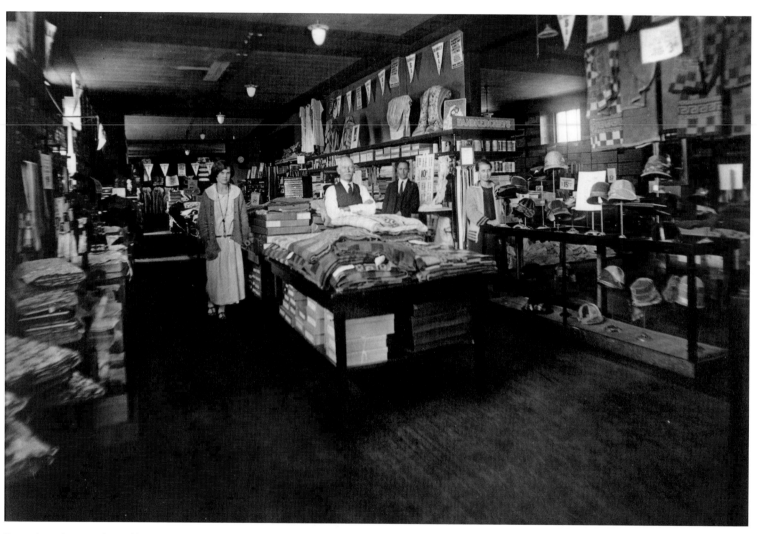

Even though a number of large department stores existed downtown, many people still shopped at smaller area businesses. One such neighborhood fixture in the 1920s was Henly's Department Store, located at 175 Concord, a main street on St. Paul's West Side today known as Cesar Chavez Street.

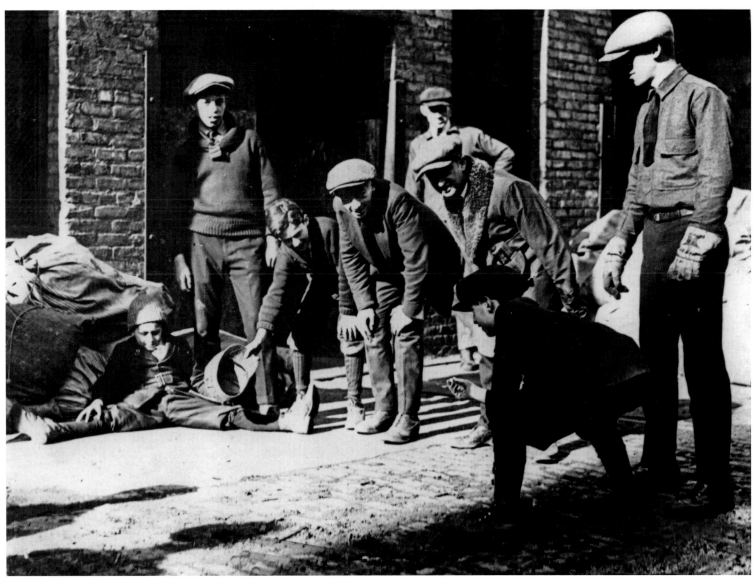

Shooting marbles was a very popular sport in the 1920s, especially among city boys. It looks like there are a few adults observing as well. Photographers loved to document this sort of scene for the local newspapers.

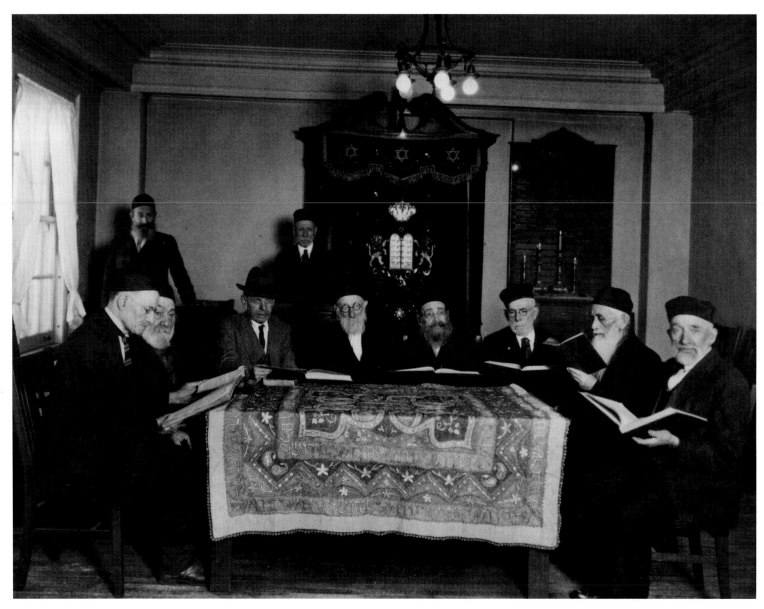

A Hebrew service in the Jewish Home for the Aged in the mid-1920s attracted a cameraman. The institution was opened on Wilkin Street in 1908 by a group of Jewish women and moved to its present location on Midway Parkway near the State Fair Grounds in 1923. It is now known as the Shalom Home.

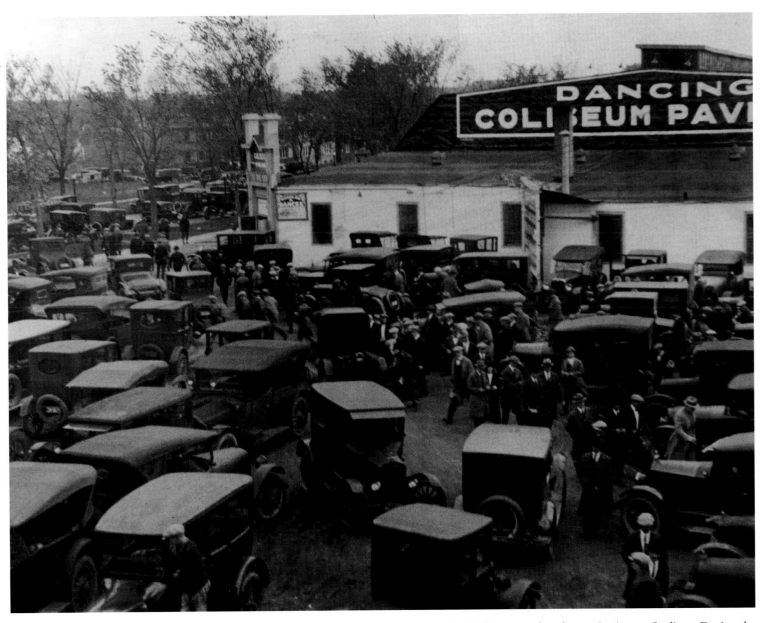

The owners of the cars parked at Coliseum Pavilion are likely headed to a baseball game at the adjacent Lexington Stadium. During the day, home runs sometimes landed on the Coliseum's roof. At night the hot spot, with its rubber-lined dance floor, featured local musicians and visiting stars including Fats Waller, Benny Goodman, and Louis Armstrong.

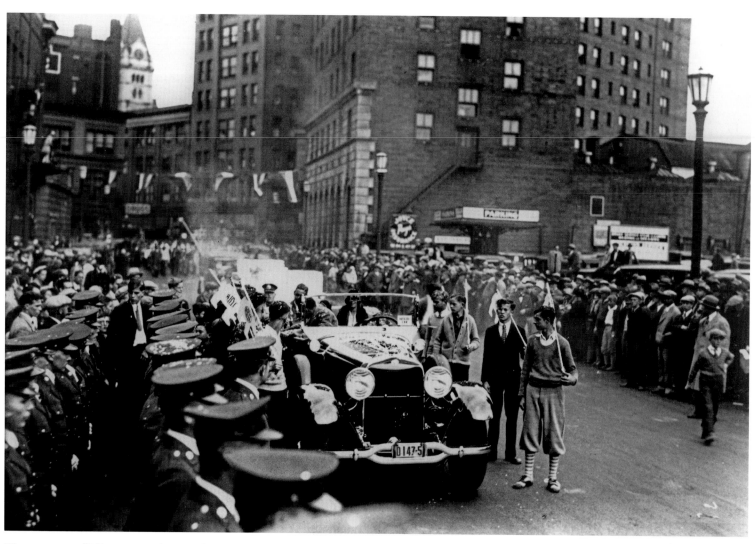

The governor of Minnesota and a crowd estimated at 20,000 greeted Harrison R. "Jimmy" Johnston with a parade upon his return to his St. Paul home. He had just won the 1929 National Amateur Golf Championship.

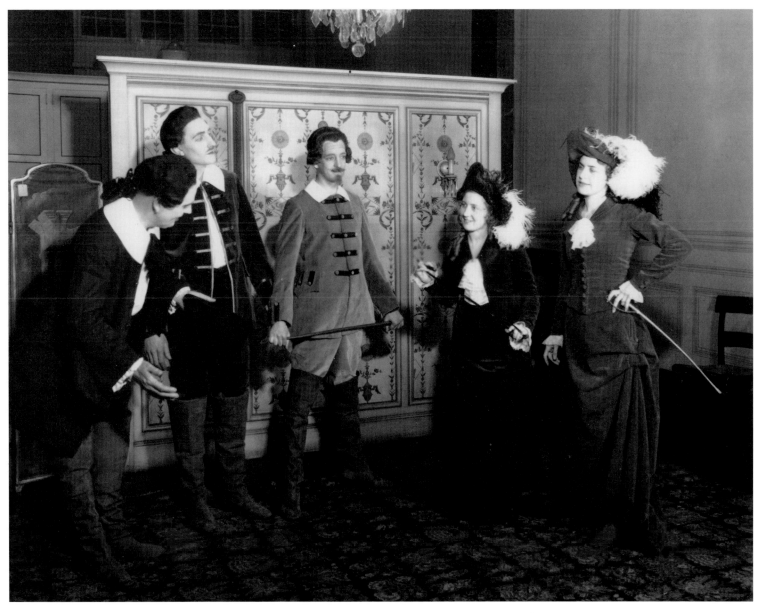

The St. Paul Municipal Opera opened its doors in December 1933. This is a promotional photo for *Martha,* which was presented during their second season. The group initially featured local performers, but later invited "stars." Almost all productions were sung in English, not Italian, French, or German, a somewhat controversial approach. They staged seasons every year until merging into the Minnesota Opera in 1975.

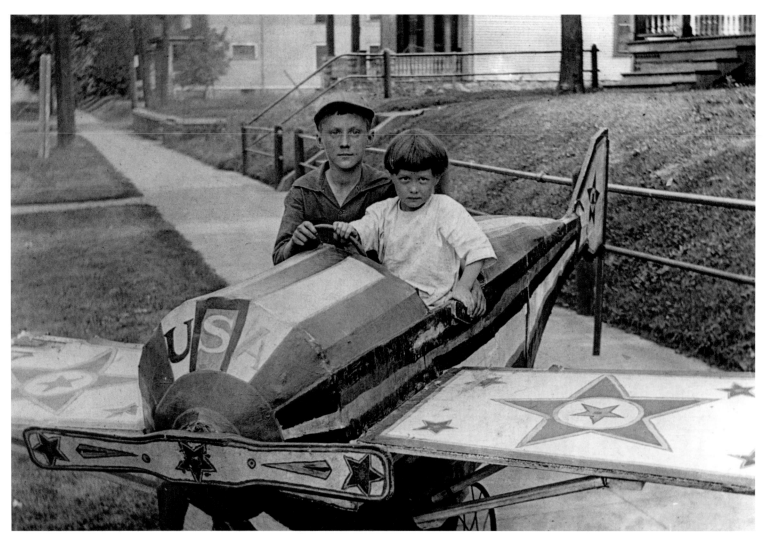

Two St. Paul children pilot a miniature airplane on the 900 block of East Minnehaha Street in the late 1920s. An itinerant traveling photographer, abandoning the older goat-and-cart prop for this one, catered to the new fascination with flight in capturing this image.

In the 1920s, St. Paul's rising population and good economy led to another housing boom. Increasing automobile use made areas not served by the streetcar more attractive to small developers. The houses on the north side of the 1100 block of Englewood were all built by Theodore Mertens between 1928 and 1929.

The City and County Courthouse under construction at Kellogg and Wabasha in 1931. Shortly after St. Paul floated bonds for the building's construction, the stock market crashed. Prices and wages dropped, leaving the city extra money, which it used to create a splendid art deco structure featuring costly stone and 20 different rare woods.

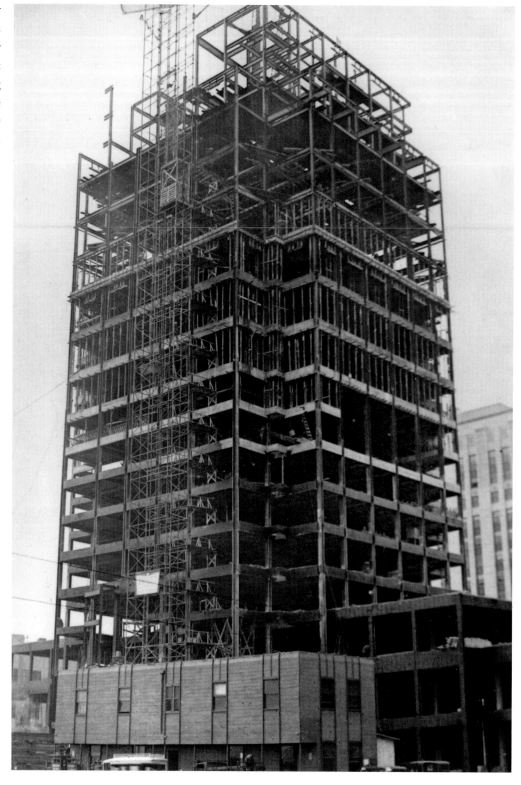

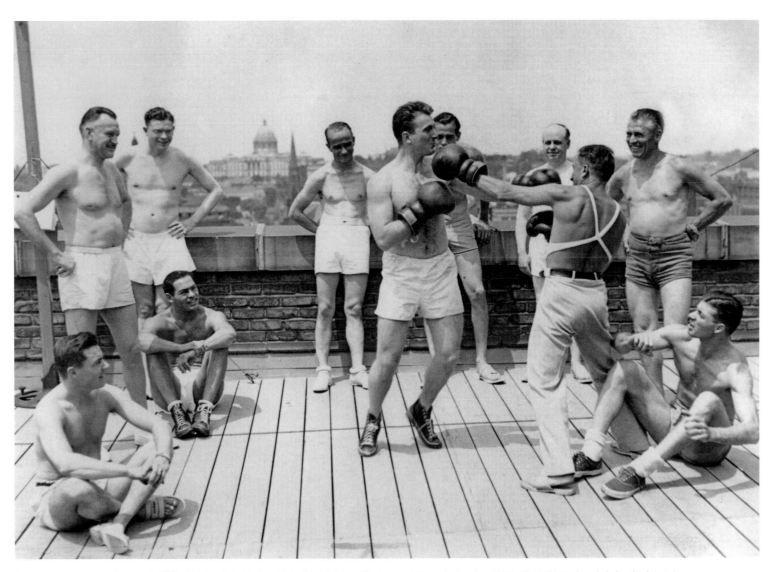

Boxing practice on the roof of the St. Paul Athletic Club, high above Cedar and Fourth, in the 1930s. In 1917, the club built this 14-story brick home that included dining and meeting areas, exercise facilities, a swimming pool, and rooms for short-term or long-term residents. Its doors closed in 1991, but the building reopened in 1998 as a health and fitness club.

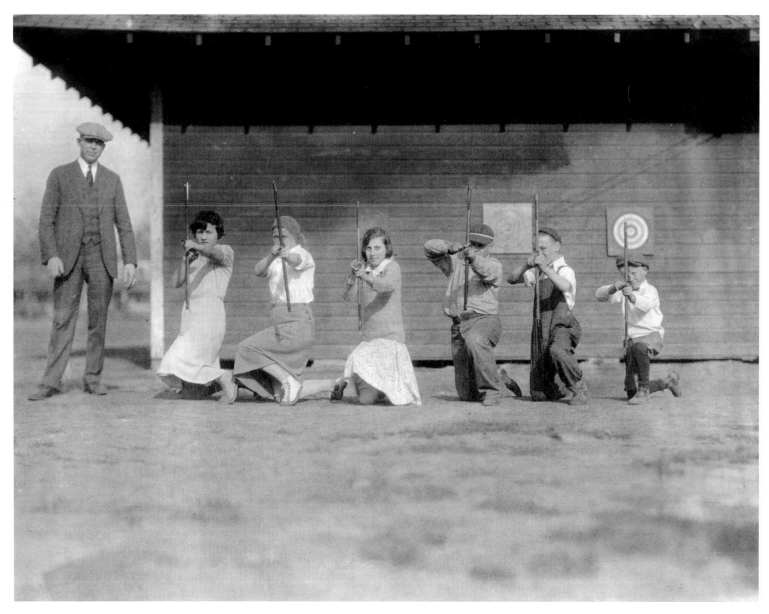

Before the playgrounds began to focus on the sports of football and baseball, they tried to interest youngsters in a variety of individual activities such as archery. These Palace Playground children are practicing, it appears with arrows tipped by suction cups, for a citywide contest that was taking place sometime in 1931.

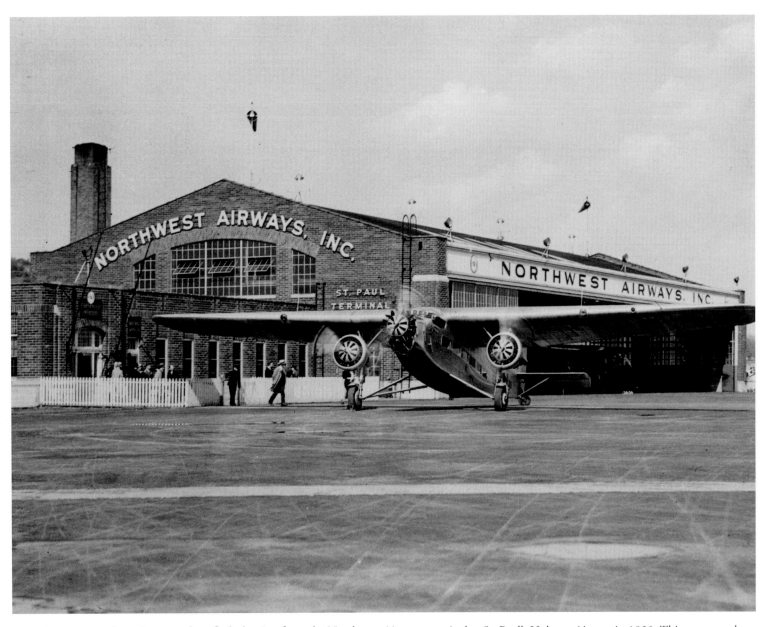

A customer is hurrying to make a flight leaving from the Northwest Airways terminal at St. Paul's Holman Airport in 1930. This company later merged with several others and became Northwest Airlines. Although mail delivery dated back a few years earlier, the first passenger service was offered in 1926, between the Twin Cities and Rochester, Minnesota.

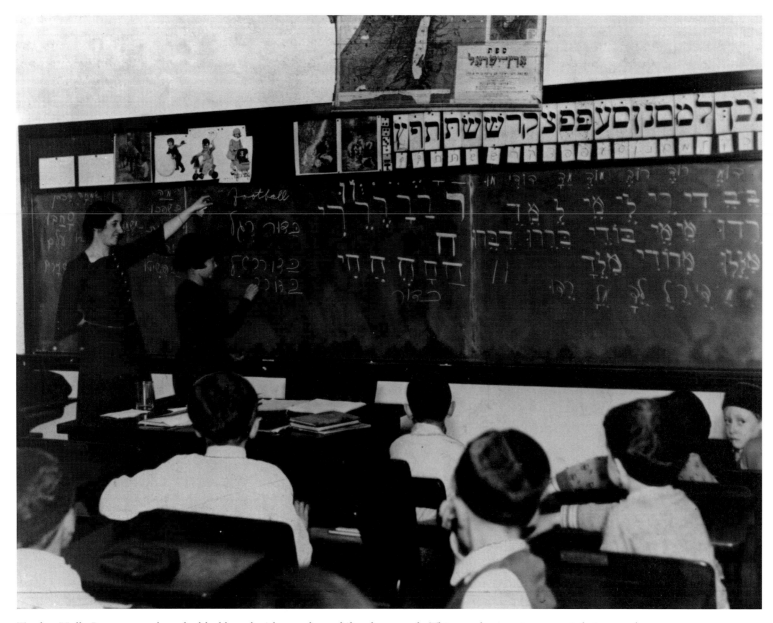

Teacher Holly Berman stands at the blackboard with a student while others watch. This mostly attentive group is being taught Hebrew one late afternoon in 1931. The class met at four o'clock every weekday at the Jewish Education Center in St. Paul, located at 743 Holly Avenue.

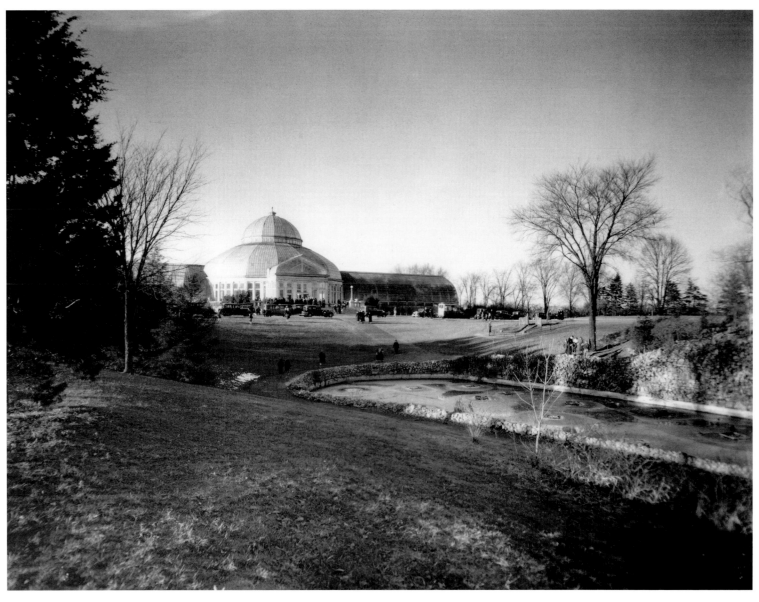

The Como Conservatory as it appeared around 1930. In the foreground is a pond with giant lily pads, at the time a popular spot for taking photographs. The unique glass-enclosed building, designed to house exotic plants and host flower shows year round, opened in 1915. The recently renovated conservatory is now on the National Register of Historic Places.

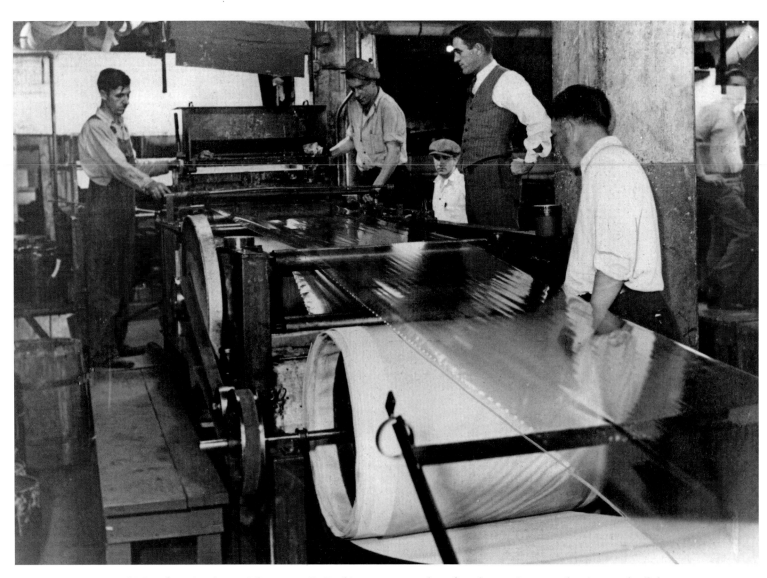

Minnesota Mining and Manufacturing (now 3M) came to St. Paul in 1910 as a maker of sandpaper. In 1931, they invented cellulose tape. "Scotch Tape," as it was called, soon became their most important product and helped make the company a large local employer and eventually a leading international corporation. This image shows the tape being manufactured.

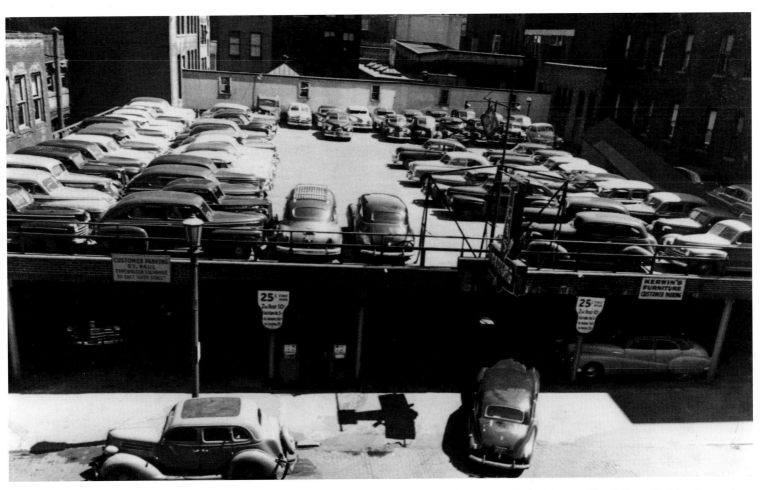

The increased use of automobiles reshaped downtown as the city searched for ways to deal with cars. The DeLoop Parking Ramp dates to 1931, when a businessman built this platform on top of his gas station. It was one of the first, but certainly not the last attempt to deal with the need for parking spaces in St. Paul.

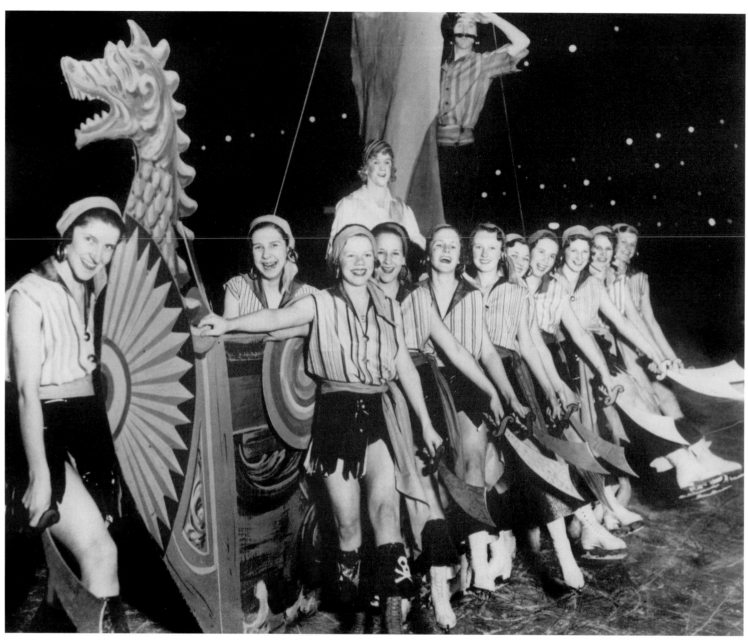

Eddie Shipstad and Oscar Johnson taught themselves to skate on Como Lake in the 1920s and their daring stunts began to draw large crowds. Their partnership evolved into the nationally known Ice Follies, which was based in the city until 1939, when they moved their organization to California. This is one of their highly costumed and well-choreographed skating acts at the St. Paul Auditorium in 1934.

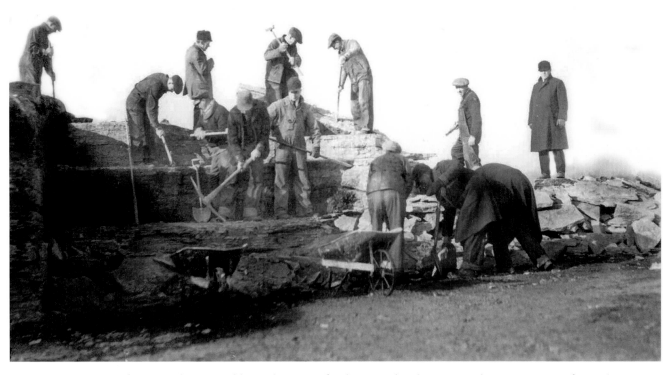

A group of men are shaping and laying limestone for the St. Paul park system in the 1930s as part of a Works Progress Administration project. Designed to provide needed employment during the Depression, the WPA hired men and women to work at a variety of jobs, including construction, landscaping, art, writing, and teaching.

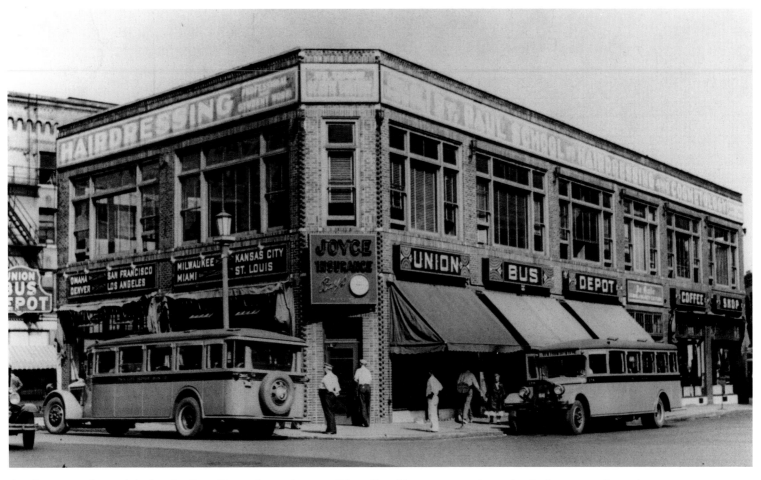

People were on the road during the Great Depression and many of them found bus transportation to be the least expensive and most readily available means of getting around. The year 1934 was a busy time for the downtown Union Bus Depot. With its accompanying coffee shop, it was located at 397-401 St. Peter in downtown St. Paul.

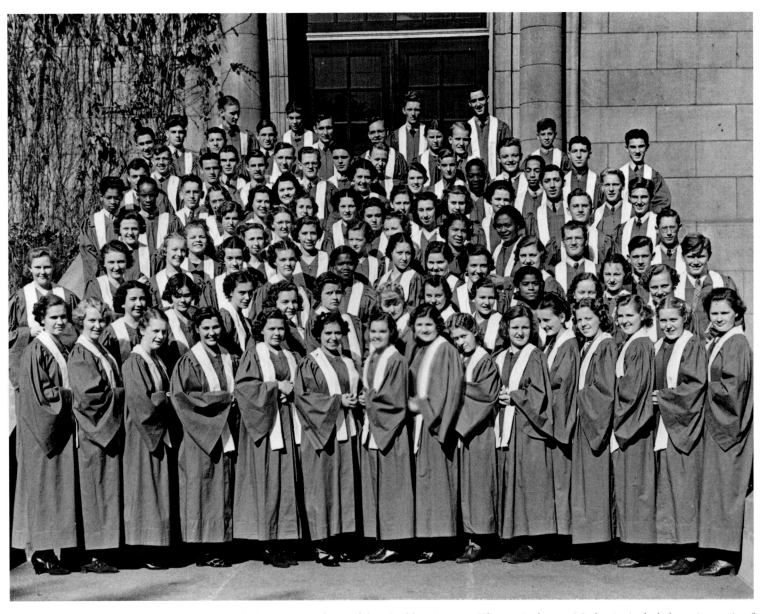

The Mechanic Arts High School choir poses in front of their building in 1937. The curriculum at Mechanics included a unique mix of pre-college academics and vocational skills. Graduates include mystery writer Mabel Seeley, civil rights activist Roy Wilkins, famed race-car driver Tommy Milton, and U.S. Supreme Court Justice Harry Blackmun.

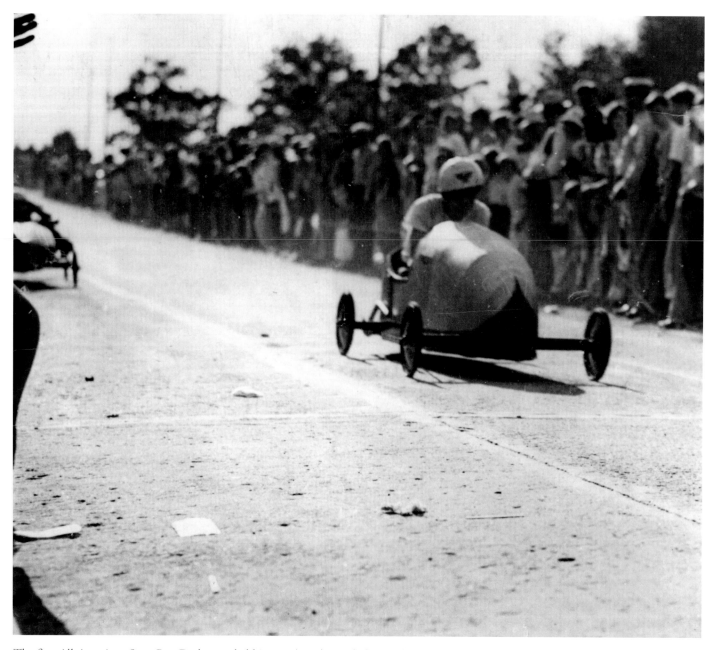

The first All-American Soap Box Derby was held in 1934, and soon kids were barreling down hilly streets in St. Paul. Seventh-grader Herbert Joe Garelick is caught in action, taking first place in the July 1938 race. He won a medal, a wristwatch, a new suit, and an all-expense-paid trip to the national competition in Akron, Ohio.

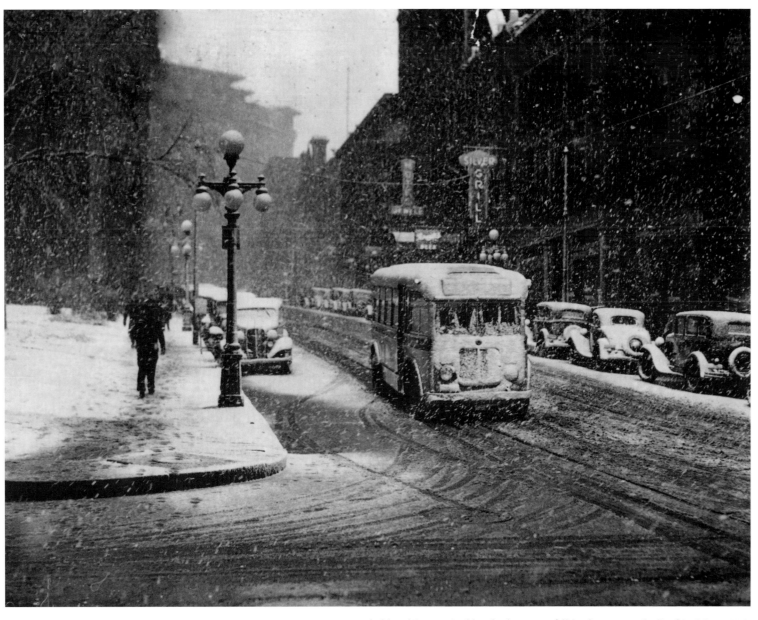

Even Minnesotans were probably a bit surprised by the late snowfall in downtown St. Paul in May 1935.

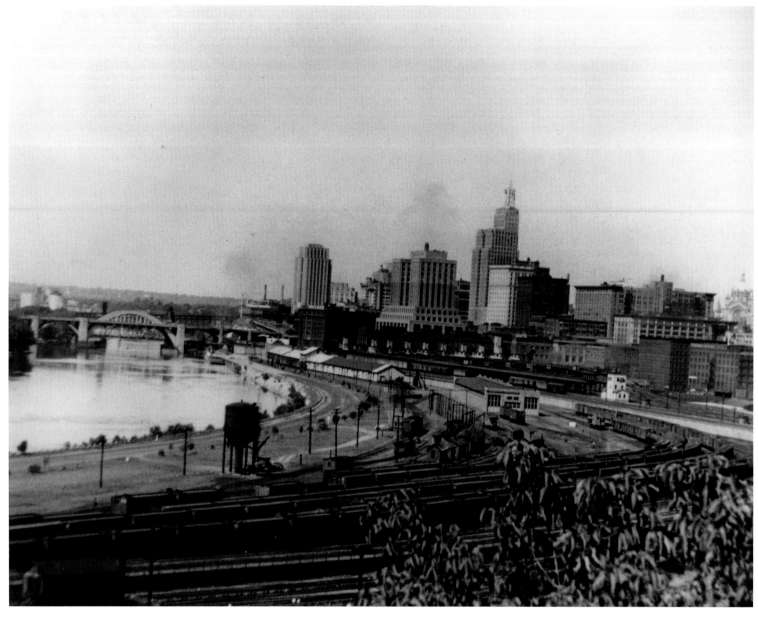

This view of downtown and the busy railroad yards was recorded from Indian Mounds Park around 1935. The City and County Courthouse stands completed in the center background, and the First National Bank looms over the rest of the skyline.

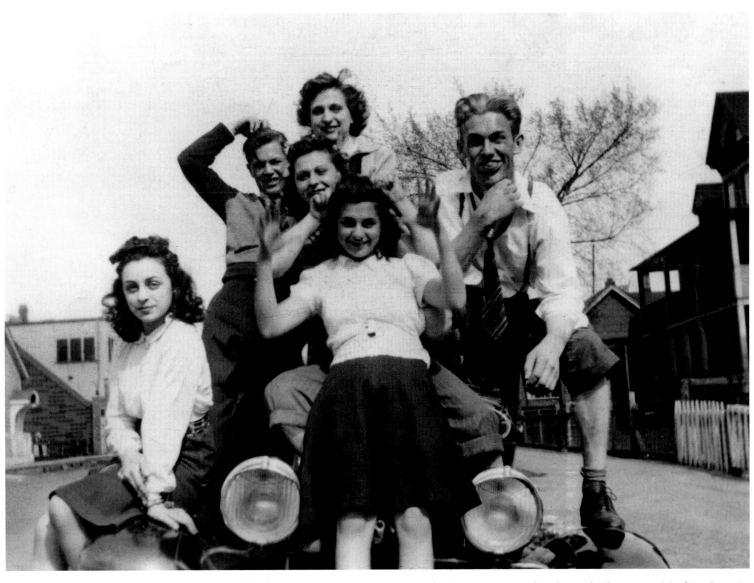

A group of enthusiastic teenagers in 1937 pans for the camera atop their hot rod. They are on Hopkins Street in Railroad Island, one of the old Italian neighborhoods of the city.

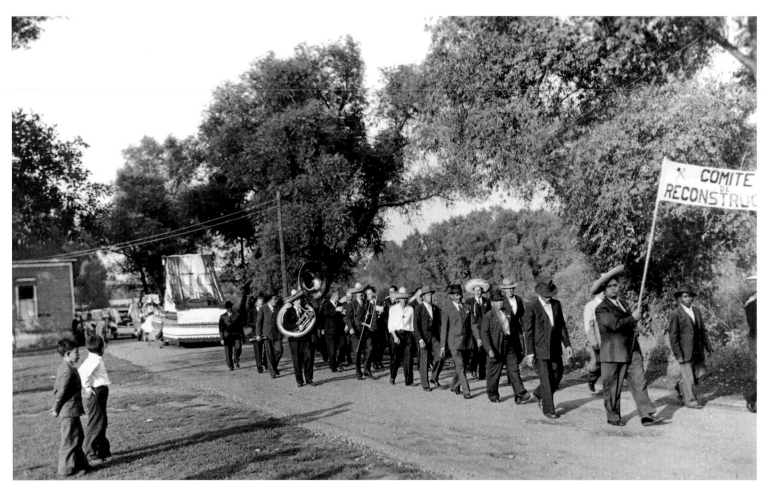

This commemoration of Mexican Independence Day was photographed on St. Paul's West Side in September 1938. The group with the banner is the Comite de Recontruccision, a local men's service organization. At the time they were raising money to build a home in the community for Our Lady of Guadalupe Catholic Church.

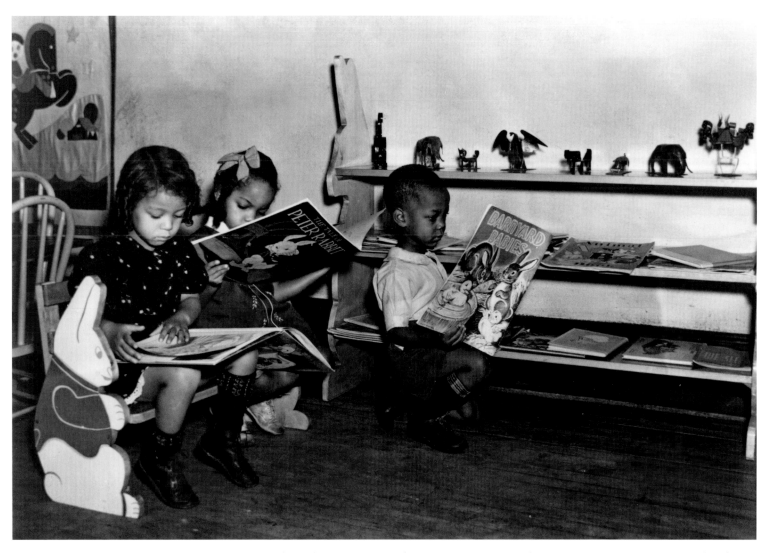

Children are engrossed in reading at the Hallie Q. Brown Settlement House in 1938. This important institution in St. Paul's African-American community, incorporated in 1929, was named in honor of a national black educator. In the 1930s, with help from the Works Progress Administration, this nursery was added to the organization's variety of social programs.

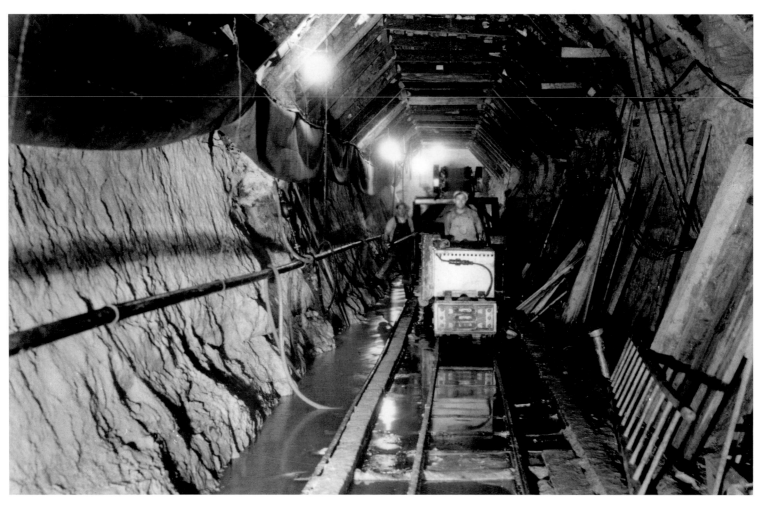

Disposing of sewage has always been a problem for cities and intensified in St. Paul as the urban area expanded. Finally it was decided to have a metropolitan-wide facility along the Mississippi and stop sending raw sewage directly into the river. This 1937 photograph captures the construction of one of the large underground tunnels needed for the Pig's Eye treatment plant.

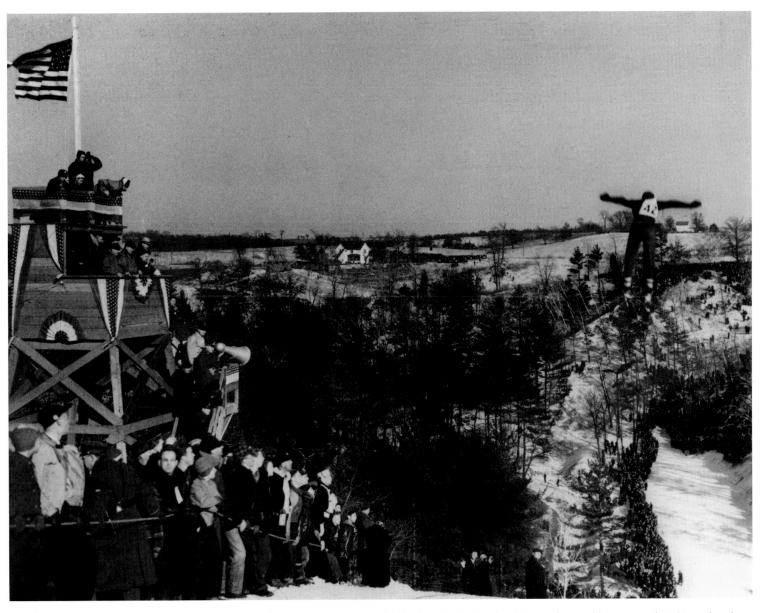

Bundled-up supporters are attentive as a skier soars over trees and hills. The Battle Creek ski jump, featured here around 1940, replaced an earlier jump in Indian Mounds Park. Battle Creek Park, located in the southeast corner of St. Paul, is an 846-acre regional facility with a recreation center, ball fields, walking trails, and many other amenities.

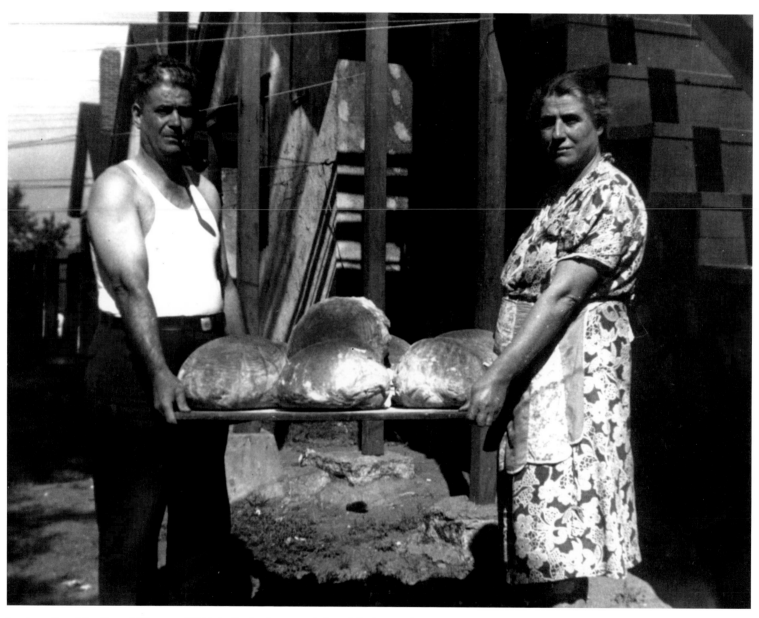

Luciano Cocchiarella and Filomena D'Aloia display homemade bread fresh out of an earthen oven. Some of the Italian families in this Railroad Island neighborhood still did their own baking in 1940. Many had large gardens filled with tomatoes and other vegetables for traditional recipes and often grew grapes for wine making.

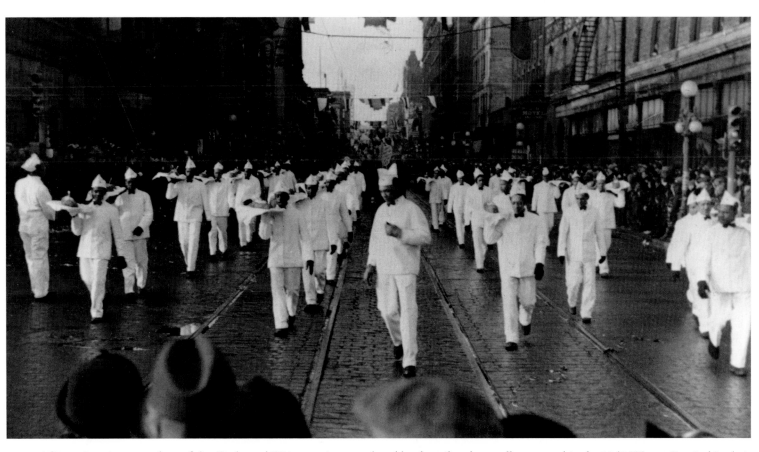

African-American members of the Cooks and Waiters unions employed by the railroad, proudly appeared in the 1941 Winter Carnival in their work uniforms. Some of the marchers showed their dexterity by carrying food trays down the length of the parade route.

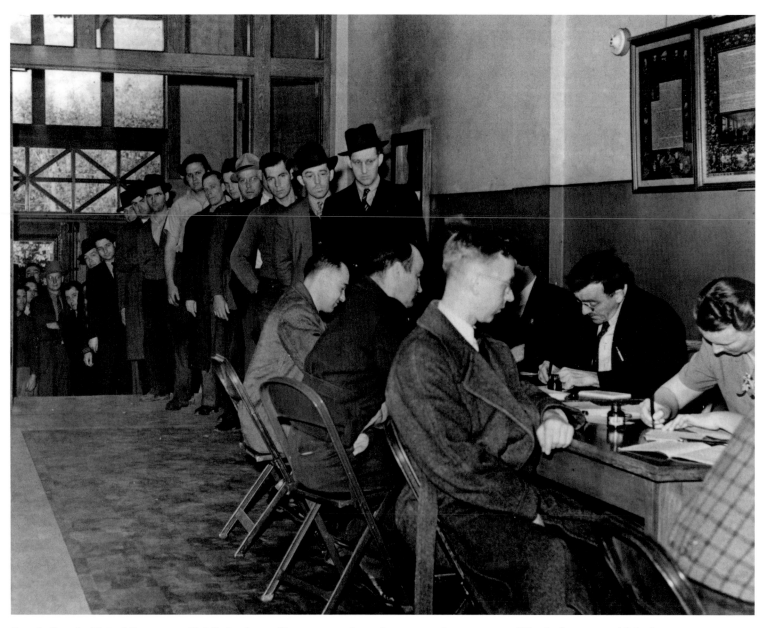

Even before the United States was officially in the conflict overseas, the nation was starting to prepare. The draft was reestablished in late 1940 and people were joining the armed services. This group, according to notes with the photograph, is lined up to enlist at Humboldt High School on St. Paul's West Side.

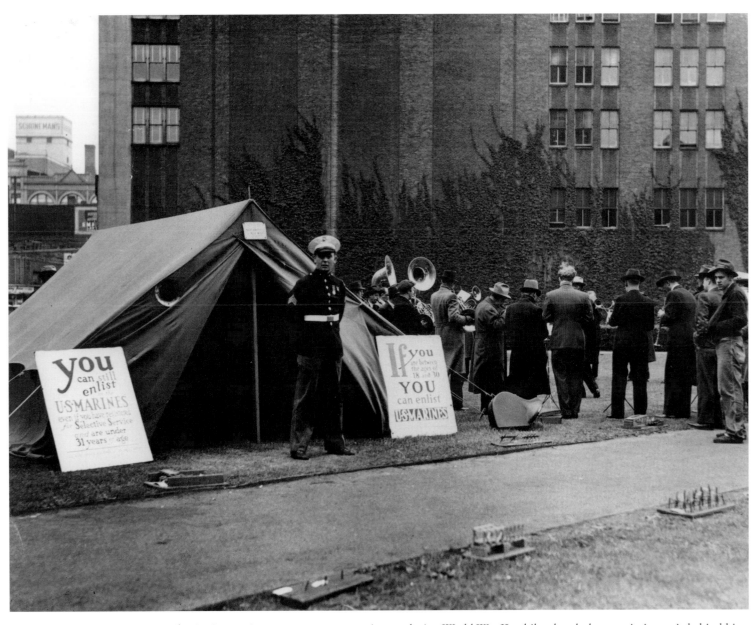

An enthusiastic recruiter encourages men to sign up during World War II, while a band plays patriotic music behind him. Signs remind people that they could join the U.S. Marines even if they had already registered for the selective service. The setting is Fourth and Wabasha—the time, 1943.

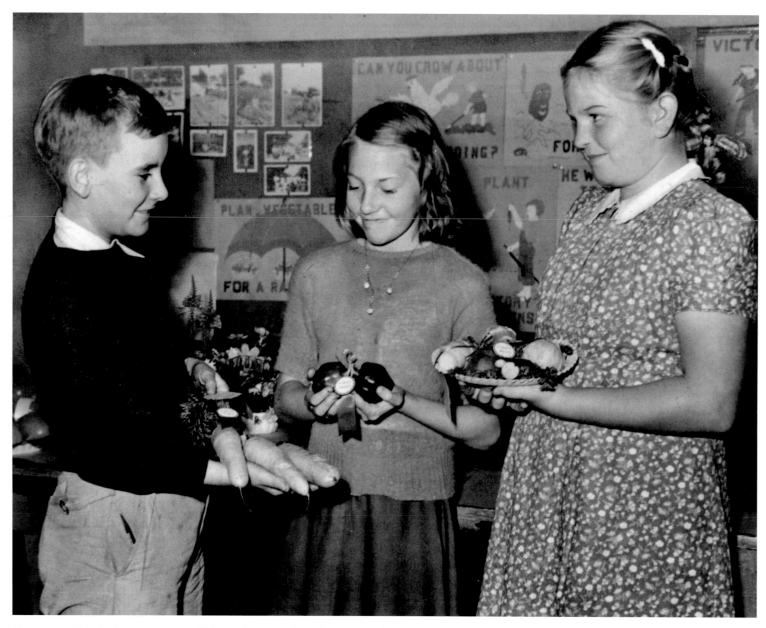

Shortages and rationing were a way of life on the home front during World War II. Because so much farm production went into the war effort, people were encouraged to raise their own food in backyards or at other sites. This trio shows off vegetables they have grown in the "Victory Garden" at St. Paul's Tilden School.

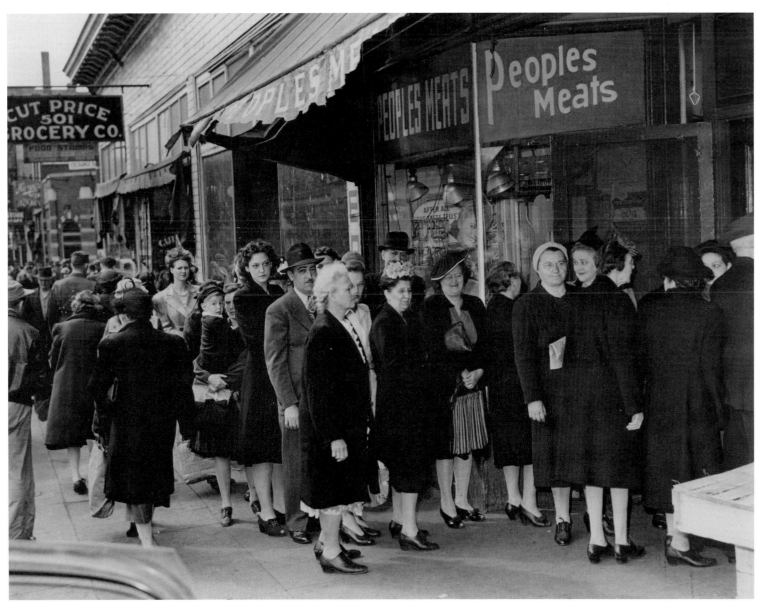

The 1945 headline above this newspaper photo read "Meat Shop 'Siege' in St. Paul." Because of wartime rationing, Peoples Meats on Wabasha would let only a few people at a time inside as a way to "avoid near riots." The wait could be up to an hour, and many, as one shopper put it, were willing to settle for "anything that's left."

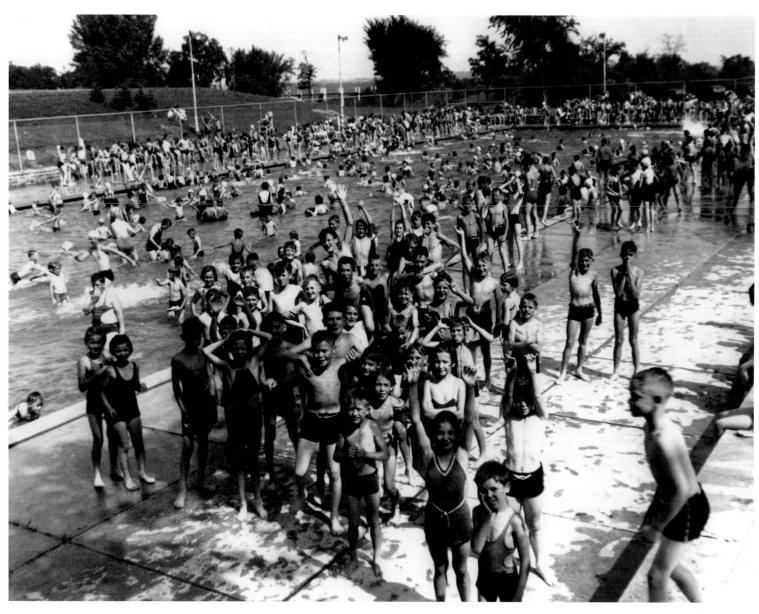

Wartime or not, kids like to splash around in the water. These children seem to be thoroughly enjoying themselves at St. Paul's Highland Park swimming pool in 1945. Some are well aware that their photo is being taken and are hamming it up for the camera.

THE MODERN METROPOLIS

(1946–1970s)

The postwar years brought more changes to St. Paul. Thousands of men and women returned from the armed forces and faced a housing shortage. Soon there was a construction boom in the remaining undeveloped areas. Even so, the city's population was decreasing for the first time and aging as well.

The suburbs were becoming a more popular destination for housing and shopping. Freeways accentuated the trend, making it easy to live in the suburbs and commute into the city. While they made it more convenient to get around the city, the easier travel also began cutting into local shopping. "Mom-and-pop" businesses were challenged by chain stores.

People loved their cars and the convenience of drive-ins of all sorts—restaurants, banks, theaters—which sprang up on main thoroughfares. Rock-n-roll joined jazz, polka, and classical music on the radio, and television came to the Twin Cities.

St. Paul lost several large manufacturing companies and struggled to redevelop. Starting in the 1950s, the city undertook renewal projects, a process that sometimes had unfortunate results. The magnificent Ryan Hotel fell to the wrecking ball in 1962 and today's Landmark Center barely escaped being torn down for parking.

The aging center city became less retail-oriented and shifted toward office buildings and attractions like museums and performance venues that would draw people downtown. An innovative skyway system was created, allowing shoppers and workers to avoid venturing outdoors during inclement weather, taking pedestrians off the sidewalks.

St. Paul was divided into 17 community councils in the 1960s, designed to address neighborhood matters. Along with city officials, they struggled with issues such as zoning, code enforcement, crime, and development that included public housing for low-income and senior populations.

Starting in the 1970s, some suburbanites came to the city to restore older homes and several historic districts were established, often raising concerns about gentrification. But the largest growing populations were Latinos, African Americans, and immigrants from Asia and Somalia.

Although the modern era had brought many changes, St. Paul believed it had drawn on its proud history and was looking forward to a bright future.

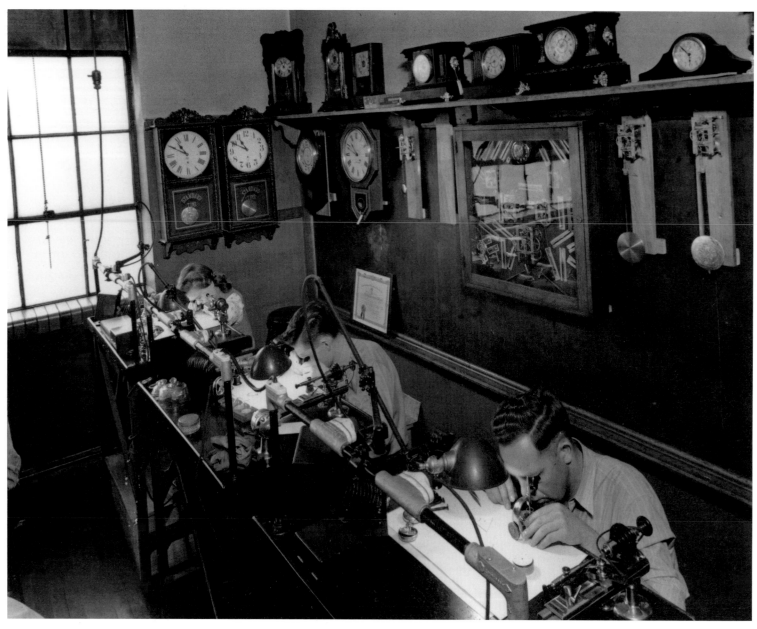

After the Second World War, returning service men and women were confronted by a housing shortage. On the bright side, Congress passed a G.I. College Bill that allowed free access to higher education. This clock and watch making class at St. Paul vocational school may well have had some veterans enrolled in it in the late 1940s.

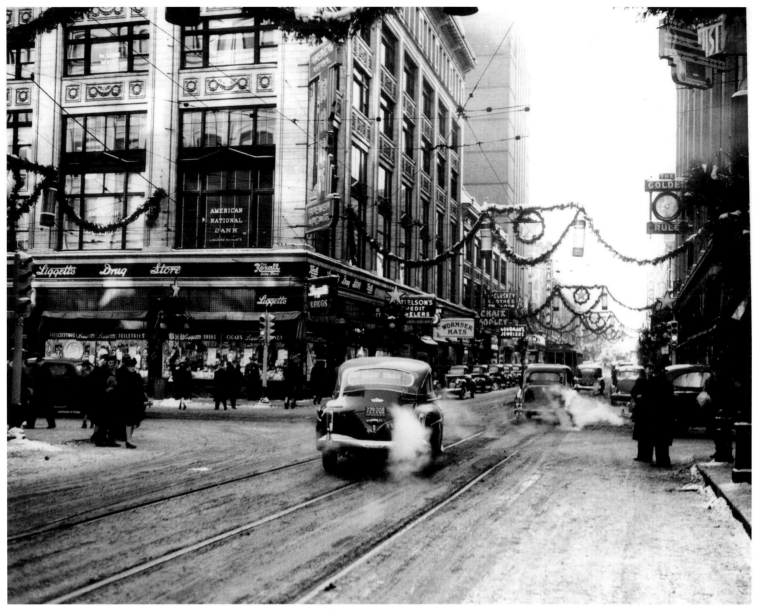

A 1946 street scene, facing east on Seventh Street, is filled with people, automobiles, and a streetcar rolling west toward Wabasha. There are druggists, jewelers, clothing shops, a hat store, the Golden Rule department store, a place to do banking, and lots of signage.

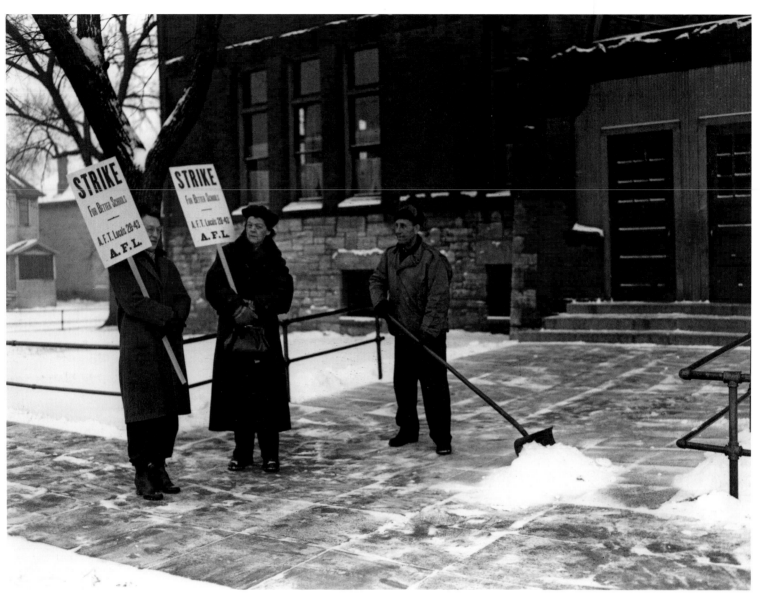

These picketers were part of the first organized teacher's strike in the country. It started in October 1946 and was settled six weeks later. The successful action brought increased funding, free textbooks for students, and other improvements for the St. Paul schools. Voters soon agreed to establish an independent school district for the city.

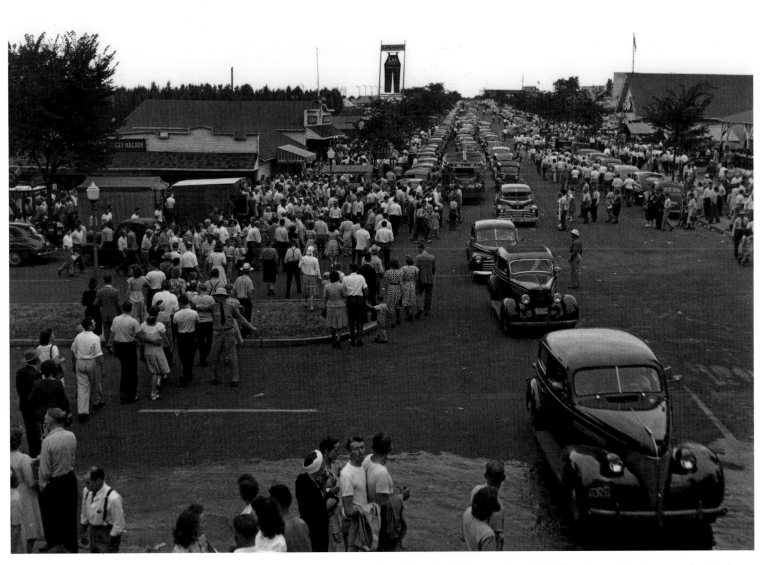

Cars carefully avoid the pedestrian crowds at the 1947 Minnesota State Fair. The thousands who come for the shows and displays, rides, and the food have been welcomed by St. Paul since 1895, when the event settled permanently on a 200-acre plot of land on the northern edge of the city.

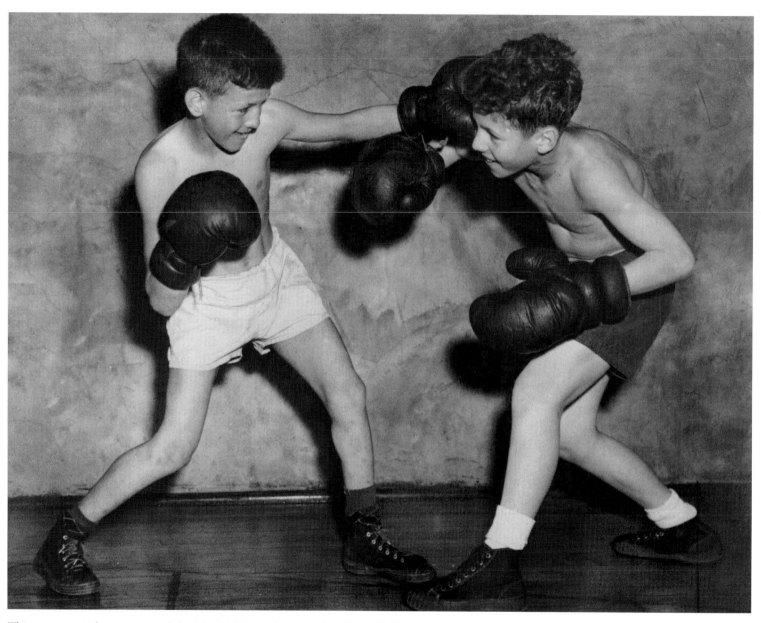

This newspaper photo promoted the May 1947 open house at the Christ Child Center on St. Paul's East Side. In addition to sparring demonstrations, the event would feature music, a style show, and the presentation of a new "talkie movie projector." The two 12-year-old boxers are Joseph Ferrozzo, on the left, and John Pilla.

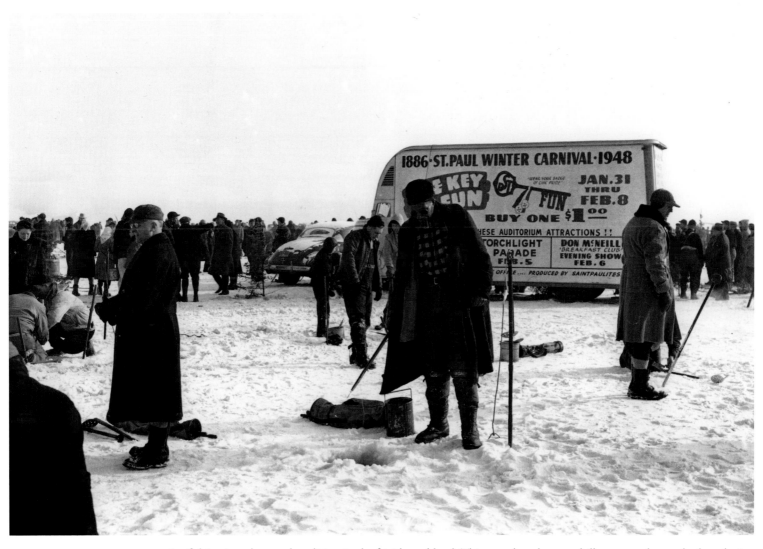

Ice fishing is an honored tradition in the frigid northland. This snapshot shows a chilly contest that took place during the St. Paul Winter Carnival in February 1948.

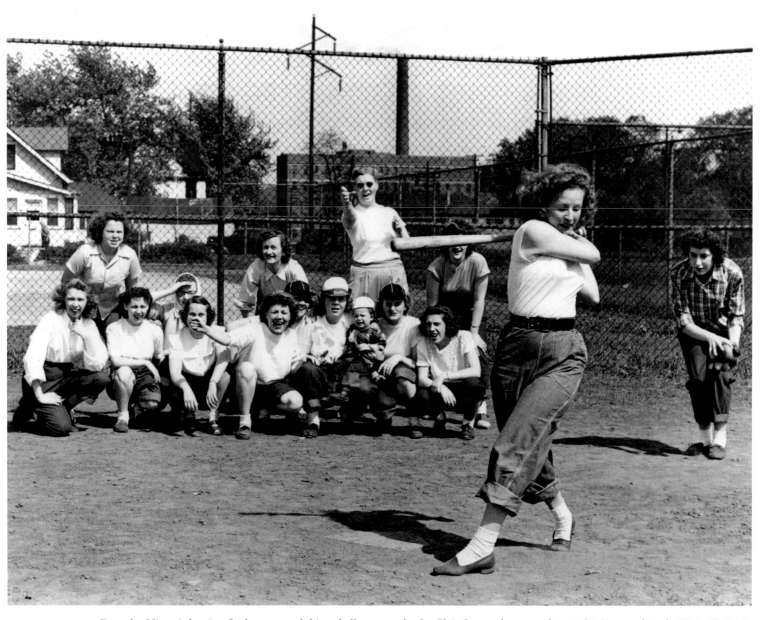

Dorothy Hines is batting for her women's kittenball team at the St. Clair Street playground in 1948. Invented in the Twin Cities in the 1890s, it became a very popular sport among both men and women. It spread from fire department teams to area playgrounds and eventually other cities, evolving into today's softball.

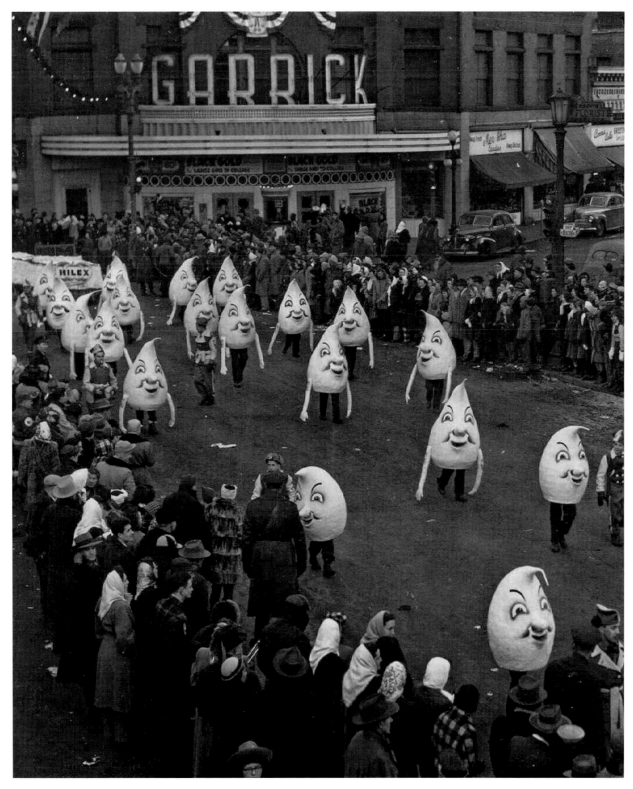

The Hilex Company of St. Paul marketed bleach products, so their contribution to the Winter Carnival was a troop of drops of bleach, made of fiberglass. Shown here in 1948, they were among the most popular marching groups, and though the number of Hilex Drops has been greatly reduced, they still waddle down the street on an annual basis.

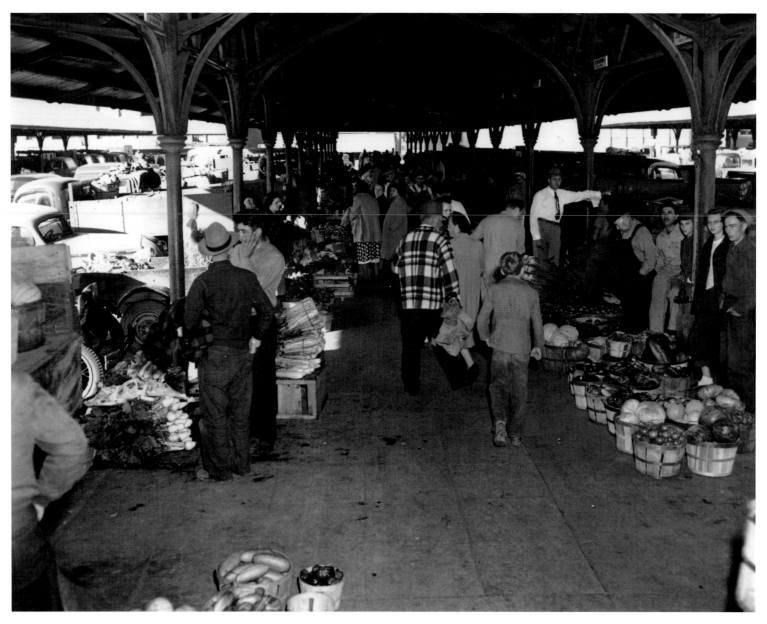

Baskets of tomatoes, cucumbers, and other home-grown foods attract early morning shoppers to the St. Paul Farmer's Market in the northeast corner of downtown. This is how it looked in 1949, nearly a century after it started. The market is still going strong today, bringing the public locally grown food, flowers, and other products from nearby family farms.

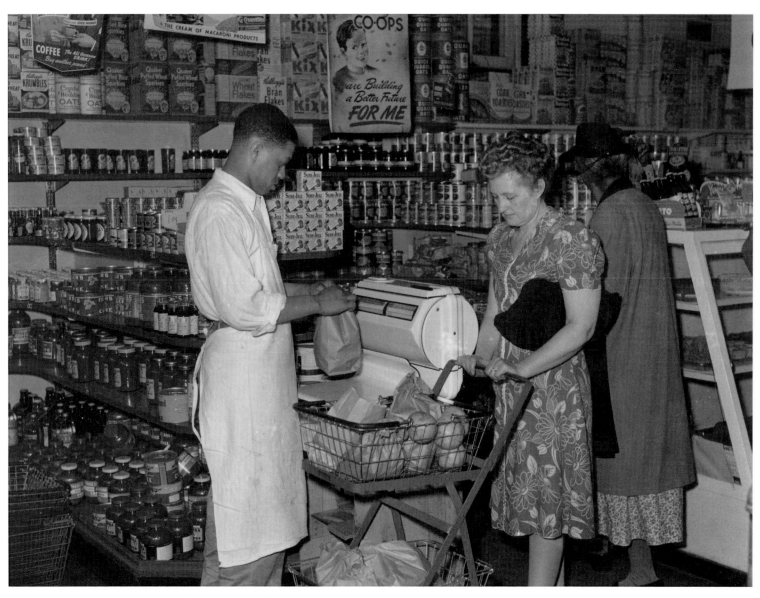

The Rondo area contained a vibrant African-American community until it was destroyed by construction of the freeway. In 1950 the Credjafawn Food Coop was located on Rondo Avenue near Dale Street. Members could conveniently purchase food at low prices. The sponsoring Credjafawn Club also opened a credit union, provided students scholarships, and labored for social justice.

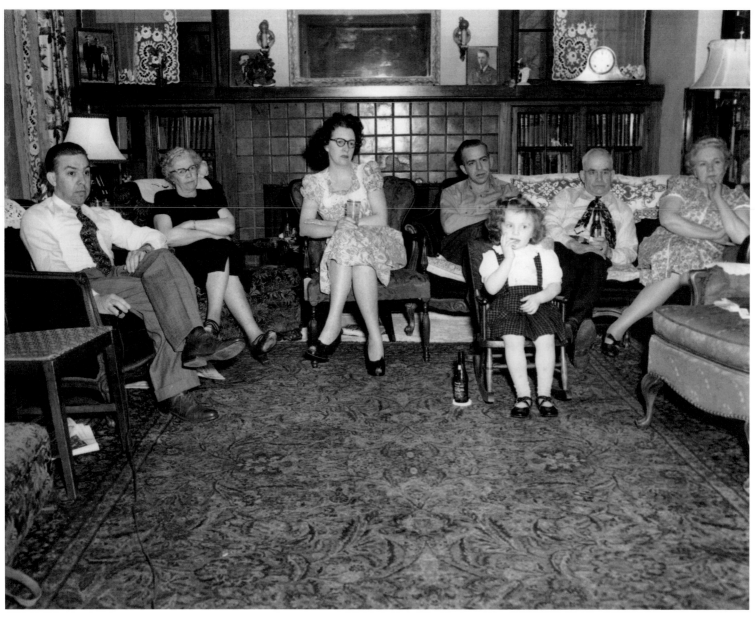

Television had a tremendous role in shaping our modern culture. St. Paul was no exception. The Armacher family is captured here, watching an unidentified show in 1951. According to records, the image was recorded by William Junior. He may be the person in the chair at left, who appears to be holding a hand-operated remote shutter release.

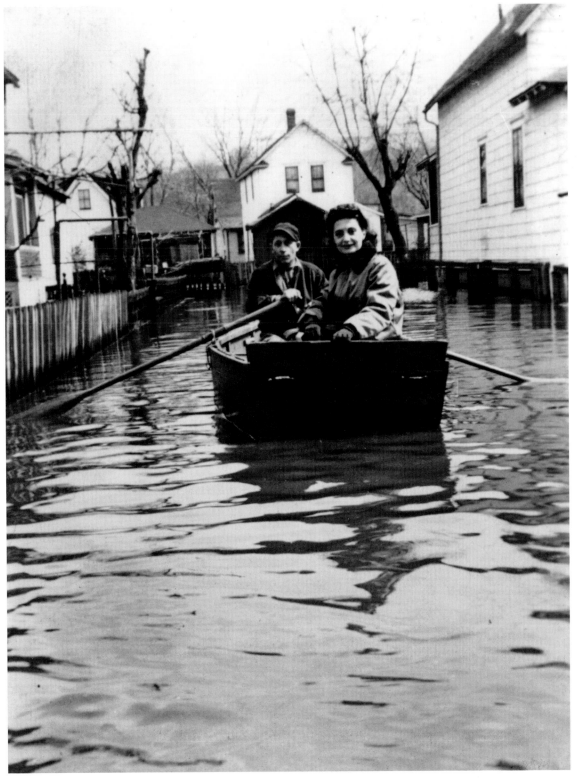

Homes located on low-lying land along the Mississippi River were always in danger when the water began rising. The epic flood of 1952 swamped communities on both sides of the river. Leonard (Guv) Todora and Ann Todora Stanley are shown here in a rowboat, taking note of the damage done to the upper levee homes.

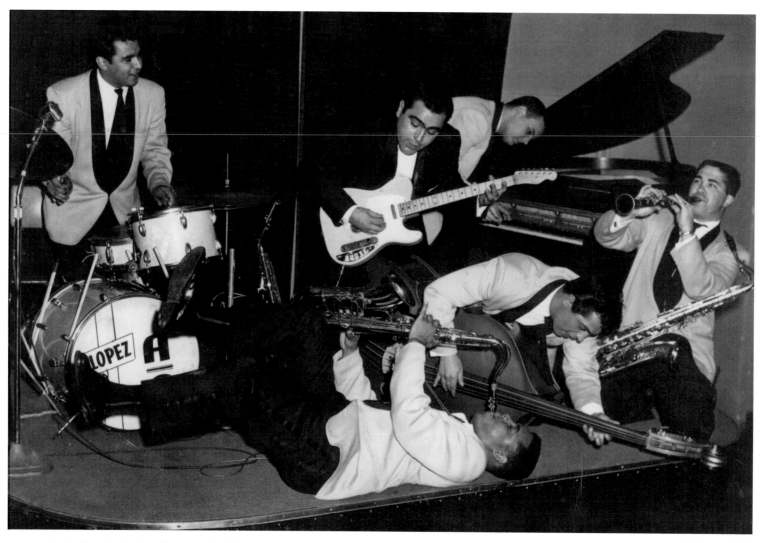

Augie Garcia, playing the guitar, has been called "the godfather of Minnesota rock and roll." This West Side singer, accompanied by drummer Jessie Lopez, usually performed in Bermuda shorts. The Augie Garcia quintet's heyday was from the mid-fifties through the sixties, and their biggest hit was "Hi Yo Silver." Many fondly remember the night they opened for Elvis at the St. Paul Auditorium.

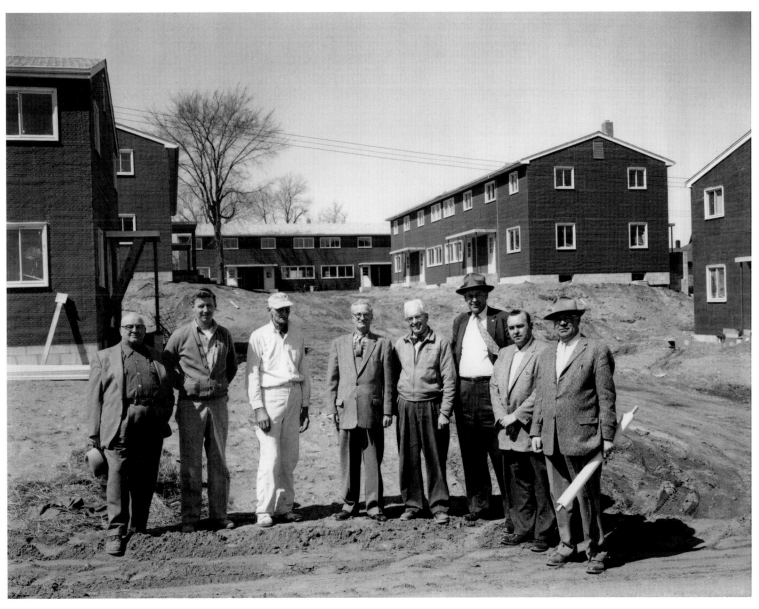

Like other cities in the postwar era, St. Paul used federal funding to remove slums and construct public housing for low-income residents. A group of foremen proudly pose in front of the Mount Airy project in April 1958. The city decided to build townhouses for families and usually reserved high rises for seniors.

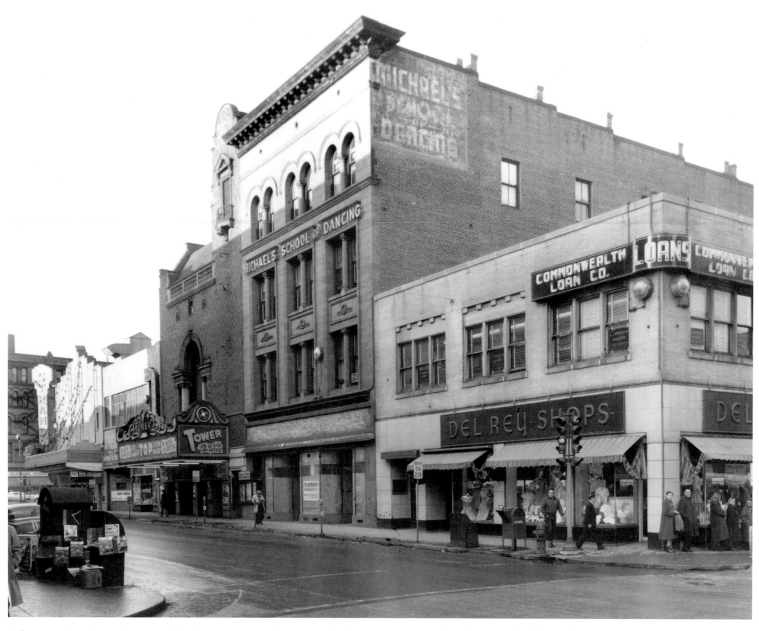

A few people wait at a bus stop. Nearby are two second-rate movie theaters, a newsstand, and a vacant building. This somewhat forlorn street scene illustrates downtown St. Paul, a bit lonely and shabby, in 1959. It was hard to compete with suburban shopping in shiny new stores with plenty of free parking.

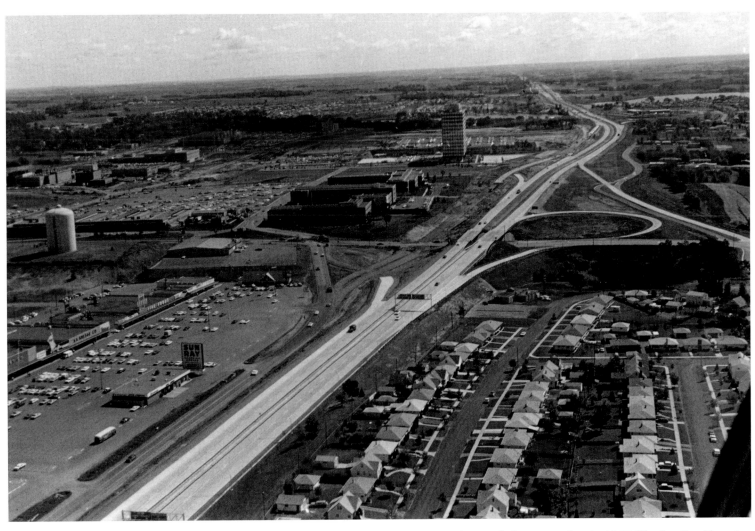

The interstate freeway system was having a great impact on St. Paul by the time this aerial photo was taken in 1967. The Sun Ray Shopping Center shown at left boomed because it was located near exits. On the right are new suburban-like houses in the Battle Creek neighborhood. In the distance across McKnight Road is the new 3M campus in nearby Maplewood.

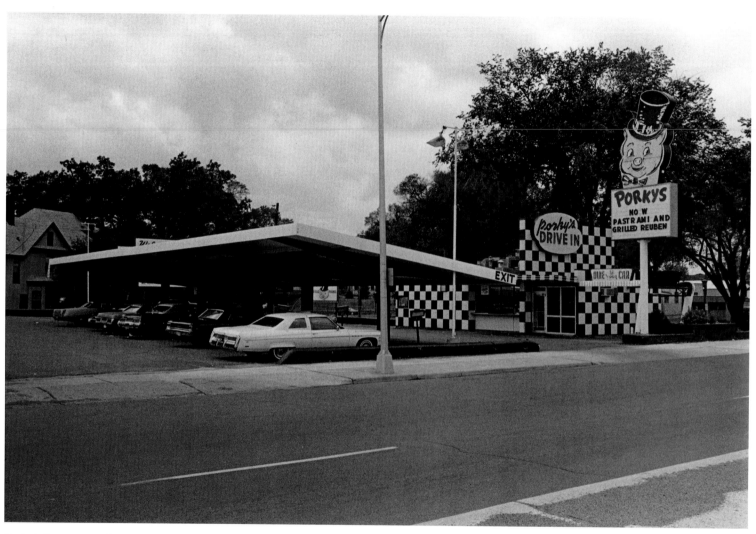

Porky's Drive-in, with its trademark black-and-yellow checks, opened on University Avenue in 1953. Youngsters flocked there to eat "twinburgers" and skin-on fries while showing off their autos. Porky's is still there—without carhops—as an extant remnant of a time when "cruising" became part of a teenage automobile culture.

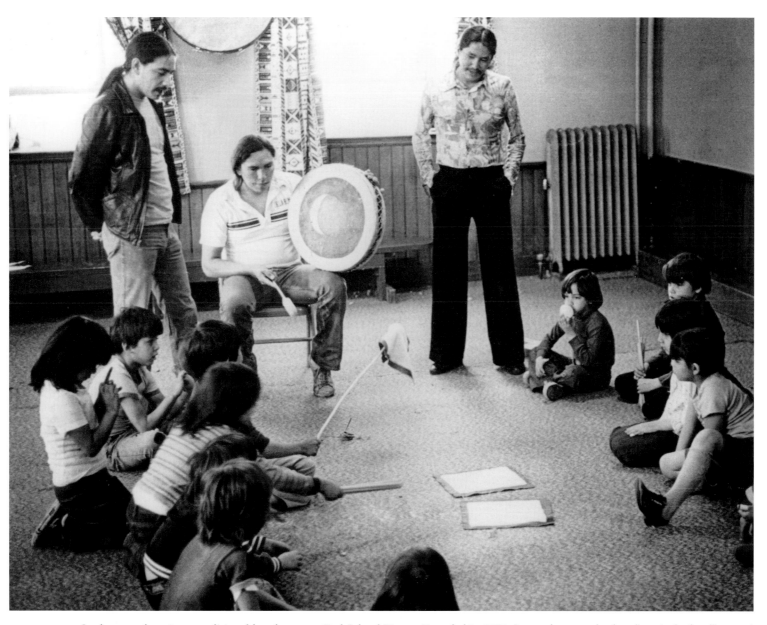

Students are learning a traditional hand game at Red School House. Founded in 1971, it was the second urban "survival school" started by the American Indian Movement. Located in an inner-city neighborhood, it developed a K-12 curriculum that mixed academics with cultural awareness for its mostly Ojibway students.

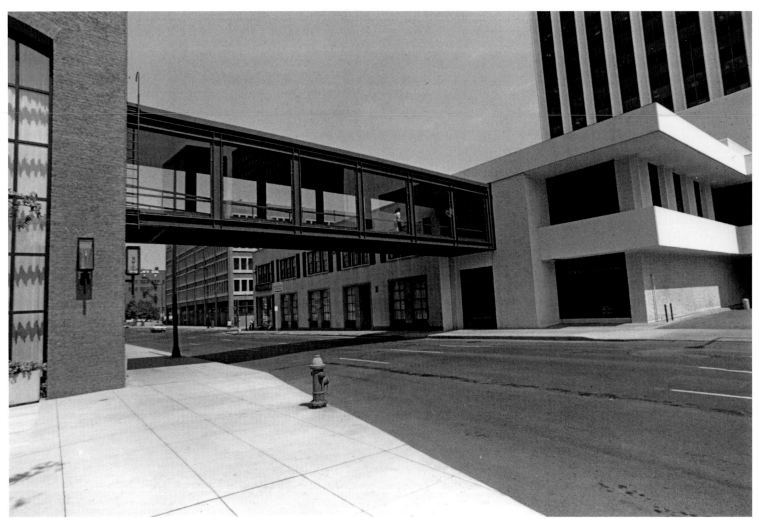

Downtown skyways were a late 1960s Twin Cities innovation. Prompted by the harsh winter weather, they connected downtown buildings so that people wouldn't have to go outside. This one on Sixth Street linked Twin Cities Federal and American National Bank. One result of the system was to take people off the sidewalks and make second-level real estate much more valuable.

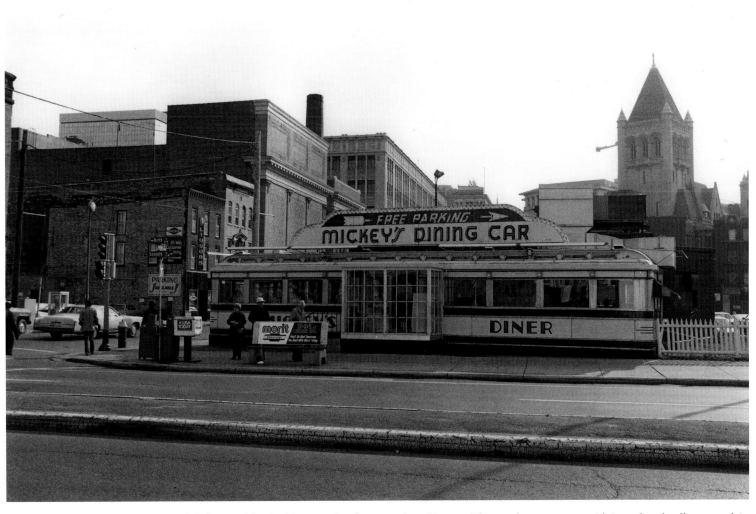

Mickey's Diner on East Ninth has served food 24 hours a day for more than 60 years. This art deco structure with its red-and-yellow porcelain paneling and neon signage was inspired by railroad dining cars. Prefabricated in the late 1930s and shipped to St. Paul, it was put on the National Register of Historic Places in 1983.

As the Vietnam War grew more unpopular, the number of people in marches began to swell. Students, union members, peace advocates, and everyday folks gathered to show their opposition to the conflict overseas. This 1972 march to the State Capitol was the largest anti-war protest St. Paul had ever experienced.

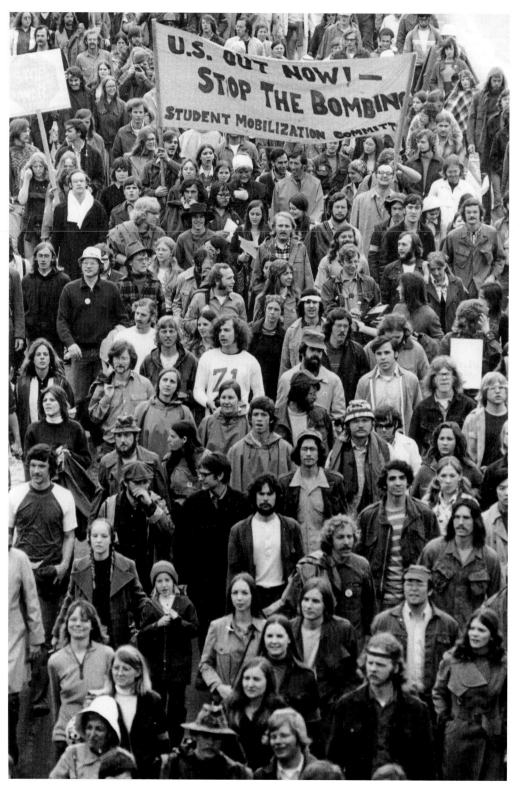

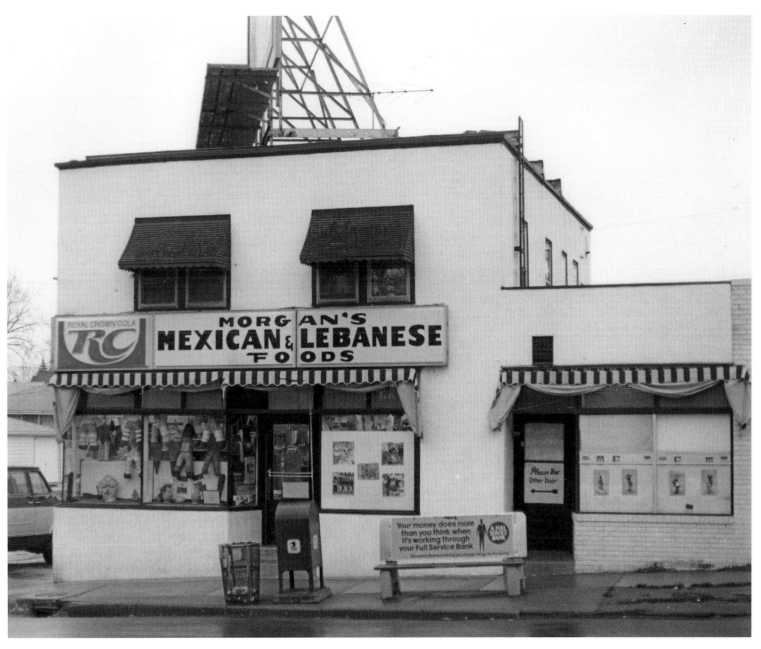

Morgan's Foods was started as a mom-and-pop store that primarily served the culinary needs of the Lebanese residents of the West Side. Over the years, as local demographics changed, they also began catering to the growing Mexican-American community. It has since gone out of business.

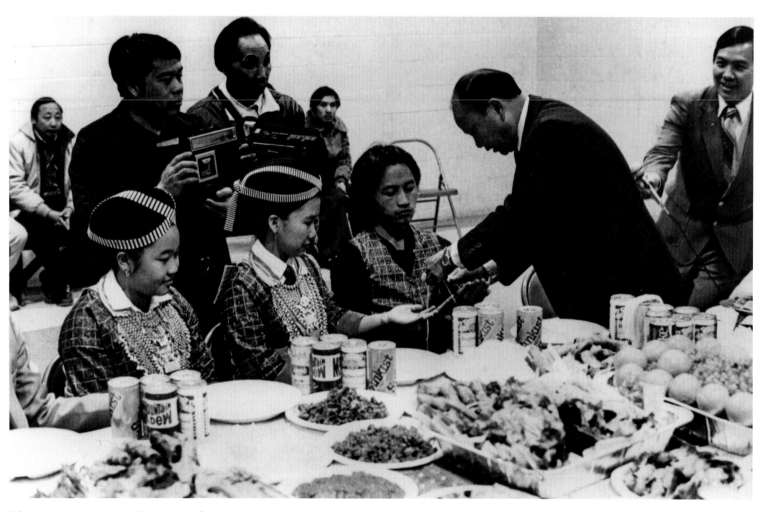

The Hmong, a Laotian ethnic group, fought with the U.S. during the Vietnam War in what they called "the CIA secret army." After the conflict, many sought refuge in the United States, and St. Paul is now home to the largest Hmong community outside Asia. The man speaking to the couple at their wedding celebration is General Vang Pao, who headed their military forces in Laos.

Notes on the Photographs

These notes, listed by page number, attempt to include all aspects known of the photographs. Each of the photographs is identified by the page number, photograph's title or description, photographer and collection, archive, and call or box number when applicable. Although every attempt was made to collect all available data, in some cases complete data was unavailable due to the age and condition of some of the photographs and records.

184 KITTENBALL GAME
Minnesota Historical Society
GV3.11 p119

185 HILEX DRIPS
Ramsey County Historical
Society
Kenneth Wright Winter
Carnival Photos
March 1948

186 FARMER'S MARKET
Minnesota Historical Society
MR2.9 SP3.1M p286

187 FOOD COOP
Minnesota Historical Society
HF4.6 p7

188 WATCHING TELEVISION
Minnesota Historical Society
HC6.3 p7

189 1952 FLOOD
Minnesota Historical Society
QC2.2d p65

190 ROCK MUSIC
Minnesota Historical Society
I.357.1

191 PUBLIC HOUSING
Minnesota Historical Society
Norton & Peel 251578

192 DOWNTOWN 1959
Ramsey County Historical
Society
1980.29.14

193 NEW FREEWAY
Minnesota Historical Society
MR2.9 SP1n p51

194 PORKY'S DRIVE-IN
Minnesota Historical Society
MR2.9 SP3.1P p37

195 SURVIVAL SCHOOL
Minnesota Historical Society
L4 p119

196 SKYWAY SYSTEM
Minnesota Historical Society
MR2.9 SP2.1 p168

197 MICKEY'S DINER
Minnesota Historical Society
Mr2.9 sp3 1M p229

198 PEACE MARCH
Minnesota Historical Society
E455 p25

199 MORGAN'S FOODS
Minnesota Historical Society
MR2.9 SP3.1M p233

200 HMONG WEDDING
Minnesota Historical Society
GT3.32r r7